IMAGES
OF THE WEST

IMAGES OF THE WEST

Survey Photography in French Collections,
1860–1880

Edited by François Brunet and Bronwyn Griffith

Essays by François Brunet and Mick Gidley

musée
d'art américain
giverny
terra foundation
for american art

Distributed by The University of Chicago Press

Published in conjunction
with the exhibition "Images of the West:
Survey Photography in French Collections,
1860–1880" held at the Musée d'Art
Américain Giverny/Terra Foundation
for American Art from
July 10 to October 31, 2007.

This exhibition is organized
with the support of the Société
de Géographie and of the Bibliothèque
Nationale de France, Paris.

{BnF
Bibliothèque nationale de France

This exhibition is made possible
through a generous grant from
the Terra Foundation for American Art.

musée
d'art américain
giverny
terra foundation
for american art

© 2007, Terra Foundation
for American Art

Musée d'Art Américain Giverny
99, rue Claude Monet
27620 Giverny
www.maag.org
ISBN: 978-0-932171-54-2

EXHIBITION

Director and President
Elizabeth Glassman

Administration
Diego Candil

Chief Curator
Sophie Lévy

Assistant Curator
Vanessa Lecomte

Exhibition Curators
François Brunet
and Bronwyn Griffith

Registrar
Catherine Ricciardelli
Olivier Touren

Conservation
Véronique Roca

Exhibition Design
Jasmin Oezcebi

Display Panels
Franck Vinsot

Installation
Didier Dauvel
Didier Guiot

Education
Veerle Thielemans
with the assistance of
Ewa Bobrowska-Jakubowski
and Miranda Fontaine;
Hélène Furminieux

PUBLIC RELATIONS

Géraldine Raulot in Giverny
and Catherine Dufayet
Communication in Paris

LENDERS

Paris
Bibliothèque Administrative
de la Ville de Paris
Bibliothèque Centrale du Muséum
National d'Histoire Naturelle
Bibliothèque Nationale de France
Club Alpin Français
Collection Marc Walter
École Normale Supérieure
Musée du Quai Branly
Musée d'Orsay
Société de Géographie

Chalon-sur-Saône
Musée Nicéphore Niépce

PUBLICATION

Editor and Production Manager
Francesca Rose with the assistance
of Audrey Klébaner

Translation from French
Jim Gussen

Graphic design
Pierre Péronnet
and Wijntje van Rooijen

Color Separations
Les artisans du Regard

Printed and bound
by Conti Tipocolor, S.p.A, Florence

Front cover:
Timothy H. O'Sullivan, *Sand Dunes,
Carson Desert, Nevada* (detail), 1868
© BnF/Société de Géographie

Back cover:
John K. Hillers, *Walpi,
Moqui Town, Arizona*, 1879–80
© BnF/Société de géographie

Library of Congress Cataloging-in-Publication Data

Images of the West : survey photography in french collections, 1860-1880 /
Edited by Francois Brunet and Bronwyn Griffith; Essays by Francois Brunet and Mick Gidley.
 p. cm.
 "Images of the West: Survey Photography in French Collections, 1860-1880 held
at the Musee d'Art Americain Giverny/Terra Foundation for American Art: Chicago,
2007 from July 10 to October 31, 2007."
 Includes bibliographical references and index.
 ISBN-13: 978-0-932171-54-2
1. Photography--West (U.S.)--History--Exhibitions. 2. Photographers--West
(U.S.)--Exhibitions. 3. West (U.S.)--Pictorial works--Exhibitions. I. Brunet, Francois.
 II. Griffith, Bronwyn.
 TR23.6.I53 2007
 770.978--dc22
 2007018879

CONTENTS

PREFACE

"Images of the West: Survey Photography in French Collections, 1860–1880," presented at the Musée d'Art Américain Giverny, is the result of five years of hard work by an international team of scholars. The Terra Foundation for American Art is proud to support the exhibition, which presents a broad panorama of the survey photographs of the American West for the first time in Europe. Produced during federal expeditions from 1876 to 1879, these historic photographs have received a great deal of attention and study in the United States, but remain relatively unknown to European audiences. This is surprising when the rich holdings of French institutions and collectors allow us to assemble such remarkable examples. The study of the development of these collections provides a new understanding of their historic importance, long-standing transatlantic ties, and a worldwide fascination with the new American territories.

"Images of the West" is the result of an inspiring collaboration between a specialist and a museum. It has benefited from twenty years of research that François Brunet has devoted to this subject, begun during his study of these survey photographs for his doctoral thesis completed at the École des Hautes Études en Sciences Sociales. With the help of Bronwyn Griffith, former Associate Curator at the museum and specialist in photography, and with the support of Sophie Lévy and Vanessa Lecomte, François Brunet successfully assembled more than 120 works—original prints, portfolios, stereoscopic photographs—produced by renowned photographers such as Carleton E. Watkins, Timothy H. O'Sullivan, William H. Jackson, Antonio Zeno Shindler, Alexander Gardner, John K. Hillers, Andrew J. Russell and William Bell. Brunet brought a great deal of enthusiasm to the project as well as his subtle, historic point of view, tireless efforts, and a remarkable openness and flexibility, which were key to the success of the project and the catalogue. Bronwyn Griffith also deserves special acknowledgement for her active involvement in every phase of this project.

This exhibition would not have been possible without the exceptional participation of the Société de Géographie and the Bibliothèque Nationale de France whose loans represent more than half the works assembled here. We thank them for their extraordinary generosity.

We also thank all the museums, institutions, associations, and private collectors who have so generously participated in this project with loans of important works of art. Among them, we would especially like to thank the following scholars: at the Bibliothèque Nationale de France, Olivier Loiseaux, Chief Curator of the Département des Cartes et Plans, Head of the Collections of the Société de Géographie, generously made available the vast holdings of the Société de Géographie, and offered precious advice and support; Sylvie Aubenas, Curator of the Département des Estampes et de la Photographie shared with us her time and knowledge and helped us obtain important loans; at the Société de Géographie, Jean Bastié, President and Michel Dagnaud, General Secretary; at the Musée d'Orsay, Françoise Heilbrun, Chief Curator of the Photography Department and Joëlle Bolloch, Archivist; at the Musée du Quai Branly, Christine Barthe, Chief Curator of the Photographic Collections, Heritage Unit, kindly shared important information and rare works from a museum still in its formation, and Carine Peltier, Curator of the Image Library; at the Musée Nicéphore Niépce in Chalon-sur-Saône, Christian Passeri, Curator; at the Bibliothèque Administrative de la Ville de Paris, Pierre Casselle, Chief Curator, and Agnès Tartié, Curator of Photographs; at the Bibliothèque Centrale du Muséum National d'Histoire Naturelle, Christine Bonnefon and Sylvie Devers, Curators; at the École Normale Supérieure, Laure Léveillé, Director of the Bibliothèque Générale; at the Club Alpin Français, Alina Sepulveda, Librarian; and lastly, Marc Walter.

Among the numerous curators, collectors and experts who also shared help and support, we would like to extend special thanks to Olivier Gérard, descendant of the collector Léon Gérard, for his recollections and Françoise Reynaud, Senior Curator of the Photographic Collections at the Musée Carnavalet, whose scholarly and technical advice were particularly helpful; Sylviane de Decker, collector; Isabel Girardot, Administrator at the Bibliothèque du Sénat; Jean-Philippe Dumas, Senior Curator for Cultural Heritage at the French Ministère des Affaires Étrangères; Pascal Mongne, Ph. D. of Pre-columbian archaeology and art history, Professor at the École du Louvre; Marie-Christine Thooris, Curator of the Reserve Collection and Heritage Resource of the École Polytechnique; Shannon Perich, Curator at the National Museum of American History, Smithsonian Institution.

We express our gratitude to François Brunet and Mick Gidley who shared their expert knowledge with us throughout the

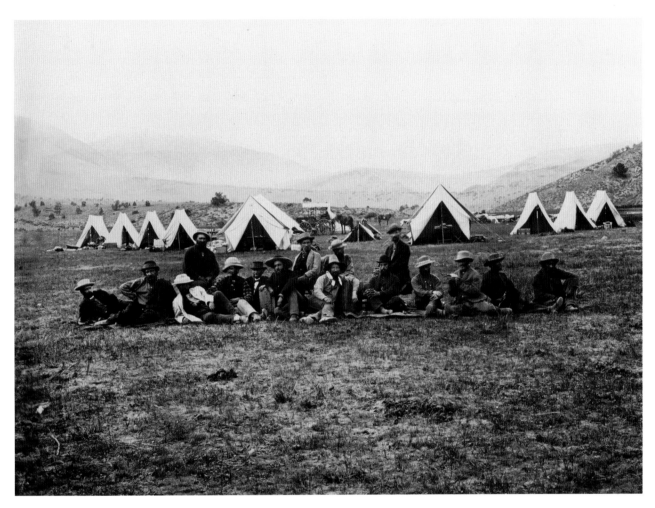

Timothy H. O'Sullivan | *Group of Officers and Assistants at Rendezvous Camp near Belmont, Nevada*, 1871
Albumen print, 20×28 cm | Société de Géographie, Paris

project and whose scholarly essays enrich this publication. We would like to thank the Réunion des Musées Nationaux, co-editor of this catalogue and especially Catherine Marquet, Head of the Publications Department. This beautiful book was produced at the Musée d'Art Américain Giverny by Francesca Rose, Head of Publications, and Audrey Klébaner, Editorial Assistant. We hope that this exhibition and its catalogue will inspire enthusiasm and curiosity among our international visitors.

Veerle Thielemans, Head of Academic Programs, and Ewa Bobrowska-Jakubowski, Coordinator of Academic Programs, coordinated a colloquium related to "Images of the West" and "Mythologies of the West," a wonderful exhibition organized by Laurent Salomé and FRAME (French Regional and American Museums Exchange), in collaboration with the Musée des Beaux-Arts de Rouen. "Mythologies of the West" is devoted to paintings and sculptures of the American West and overlaps with "Images of the West" in nearby Giverny.

An exhibition of this magnitude requires the efforts of many members of the Terra Foundation for American Art and the Musée d'Art Américain Giverny teams and we are grateful to all who contributed their expertise and talents to the development of the project.

Finally, the unflagging support of the Terra Foundation for American Art Board and its president Marshall Field V has been essential to the realization of this exhibition, as for so many others.

Elizabeth Glassman
Director, Musée d'Art Américain Giverny
President, Terra Foundation for American Art

INTRODUCTION

BRONWYN GRIFFITH

AN ARDOR FOR DISCOVERY marks the period immediately following the American Civil War. The western territories held promise of the American future, with vast expanses of land for settlement and abundant natural resources to be tapped. Earlier governmental expeditions had employed artists to render the landscapes and, as the expeditions continued and expanded after the war, photography came to play a central role in the documentation and promotion of the American West. Often spoken of under the rather general term "survey photography," the disparate nature of the federal expeditions that produced these images was anything but coordinated. Organized by competing agencies, the Department of War and the Department of the Interior, the surveys overlapped in their scope as they vied for funding. The thousands of photographs taken for the four major government surveys were never simply an illustration of vast expanses, Native American peoples, and the early white settlement of the rugged West, though this was and remains part of their appeal; rather, they were pictures with multiple objectives, some more transparent than others.

A brief perusal of the extensive bibliography on survey photography shows enduring interest from scholars in several different fields, including geography, art history and American studies. Recent scholarship continues to demonstrate the value of these images, yet curiously the photographs have never been considered outside a strictly national context, with exhibitions and publications barely extending beyond the borders of the United States. The aim of this study is to shift the discussion into a more international perspective by using French public collections as a revealing case study of the dissemination of these photographs and their reception. Delving into the significant collections of survey photography in France provides an apt opportunity to consider the scope of their international distribution and the motivations behind it. What becomes apparent is a deliberate American initiative to promote abroad national science and expansion through the circulation of these photographs and the official reports they accompanied. To accomplish this, two fundamental factors were at work: American interest in cultivating relations with colleagues abroad, something that undoubtedly held weight in Washington, D.C., and French curiosity about the discoveries made in the expanding Western territories of the United States. The result, nearly 150 years later, is an extensive

holding of survey photographs in French public collections in superb condition, yet little studied.

In the following pages, essays by two European scholars contribute to a new, more nuanced understanding of these treasured photographs. In a remarkably concise essay, François Brunet provides not only the socio-political framework of the surveys, but also new research into the provenance of the French collections including correspondence between key American figures and their French colleagues at numerous scientific organizations. The correspondence includes information about the donation of reports and collections of photographs, including some rare deluxe editions. Other collections are the legacy of French adventurers who traveled in the American West systematically collecting hundreds of photographs of the landscapes and the native peoples. Brunet also considers how a convergence of initiatives brought generous funding to the surveys and gave photography a status theretofore unknown coupled with an unprecedented scale of distribution that included stereoscopic views, albums, catalogues of photographs available for purchase, large format prints for exhibition at numerous world's fairs and illustrated brochures, some trilingual. Also included are the appendices with essential information about the history of principal collections, which will be of particular interest to scholars in the field.

Another undertaking central to the aims of this project was to reunite the landscape and Native American photographs which have been systematically separated, with a disproportionately keen interest in the former. Though taken concurrently, the landscapes and the ethnographic photographs of Native American Indians have rarely been together in exhibitions and publications. The disassociation of the two subjects not only limits the understanding of the survey photographer's aims and assignments, but it also removes them from their original context. When viewing the photographs of Native Americans, it is relevant that they were taken at the same time as the landscape photographs, some under the directives of the survey leaders, and were an integral component of the visual documentation.

The impact that white settlement had on the Native American populations was devastating, and their displacement in

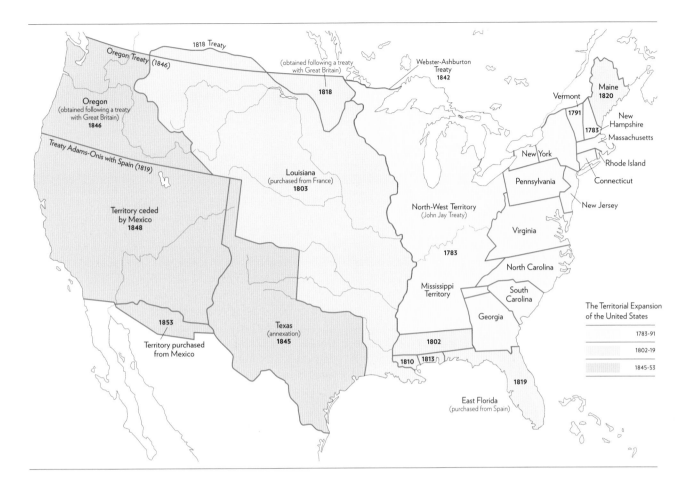

The Territorial Expansion
of the United States

	1783-91
	1802-19
	1845-53

the name of progress and national expansion brutal. Intended as scientific documentation, the photographs are heavily weighed down by this history and not surprisingly scholars have most often interpreted them strictly as a tool of the oppressors. There is an unavoidable, uncomfortable feeling of 'otherness' or alterity and the tragic history of these displaced peoples, so often overshadowed by the collective myths about the American West cultivated by both popular culture and "official" history. In an insightful essay, Mick Gidley calls into question the intended objectivity of the Native American photographs and evokes the complications inherent in attempting to interpret the images. Limitations dominate, especially since the degree to which the Indians participated and any motivations they may have had in doing so will forever remain a mystery. Gidley points out that to restrict the reading to that of the domineering white settlers and the victimized Native Americans, limits the Indians to the role of the oppressed thus denying that they exercised any power to refuse or resist participation, or perhaps more interesting still to use the photography for their own purposes. In the absence of this

information, the full intent of the photographers and their sitters thus remains indecipherable.

Rather than demystifying the West, survey photographs have been often removed from their original context to be used in the mythmaking. The keen interest in the American West in France has been cultivated since the exhibition of George Catlin's Indian Gallery at the Louvre in 1846 and tours of Buffalo Bill's Wild West Show fifty years later. The image most French have has likely been formed more through the "cowboys and Indians" of the Hollywood western film genre than the more complex but equally dramatic history, and this is not surprising when one considers that the same is largely true of most Americans. Yet, the rich holdings of survey photography in French public collections is testament to a long-standing fascination with the American West that goes deeper. Published in both French and English, this study aims to brings to light important collections that have been virtually unexplored by scholars in the field until now and to return to the international dialogue about survey photography with the gift of both hindsight and groundbreaking scholarship.

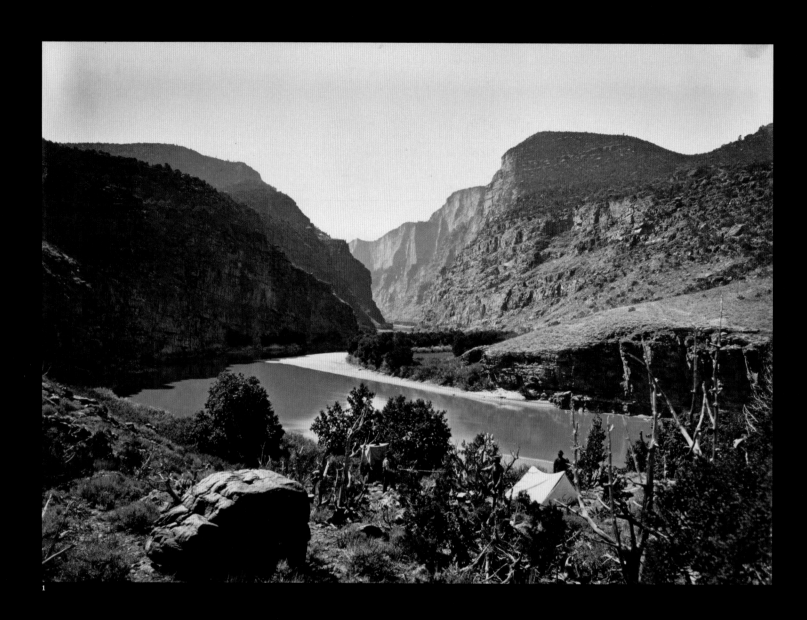

"WITH THE COMPLIMENTS OF F. V. HAYDEN, GEOLOGIST OF THE UNITED STATES"

Photographic Policies of American Exploration

FRANÇOIS BRUNET

Pictures were essential to the fulfillment of the doctor's plan for publicizing the Survey; but the basic purpose was always exploration. I cannot be too careful in emphasizing the fact that in this and all the following expeditions I was seldom more than a sideshow in a great circus.

— WILLIAM H. JACKSON, 1940[1]

I admire the prodigious activity displayed by American scientists in describing the vast regions, almost all of them uninhabited, that make up the Republic of the United States. When I compare the results obtained on the other side of the Atlantic to those achieved in old Europe, I am forced to acknowledge that we find ourselves in an inferior condition. Although we have plenty of geologists, we almost completely lack the animating breath of private initiative, and our governments prefer to dream of Bayonettes [sic] *and battleships rather than of promoting progress by means of the arts and sciences.*

— HENRI COQUAND, geologist from Marseilles, letter to Ferdinand V. Hayden, 1878[2]

1 Jackson [1940] 1986, 201. 2 Coquand to Hayden, September 5, 1878, Hayden Survey Records, Letters Received from Foreign Countries, Record Group 57, United States National Archives and Records Administration.

Timothy H. O'Sullivan | *Entrance to Grand Canyon*, 1872
Albumen print, 20×28 cm | Société de Géographie, Paris

IMMEDIATELY AFTER THE CONCLUSION of a bloody civil war, America's Congress opened the West to a vast program of development that sealed the destitution of those Indian tribes that had not yet been subjugated and enshrined the victory of the democratic and capitalist North over the agricultural and traditionalist South. The slogan "Go West!" was followed by a great movement of emigration and a frenzy of study tours, prospecting efforts, and surveys of all kinds. The entire nation, at least that portion that was Yankee and white, went to the West in fact or in thought to carve out its dream of a bright and prosperous future. This dream of the West served as an outlet for the nation's rifts and fractures, even as it promised to hasten the repression of Indian resistance. It would be given concrete form—and would be sometimes co-opted—by those new giants, the railroad, mining, land, and agricultural companies. But it was above all the federal government's campaign of exploration, an old enterprise to which Congress gives new life at this time, that would define the collective consciousness and image of this idealized West. This image, which was foundational for the future, combined scientific and popular descriptions with many different kinds of images depicting all—or almost all—there was to see in the West, from cactus needles and foliated mica patterns to the awe-inspiring landscapes of Yosemite, Yellowstone, and the Grand Canyon (fig. 2) and the figures of those "Redskins" whose "vanishing" was generally lamented, more often than not in full regalia. Painters—and not the least of them—helped to shape this image: Albert Bierstadt, Thomas Moran, and Sanford Gifford.[3] After 1865, however, this image was dominated for the first time by photography and the visions of a group of photographers without historical precedent or parallel. Primarily immigrants and self-taught experts in the difficult process of wet collodion on glass,[4] from 1860 to 1880 these "operators" were employed by the various institutes and surveys charged with producing the official description of the new territories. A few names stand out among a great many others: Alexander Gardner, a Scotsman by birth; the Irish-American Timothy H. O'Sullivan; the Englishman William Bell; Hanover native John K. ("Jack") Hillers; the Bulgarian (or Romanian) Antonio Zeno Shindler; and finally the native-born Americans Carleton E. Watkins, Andrew J. Russell, and William H. Jackson.[5] It was these "survey photographers" who created the classic face of the "wonders of the West" and did the same for the West's first inhabitants, whom they turned into visual myths. Their production is unique in a number of respects: in its scope (thousands of negatives, tens of thousands of prints); in its wide initial distribution (in the United States but also in Europe); in the official nature of its source (in this respect the corpus of exploration may have its only par-

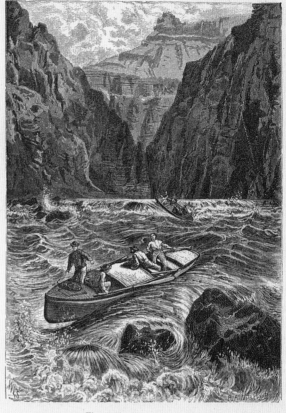

Figure 28.—Running a rapid.

2

R. A. Muller
"Running a Rapid" in John W. Powell,
Exploration of the Colorado River and its Tributaries;
Explored in 1869, 1870, 1871 and 1872 (Washington, D.C.: 1875),
fig. 28. Xylograph, 13.5×9.5 cm
Bibliothèque Administrative de la Ville de Paris

allel in the documentary campaigns of the New Deal); but also and above all in its extraordinary technical and visual qualities. The technical heroism and spectacular beauty of the large views of Watkins, O'Sullivan, Jackson (cat. p.116), Bell, and Hillers—whose negatives reach 20×25 inches in size—were recognized at the time, even if the dominant representation of photography as "sun painting" (a mere technology of accuracy) prevented it from receiving academic recognition. Because of these qualities, the survey photographers are recognized today as the primitives of American photography. With this corpus, or at least its landscape component, which since the 1960s has been exhibited, published, and

3 See Goetzmann and Goetzmann 1986, 143–232. **4** This negative-positive process, which became widespread in the United States after 1860, required that the glass plate be coated on-site with a wet, collodion-based emulsion and then exposed and developed immediately, before the emulsion could dry. The operators had to be careful to avoid a wide variety of hazards (impure water, dust, insects, etc.), while the size of the plates (up to 45×65 cm), which determined the size of the prints (since enlargement was not possible), entailed equipment and means of transportation of considerable size. **5** See appendix, biographies, 118–20.

commented ad infinitum and rephotographed several times, we stand before one of the great moments of American photography.[6] Hence the question that will be raised in this essay: how did a federal government that was in principle little inclined to finance the arts and sciences come to finance, organize, and disseminate a collection like this one, whose potential documentary usefulness pales today beside what Martha Sandweiss calls its "legends"[7]—its ideological, promotional, cultural, narrative, and artistic functions? Can one speak in this respect of a policy? If so what were its goals—including its international ones, for the images were also disseminated abroad, especially in France?

In fact, this question is relevant to the entire history of American exploration, beginning with the first crossing of the continent by Thomas Jefferson's emissaries, Captains Lewis and Clark, in 1804–06. A lavish enterprise, exploration accompanied the continental expansion of the United States from the beginning, without being reducible to it. Although it was the prerogative of the prestigious Army Corps of Engineers until 1860, it was never restricted to a strategic vision of the territory. On the contrary, it produced a superabundant literature and iconography marked, in the spirit of Alexander von Humboldt, by a dazzling collaboration of the sciences, arts, and letters. Thus, in addition to supporting territorial expansion, exploration also served the cultural development of the United States, and beginning in the 1850s with the Pacific Railroad Surveys, fulfilled a function of social public relations.[8]

Thus, it is all the more striking that, until around 1860, American explorers should have remained largely indifferent to photography. In Europe—since the official publication of the daguerreotype in 1839—exploration had seemed to be a natural field of application for the "accuracy" of photographic "reproduction." Throughout the 1840s and 1850s this obvious affinity prompted and informed such undertakings—organized by academies and learned societies—as the Mission Héliographique Française and the voyages of Maxime Du Camp, Francis Frith, and Felice Beato to the European colonial regions.[9] There is nothing comparable in the United States. Between 1840 and 1860, some thirty expeditions accompanied the aggressive policy of expansion that led in 1848 to the annexation of California and the entire Southwest (see map, p. 9) and then to the pilot studies for the transcontinental railroad. Nevertheless—and despite the Americans' unrivaled infatuation with photography—this phase of

3

Arthur Schott
"View from Monument no. VI, looking towards monument no. V" in William H. Emory, *Report on the United States and Mexican Boundary Survey, Made under the Direction of the Secretary of the Interior* (Washington, D.C.: 1857)
University of Michigan, Ann Arbor. Making of America

exploration was actually marked by the ascendancy of drawing (fig. 3).[10] A simple explanation has often been advanced for this paradox: the daguerreotype, which was the dominant form of photographic technology in the United States in the 1850s, produced a single image (a positive on a silver plate) and was poorly suited to representing landscapes, while the collodion on glass process, which combined the precision of the daguerreotype with large size and above all allowed for the duplication of prints, did not become widespread until around 1860. And yet there was no shortage of private operators who, as early as the 1840s, made daguerreotypes of the frontier towns and their populations, to say nothing of the new urban landscapes of Cincinnati, St. Louis, and San Francisco. Moreover, a small number of Daguerrean experiments in exploration—including those of John L. Stephens in the Yucatan in 1843 and those of John C. Frémont in the West, especially in 1853—show that there were indeed individuals determined to surmount the associated technological obstacles, who succeeded in printing extremely high-quality engravings from their shots (fig. 4). It should be noted that these exceptions often took place in the context of institutional rivalries, imperialist designs, and personal ambitions, and that in these cases photography did not fulfill specific descriptive needs so much as it served more highly symbolic intentions, indeed intentions that already anticipated the later

6 This canonization has focused on the notion of landscape; see Szarkowski 1963; Naef and Wood 1975; Ostroff 1981; Wolf 1983; Jussim and Lindquist-Cock 1985; Trachtenberg 1989; Castleberry 1996; and Snyder 2006. A significant exception is the very rich discussion provided by Sandweiss 2002, 181–206. For more information on the "rephotographic" campaigns, see Klett 1984 and 2004. **7** See Martha Sandweiss's important book published in 2002. **8** Copies of the richly illustrated reports of the Pacific Railroad Surveys were distributed in the thousands. See Taft 1953, 254–56 as well as Goetzmann [1966] 1972, 265–352; Ron Tyler, "Illustrated Government Publications Related to the American West, 1843–1863," in Carter 1999, 156–58. **9** For more on the Mission Héliographique see Mondenard 2002; on the "golden age" of travel photography see Newhall 1982, 43–56. In the late 1840s the Muséum d'Histoire Naturelle adopted the daguerreotype as a means of reproducing "human types" (Barthe 2003). **10** See Tyler in Castleberry 1996, 41–48; Goetzmann and Goetzmann 1986, 100–12.

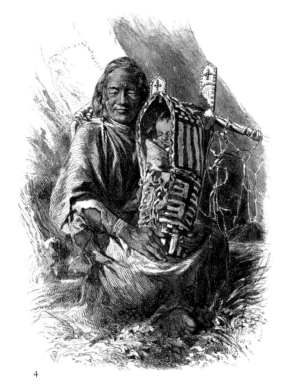

4

After Solomon Nunes Carvalho
"Old Indian Woman and Papoose" in John Charles Frémont,
The Evolution of the Great West (Chicago: 1860s), leaf no. 22
Xylograph after daguerreotype
University of California, Berkeley. The Bancroft Library

al autonomy and brilliant graphic tradition. Unlike their English and French colleagues, these military engineers had not been trained in photography and had not undertaken any methodological reflection on the subject.[13] They were reluctant to incorporate into the equipment of exploration a technology that was still new, was often suspected of charlatanism, and meant turning to confirmed experts—the professional photographers—who were strangers to the culture of exploration. These reservations were destined to be swept aside by the massive influx of photographers into the field of exploration after the Civil War.

A slaughter second to none in the nineteenth century, the Civil War has often been described as the first modern conflict, in particular because of the role that was played in it by photography and photographers. Several dozen operators, most of them Yankees and employees of the portraitist and photo-agency director *avant la lettre* Mathew B. Brady, conveyed a detailed and sometimes harsh vision of the war in thousands of photographs, relayed in the form of engravings by the illustrated press.[14] Among them were some of the future leading lights of exploration photography, in particular Gardner, an ex-associate of Brady's who had left him to form his own group of operators in 1862 in the wake of a copyright dispute; but also O'Sullivan, the author of hundreds of scenes of camps and military fortifications as well as macabre views of corpses (fig. 5). Other photo-explorers also began their careers in the Civil War, including Russell, Jackson, and Bell, who photographed wounds and mutilations for the Army Medical Museum beginning in 1863. In this respect, it has been pointed out how appealing it must have been to these photographers, trained in the horrors of the war, and their audiences to turn to the exploration of the great landscapes of the West (fig. 6).[15] In addition to this catharsis, however, a professional and social dimension must also be mentioned. It was the war that placed the army in contact with the world of professional photographers, who were subject to the imprimatur of the military authorities and generally limited to photographing soldiers and equipment at rest. Numerous bonds were forged in this way, both personal and functional, and some of the operators performed technical tasks (O'Sullivan reproduced maps for the Army of the Potomac, while Russell photographed military fortifications). The Civil War was also a watershed in the popularization of the photographic image thanks to the spread of the glass process and the expansion of "stereoscopic views," double images that created the impression of depth when viewed through a stereoscope. The portraits in "carte-de-visite" format that were exchanged by the soldiers and their families became commonplace objects. Moreover, photo-

rise of media consciousness.[11] A tentative evolution beyond these initial stages did begin to take shape in the late 1850s with the expeditions of Ives, Lander, and Simpson. But what really stands out from this period is the surprising diagnosis pronounced by Captain James H. Simpson upon returning from his expedition to Utah in 1859—a point at which photographers such as Gustave Le Gray, Charles Nègre, Francis Frith, and Roger Fenton had already gained recognition and respectability for landscape photography in Europe and the very year that Désiré Charnay completed his extensive report on the Yucatan.[12] Simpson, who had hired two photographers supplied with high-quality equipment, acknowledged his failure and concluded that "the camera is not adapted to explorations in the field, and a good artist, who can sketch readily and accurately, is much to be preferred." Even given the limits of the daguerreotype, this diagnosis above all reflected the topographical engineers' attachment to their profession-

11 For more on the case of Frémont see Brunet 1998; for detailed analyses of several of these exceptions see Taft [1938] 1964, 248–70; Brunet 1993, 1:159–92; and Sandweiss 2002, 88–108. **12** See Barthe 2007 and Brunet 2007a. **13** The excerpt from Simpson's report is cited by Taft [1938] 1964, 267. Photography, which was taught at the Royal Engineer Establishment in Chatham beginning in 1856, was employed by the British Corps of Engineers in border surveys (cf. Goetzmann 1959, 427–32; Birrell 1975). The analysis suggested by Sandweiss 2002, 128–32 agrees with ours in every respect. **14** See Frassanito [1975] 1996; Panzer 1997. **15** On O'Sullivan see Naef and Wood, 126–28 (by contrast, Snyder 1981, 49–51 emphasizes the continuity between the spectacle of the war and the sublimely inhospitable character of O'Sullivan's views of the West); on Russell see Fels 1987, 8–14.

graphic printing lent itself to the production of albums and books, while specialized firms distributed stereoscopic views and the illustrated press turned the engraved or lithographed image "from a photograph"[16] into an everyday experience. Finally, even before it was over, the war encouraged two experiments that introduced photography into the official representation of the West.

The first of these experiments took place in California, a young state born of the war against Mexico and the Gold Rush, which by 1860 had already undergone an impressive expansion. In the eyes of those who governed it, that expansion justified an inventory of its natural resources. In 1861 the California Geological Survey was created under the aegis of the geologist Josiah D. Whitney. Supported by a group of experts newly graduated from the first specialized faculties—including the very young geologist Clarence King—Whitney conceived an ambitious scientific program that was quite out of step with his employers' more practical objectives.[17] It was partly to respond to their mounting mistrust that he finally summoned the powers of photography to the service of a more popular geology. In 1860, California, or more precisely San Francisco and its region, was already the cradle of a sophisticated practice of outdoor photography. A boomtown that was fascinated from the beginning by the image of its own sudden emergence and the champion of a no-holds-barred speculation that very early on numbered illustrated advertising (and photography) among its promotional tools, San Francisco during the war years also became a mini-cultural capital for an entire population of high-profile adventurers and artists in search of exoticism. Painters and writers rubbed elbows with the members of the California Geological Survey—above all the brilliant Clarence King—in the circle that formed around John C. Frémont and his wife at their estate of Mariposa, not far from Yosemite Valley, which, recently snatched from its native inhabitants, had now begun to be exploited by the nascent tourist industry as the ultimate natural wonderland. In the 1850s, San Francisco was a paradise for daguerreotypists and the subject of a number of ambitious photographic ventures.[18] One photographer above all others embodies the rise of San Francisco and the Sierra Nevada to the status of premier iconic and tourist territory of the West: Carleton E. Watkins, an autodidact who began his career as an expert in land disputes before establishing himself in 1861 as the master of photography at Yosemite.[19] Together with Bierstadt's monumental paintings and the images of his rivals Charles L. Weed and later Eadweard Muybridge, Watkins's views—in very large format or stereoscopic form—spread the image of the valley's sublime natural features all the way to New York and Boston and soon to Europe as well (fig. 7), where Watkins would receive a medal at the Paris Universal Exposition in 1867. Thus, with the Civil War

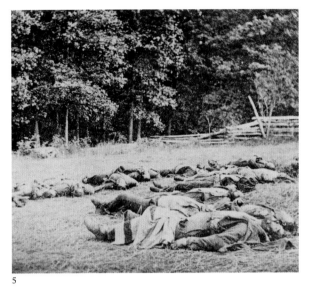

5

Timothy H. O'Sullivan
Confederate Dead Gathered for Burial at the Southwestern Edge of the Rose woods, July 5, 1863
Stereograph, 9×18 cm
Library of Congress, Washington, D.C.
Prints and Photographs Division

in full swing, Yosemite became the sanctuary of an immemorial nature perceived as an outlet for the nation's rifts and fractures and as the much sought after model of an "American landscape."[20] In 1863 Congress permitted the state of California to create a "public pleasure ground" that included Yosemite Valley and the neighboring redwood groves. When it came time to design the park, Watkins was consulted as an expert—proof that this natural sanctuary was envisioned as a realm of visual pleasures.[21] It is this national and international craze that Whitney and his team were seeking to exploit when they launched their own exploration of the valley and procured the photographer's services for the purpose. Watkins was never directly employed by the California Geological Survey but served its editorial ventures. At first Whitney purchased the images to illustrate his books; then in 1866 he provided Watkins with a camera specially intended to produce views that would then remain the property of the California Geological Survey and serve to illustrate, as pasted prints, a publication called the *Yosemite Book* (1868), which was partly touristic and partly didactic. With the question of ownership of the negatives (which had already preoccupied Gardner during the war), a legal and commercial issue began to crystallize that, for the explorers, was linked above all to the demands of publication and that became extremely important around 1867, when Congress extended copy-

16 For more on this little-known phenomenon see Gervais 2006. **17** Goetzmann [1966] 1972, 355–89. **18** For more on these various aspects see Naef and Wood 1975, 34–41; Palmquist 1983, 3–10; Brechin 1999; and Palmquist 2002. **19** See especially Palmquist 1983 and Nickel 1999. **20** See the brilliant analyses of Schama 1995, 188–96, 570–75. **21** Huth 1948, 70. In addition to Watkins, the landscape architect Frederick Law Olmsted, the park's first commissioner, also consulted the painters Thomas Hill et Virgil Williams.

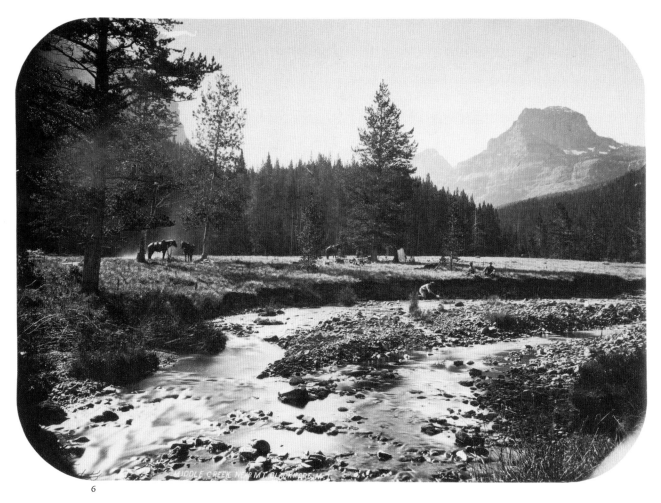

6

William H. Jackson | *Middle Creek near Blackmore, Montana*, 1873
Albumen print, 26×33 cm | Musée Nicéphore Niépce, Chalon-sur-Saône

right law to photographs.[22] As for the *Yosemite Book,* a deluxe popularizing work for the "intelligent traveler" that was later reissued in affordable editions with engraved illustrations, it inaugurated a model with a bright future in federal exploration. Thanks to Watkins's unrivaled mastery of the genre of the view, the California Geological Survey became a school of exploration photography; while his images were traveling round the world, the California Geological Survey's principal "student," Clarence King, was learning a lesson he would not later forget.

At the same time, another experiment no less important for our topic was taking shape in Washington at the Smithsonian Institution. Congress had created this semipublic museum in 1846 thanks to the bequest of the English patron James Smithson, who wished to create "an establishment for the increase and diffusion of knowledge among men." Despite the loftier scientific ambitions of its secretary, Joseph Henry, in practice this institute served as a depository for the proliferating collections amassed by American explorers both in the West and on the oceans. In the late 1850s, the Smithsonian Castle already housed tens of thousands of botanical, zoological, and mineralogical specimens, some of which went back to Lewis and Clark, as well as a great many objects, paintings, and ethnographic documents. In 1857–58, the studio of James McClees had begun to photograph the Indian delegations invited to negotiate, with the federal authorities, the famous "treaties" that actually sanctioned the destitution of the tribes. In 1859, Joseph Henry, who had a passion for both ethnography and photography, proposed the idea of building an official collection of these Indian portraits. It took ten years for this idea to be realized in the form of a remarkable exhibition of Indian photographs presented at the Smithsonian in 1869—and recently reconstructed in minute detail by Paula Fleming.[23] However, this project only came to fruition thanks to the support of the English millionaire William H. Blackmore, a speculator, philanthropist, and amateur ethnologist who—after a first visit to the

22 Welling [1978] 1987, 186, 206. Watkins was the victim of various pirating efforts at this time. **23** Fleming and Luskey 1986, 20–43; Fleming 2003, 1–13.

Carleton E. Watkins | *Five Views of Yosemite* | Five albumen prints (Isaiah W. Taber, after 1876) on mount from collodion-on-glass negatives (attributed to C. E. Watkins, c. 1865). French captions added by Léon Gérard in the late nineteenth century | Musée d'Orsay, Paris. Gift of Mr. Robert Gérard, 1987

7

B 1018 Half Dome, from "Merced River." Taber Photo., San Francisco.

Vue du demi Dôme, prise de la rivière Merced Vallée de Yosemity

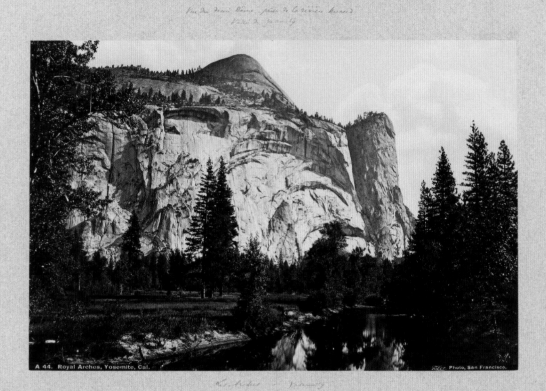

A 44. Royal Arches, Yosemite, Cal. Taber Photo, San Francisco.

Les Arches — Yosemity

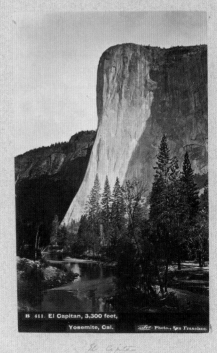

B 411. El Capitan, 3,300 feet, Yosemite, Cal. Taber Photo., San Francisco.

El Capitan Yosemity

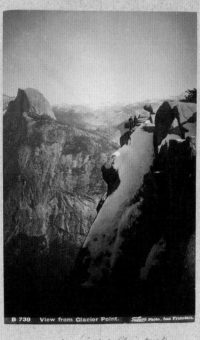

B 739 View from Glacier Point. Taber Photo., San Francisco.

Vue prise de Glacier point Yosemity

B 804. "Cathedral Spires," 2,660 feet, Taber Photo., San Franc

Les Flèches de Cathédrale Yosemity

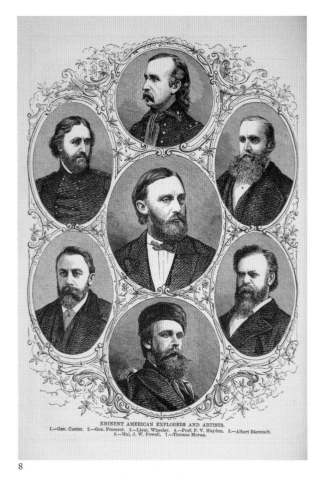

8

"Eminent American Explorers and Artists"
in Henry T. Williams, *Williams' Pacific
Tourist Guidebook* (New York: 1876), 30
Xylograph
Club Alpin Français, Paris

several hundred of his Indian photographs so that Shindler could copy them and use them to fill out the Smithsonian's collection and exhibition. The recent reconstruction of this exhibition was carried out on the basis of the "Shindler Catalogue," a compilation of titles of the images amassed by Blackmore that would later be substantially expanded by the Hayden survey in the course of the 1870s.

It is no accident that this program of Indian photography—as well as the popularization of Yosemite—should have materialized at the end of the Civil War. If the ideological stake of this war was the abolition of slavery, its profound historical meaning was the validation of the industrial and expansionist model of the North, whose cardinal objective at that time was the settlement and development of the West. It was this objective that was already served in the midst of the war by the Homestead Act (1863), which granted settlers ownership of plots they had worked for five years, and by the Pacific Railroad Acts, which provided for the building of the transcontinental railroad. And it was this same objective that was pursued in the war's immediate aftermath by the resumption of federal exploration and the massive subsidization of the companies charged with constructing the railroads (which immediately turned to photography, and in particular Russell and Gardner, for assistance with activities of prospecting and promotion).[25] This "liberation of energies" had as its direct consequence an enormous increase in pressure on the tribal territories, the subsequent eruption of the "Indian Wars," and the acceleration of what enlightened American opinion had been describing, for at least half a century and with greater or lesser embarrassment, as "the vanishing Indian." As Henry wrote in 1865 in support of his project of a "collection of likenesses of the principal tribes of the United States": "the Indians are passing away so rapidly that but few years remain, within which this can be done and the loss will be irretrievable and so felt when they are gone."[26] This argument had already been made by the painter George Catlin in the 1830s, albeit in a more accusatory tone. In the 1870s it would become a kind of refrain in support of the ethnophotographic program of the "great surveys," which represent the zenith of exploration photography.

It is paradoxical to speak of a program with respect to the exploratory boom that followed the end of the war, because neither the thousands of accumulated views and portraits nor the institutional framework of the great surveys was the result of a unified plan.[27] It was widely acknowledged that there was an increased need for information on the contours and resources of the mountainous West, and this explains the emergence of a civilian and above all geological exploration, which contrasted with the old topographical vision. But this need was not addressed by a centralized department. The United States Geological Survey

United States in 1863—embarked simultaneously on large-scale real estate ventures in the Southwest and the creation of an Indian archaeological and photographic collection.[24] It was Blackmore who assembled the core of the collection, scouring the archives for the rare preexisting Indian images. It was also Blackmore who, beginning in 1867, formalized the practice of taking "delegation photographs," for which he hired two photographers, Gardner and above all Antonio Zeno Shindler, an enigmatic figure of Eastern European descent who was a painter before acquiring a photography gallery in Washington in 1867. Thus, the leading Indian photography collection of the leading American museum had its origins in Europe: when he opened his own archaeological museum in Salisbury, England in 1867, Blackmore loaned Shindler

24 See Taylor 1980. 25 See Fels 1987; Danly in Castleberry 1996, 49–55; Sandweiss 2002, 160–76. 26 Cited by Fleming 2003, 3. On the subject of the "vanishing Indian" see Dippie 1991 and Trachtenberg 2004. 27 For more on the "great surveys" see Bartlett 1962 and Goetzmann [1966] 1972.

would not be created until 1879, at the same time as the Bureau of Ethnology. The zenith of federal exploration took the form of a competition between parallel surveys divided between the War Department and the Department of the Interior; often linked to coteries, corporate bodies, and other lobbies; and supported by a Congress that, although it was not particularly fond of science, had no choice but to fund them if it wished to support the settlement of the West. The four "great surveys" were launched between 1867 and 1870—two by the War Department (the King and Wheeler surveys) and two by Interior (the Hayden and Powell surveys)—and extended by Congress from year to year until 1878. Endowed with sizeable budgets that had a tendency to increase, these surveys turned into semipermanent agencies that, far from using a master plan to divide the relevant territory, tended instead to fight over it (see map, p. 27), including before their respective administrations, Congress, and public opinion (fig. 8). Thus it is in the double context of the mass settlement of the West and an intragovernmental rivalry that photography and photographers established themselves as central players in the exploration effort.

The year 1867 was decisive, with the creation of the Geological Exploration of the Fortieth Parallel. With far-reaching aims and considerable financial resources, it was entrusted by the Secretary of War to the very young Clarence King, who had dreamed of being "United States Geologist" ever since his Californian apprenticeship. Essentially a civilian mission despite its military framework, this survey possessed a highly ambitious plan and organizational structure that were worthy of the versatile talent of its director, a geologist but also adventurer, speculator, and aesthete whom the writer Henry Adams in retrospect described as the "ideal American." According to Adams, the goal of the survey was to create "a parallel to the continental railroad in geology,"[28] that is, to carry out (from west to east) a geological section of the North of the Great Basin, to which would be added a wide range of disciplines intended to make it possible to evaluate the deposits of precious minerals while at the same time producing a global interpretation of the geomorphology of the Rocky Mountains. Right from the start, Clarence King chose to add a photographer to the large and entirely civilian staff of his expedition, a salaried employee of the same kind, if not at the same level, as the topographer and the botanist.[29] While this is a minor measure in terms of the global reengineering of exploration that King carried out, from our point of view it is a major innovation. It may have been partially motivated by a recognition that American exploration was technologically somewhat behind the times. But it was certainly inspired by King's personal fondness for photography, a fondness he had discovered during his collaboration with Watkins at the California Geological Survey, and which, in the case of this lover of landscapes and avid reader of John Ruskin, went beyond the utilitarian logic of documentation.[30] Although King regarded Watkins as "the most skilled operator in America," he had to rest content with entrusting the post to O'Sullivan, who was probably recommended by his former employers at the Army of the Potomac. O'Sullivan accompanied King's expeditions from 1867 to 1869 and then again in 1872. After participating in a Central American expedition in 1870 (a year in which was briefly able to hire Watkins), O'Sullivan joined the War Department's second great survey in 1871 and then again in 1873 and 1874. A "geographical" operation that was every bit as ambitious as the first one, this survey was entrusted to Lieutenant George M. Wheeler with the explicit intention of thwarting civilian geology—Wheeler was to cover practically the entire West. Although he was replaced on this survey by Bell in 1872, O'Sullivan thus became the "official" photographer—the quasi-government employee—of the War Department, for which he realized nearly a thousand negatives, considered today to be the magnum opus of exploration photography.[31]

Given this context of intragovernmental rivalry, it was to be expected that the Department of the Interior would respond in some way to the initiatives of the army general staff. This it did in 1870 by launching two additional "great surveys," which also wasted no time in creating photographer posts of their own. The first and most ambitious of these surveys was entrusted to the geologist Ferdinand V. Hayden, who had been one of the first geologists in the West for the Smithsonian Institution and was closely linked to the financier and ethnologist Blackmore. Giving his expedition the grandiose title "United States Geological Survey of the Territories," Hayden conceived a program that was less systematic but much more maximalist than those of King and Wheeler, a program that in the course of twelve years would lead him to cover an immense terrain (in many cases already covered before him) and to collect a staggering variety of specimens, from moths to Indian headdresses.[32] Taking to heart the example of Whitney and the California Geological Survey, Hayden appealed to photography for editorial purposes in 1869. He purchased the negatives realized and published by Russell for the Union Pacific Railroad and republished them in a book of photographs inspired by the *Yosemite Book,* to which he gave the tantalizing title *Sun Pictures of Rocky Mountain Scenery* (fig. 19). This more commercial than scientific approach signaled Hayden's style of exploration—he

28 See Adams [1907] 1983, 1005; Wilkins [1958] 1988, 162–63. **29** The King survey paid its photographer, Timothy H. O'Sullivan, $100 a month, while the geologist received $250, his chief assistants $200, and the simple botanical and zoological "collectors" $50. A salary like this was unusual for outdoor photographers in the United States at the time (cf. Jackson [1940] 1986, 190–91, 251). On the Wheeler survey O'Sullivan earned $150 and later $175, a salary comparable to Jackson's on the Hayden survey (which, however, was augmented by commissions on the sale of images, as was also the case for Hillers on the Powell survey). **30** Wilkins [1958] 1988, 141–44, which is also the source of the following citation from King. **31** See Horan 1966; Snyder 1981; Dingus 1982; Snyder 2002 and 2006; for a historiographic appraisal and a detailed analysis of the historical conditions of O'Sullivan's style, see Kelsey 2003, 2004, 2007; Brunet 2007b. **32** See Goetzmann [1966] 1972, 489–529.

would go on to become the grand impresario of the "wonders of the West." In 1870 he hired a full-time photographer in the person of Jackson, who, unlike O'Sullivan, had been trained as a painter and owned a studio in Omaha, Nebraska. Endowed with solid business sense, Jackson joined the survey on condition that he be permitted to retain possession of his negatives, in exchange for which he agreed to supply his employer with prints on demand. This commitment would lead him to produce tens of thousands of prints to satisfy his employer's growing need for images to distribute, before going on to pursue a brilliant commercial career. It was the duo of Hayden and Jackson who (together with Thomas Moran) "discovered" and promoted the Yellowstone region, which in 1872 was transformed into the first national park with the support—whether real or imagined (we will return to this point later)—of Jackson's photographs. But Jackson also popularized other landmarks of the West, including the ruins of Mesa Verde, and also extended the Smithsonian's Indian collection.

Finally, in 1869 a fourth individual had discreetly inaugurated a brilliant career as an explorer by carrying off a perilous descent of the rapids of the Colorado River—Major John W. Powell, a retired military officer who had lost an arm and gone on to become a geographer and ethnologist for the Smithsonian Institution. He too planned a far-reaching survey that centered on the southern portion of the Rocky Mountains and the Southwest, and in 1871, for a second descent of the Colorado, he hired a photographer, Elias Olcott Beaman, who proved to be poorly suited to the task. Beaman's defection was offset by a man who had initially been hired as an oarsman, Hillers, who learned the job as he went along and quickly became a master of the art of the wet collodion. From late 1871 to 1879, Hillers took several thousand photographs for the Powell survey, images that were topographical but also, as the major's interests changed and evolved, increasingly ethnographic. Indeed, Powell became both an advocate of the reform of land granting policy in the arid Southwest and a vibrant and powerful spokesman for the rights of the tribes. Hillers would later follow Powell to the Bureau of Ethnology, where he remained the chief photographer until 1900.[33] Alongside O'Sullivan and Jackson, Hillers was the third pillar of the group of "government photographers," as they came to be known in the press,[34] state photographers whose activity and impact have no equivalent in the history of American photography, except perhaps in the context of the documentary campaigns of the 1930s. And while this burgeoning of "government photography" took place in the absence of any unified program, it is

possible nonetheless to evaluate it in retrospect as a policy, or rather a set of policies.

The first criterion is quantitative. Although we do not possess exhaustive inventories, reports and archives allow us to hazard rough estimates[35] showing that the output of the great surveys totals approximately 3,000 stereographic negatives (nearly half of them for the Powell survey alone) and 2,500 medium- and large-format negatives (three quarters of them for the Hayden and Powell surveys). As for the number of prints produced during the period, it remains a subject of speculation, but the order of magnitude is quite high, in the tens and probably hundreds of thousands. In addition to the images strictly speaking, there were also the editorial products derived from them: luxury publications (albums, portfolios, books illustrated with pasted photographic prints) but also more ordinary productions, both official (reports) and unofficial (newspaper articles, travelogues, tourist guides...), which were illustrated by engraved and lithographic transfers of photographs and by other kinds of media as well.

Production on this scale entailed considerable costs: salaries for the photographers (one to two hundred dollars a month) and their assistants, fragile and expensive equipment, and transportation costs (since the total equipment of an exploration photographer could weigh as much as a ton, at least one horse-drawn wagon was required to transport it). The mass production of prints as practiced by Hayden, Wheeler, and Powell involved personnel and equipment costs as well, as did the labor of archiving the negatives (which had serial numbers and sometimes captions inscribed on them, see fig. 9). Taking the example best known to us, that of the Wheeler survey, the total cost of the approximately 15,000 large-format prints and 70,000 stereoscopic cards published by the survey from 1871 to 1878 may have amounted to 20,000 dollars.[36] When diverse publication costs are added to these figures—even taking into account the revenue from the sale of the images—the total photographic expenses of the great surveys may be estimated at nearly 250,000 dollars. While this only represents about ten percent of the total budget of exploration, this figure makes the American government in the 1870s a major photographic operator and compels us to view photography as something more than a mere side aspect of the surveys.

If this was the case, the obvious question is, what were the functions of these outlays and the motivations behind them? Historians and critics have spent a great deal of time on this question since the 1970s, although their focus has been on the landscapes and the appropriateness of an aestheticizing approach to the "views."[37] These discussions may be summarized by an observa-

33 Fowler 1989, 15–43, 146–47. **34** "Government Photography," *The Nation*, reprinted in *Anthony's Photographic Bulletin* 5 (December 1874): 366; Welling [1978] 1987, 234; the expression had already been used for the photographers employed by federal agencies in Washington by the *Philadelphia Photographer* in 1866 (vol. 3, 214). Jackson reused the expression "government photographers" to describe O'Sullivan as well as in explicit reference to the photographers of the New Deal (Jackson [1940] 1986, 246 and Taft [1938] 1964, 288). **35** Detailed information is available in Brunet 1993, 1:419–30 and 2:app. 3. **36** Brunet 1993, 1:423–25 and 2:298–99; detailed figures are provided by J. Heller in Snyder 1981, 117 and especially Kelsey 2003, 707 and 721 n. 37. **37** Naef and Wood 1975, 50–61; Snyder 1981; Krauss 1982; Sekula 1983; Snyder 1986; Trachtenberg 1989; for a highly nuanced appraisal that refers to O'Sullivan see Kelsey 2004; see also Sandweiss 2002, 181–206 and Snyder 2006.

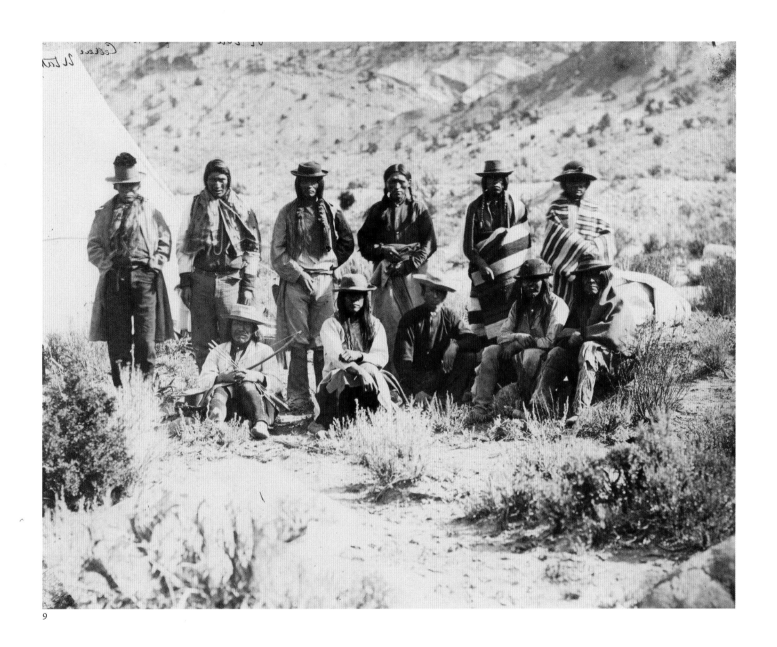

9

William Bell
Paiute Group, Cedar, Utah, 1872
Albumen print, 18×23 cm
Société de Géographie, Paris

10

Timothy H. O'Sullivan
Wahsatch Mountains, Lone Peak Summit, Utah, 1869
Albumen print, 20×28 cm
Société de Géographie, Paris

tion in the form of a paradox. While the institutional logic that governed the exploration would seem to suggest that its collections had a "scientific" or "documentary" purpose, this dimension is far from obvious when one looks at the images and considers how they were used; and it is certainly less obvious today than cultural and artistic values that seem to have nothing to do with the official logic. It is certainly true that the predominantly geological character of the surveys (which above all covered the Rocky Mountains) inspired a profusion of rocky landscapes, morphological views, and even geological details (see cat. p. 77). However, the reports and the explorers' notes contain very few didactic commentaries on these images, which are treated instead as simple records with the role of illustrations or even "studies," analogous in this sense to those of painters. To the extent that the surveys' annual reports to Congress mention their photographic activities, it is almost exclusively to congratulate themselves on the quantitative progress of this great collection of "views"— to use the established term for these topographical images— while at the same time ritually praising the irreplaceable accuracy of photography.[38] As for the sumptuous final "reports," i.e. collections of monographs categorized by field (geology, botany, mineralogy, archaeology…) that constitute a high point of scientific publishing in the nineteenth century—while they make abundant use of the photographic images, which are reproduced (and transformed) by lithographic transfer (figs. 20 and 21), they hardly comment on these illustrations at all, except, once again, precisely to emphasize their effectiveness as illustrations. It is a different story with other forms of illustration, much more technical and specialized, that appear in the botanical, petrographic, and archaeological monographs, to say nothing of the relief maps and panoramas. Much has been made of an affinity between the often desolate, even hostile settings depicted by O'Sullivan and the "catastrophist" theory of geology championed by King;[39] but this affinity is largely atmospheric and does little to account for the status and practice of this most enigmatic of all the exploration photographers (see p. 86–97), to say nothing of a ludic aspect that was highly present in the King survey (figs. 10 and 11).[40] Similarly, there has been much discussion of certain statements by Lieutenant Wheeler, who in 1872 expressed his hope that there would soon be more strictly scientific applications of photography. In our view, these statements, which are behind the reality of European scientific photography at the time, primarily reflect the embarrassment of a military official as he sought to justify an expenditure that actually eluded scientific logic.[41] In the

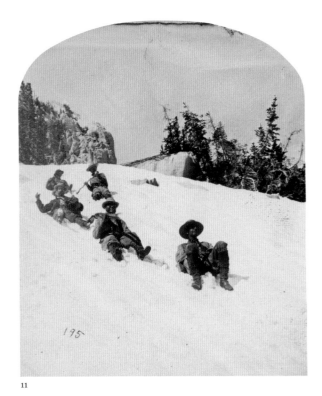

11

Timothy H. O'Sullivan
Summit of Wahsatch Mountains, Sliding Down, Utah, c. 1869
Stereograph, 11.5 × 18 cm
Société de Géographie, Paris

same way, the collections of Indian images amassed by the Powell and Hayden surveys have little in the way of "scientific" logic, beyond the (self-justifying) logic of seeking to "systematize" a collection of traces of a "vanishing race" and exploit it in the service of voyeurisms that were more or less scholarly in nature.[42] The minutely detailed catalogue of Indian photographs compiled and later revised several times by Jackson, which extended the Blackmore-Shindler catalogue, thus responds to a logic of archiving rather than that of a genuine anthropological inquiry (see figs. 12 and 13, which show the correspondence between the catalogue and the enormous Indian album that Jackson assembled by hand in 1876–77).

Thus, the current critical consensus tends to emphasize that within the exploration effort, photographers fulfilled a nonspecialized function as illustrators or "picture makers," a function in keeping with their nonacademic culture, which was foreign to the

38 For a more complete analysis see Brunet 1999. **39** This theory tinged with theology privileged sudden, cataclysmic events in the interpretation of geological phenomena; for certain critics it is reflected in the extremely rugged landscapes photographed by O'Sullivan in the Rocky Mountains. See Snyder 1981, 48–51; Goetzmann in Castleberry 1996, 57–61. **40** See Brunet 2007b. **41** These statements come from an internal report (Wheeler 1874, 11) that also contains remarks by the geologist G. K. Gilbert on the usefulness of photography. See Snyder 1986, 144–46; Trachtenberg 1989, 128–29; Sandweiss 2002, 181–206; Kelsey 2003, 708 and 722 n. 49; Snyder 2006, 20–21. By 1874, when this report was published, the photogrammetric applications mentioned by Wheeler were already widespread in Europe (see Brunet 1999, 87). **42** See the catalogue of Indian photographs compiled by Jackson (1877) with a preface by Hayden and a detailed analysis in Brunet 1994, 170–74; see also Mick Gidley's essay in this catalogue.

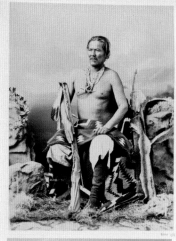 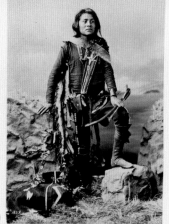 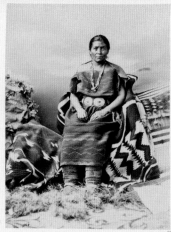

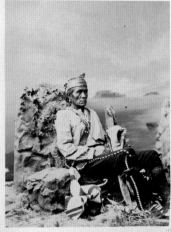 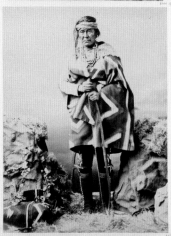 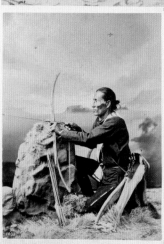

William H. Jackson
"Navajo Warriors"
in *Photographs of North
American Indians*,
1877, 1: n. p.
Médiathèque du Quai
Branly, Paris

12

William H. Jackson
"Navajos"
in *Descriptive Catalogue
of Photographs of
North American Indians*
(Washington, D.C.:
1877), 26–27
Médiathèque du
Quai Branly, Paris

24

26 CATALOGUE OF INDIAN PHOTOGRAPHS.

444. SON OF GUERITO. JICARILLA.
443, 5, 6, 8. YOUNG BRAVES. JICARILLA.
447. PAH-YEH, or *Hosea Martin.* JICARILLA.
 18. SON OF VICENTI. JICARILLA.
125. PEDRO SCRADILICTO. (Front.) COYOTERO.
126. PEDRO SCRADILICTO. (Side.) COYOTERO.
127. ES-CHA-PA. *The One-eyed.* (Front.) COYOTERO.
652. ES-CHA-PA. *The One-eyed.* (Side.) COYOTERO.
414. JOSÉ POCATI. (Front.) YUMA.
415. JOSÉ POCATI. (Side.) YUMA.
749. CHARLIE ARRIWAWA. (Front.) MOHAVE.
750. CHARLIE ARRIWAWA. (Side.) MOHAVE.
872-3. GROUPS comprising all the above included within the
Nos. 853-871.

2. NAVAJOS.

A very numerous band of the Apache Nation inhabiting
the mountains and plateaus of Arizona and New Mexico, be-
tween the San Juan and Little Colorado Rivers, ever since our
first knowledge of them. The Spaniards early recognized
their relation to the Apaches, although they differ totally from
them in their industrious habits, being by far the most civil-
ized of any tribe of Athabascan descent. They have evi-
dently been quick to take advantage of their contact with the
semi-civilized Pueblos and Moquis, and from them have ac-
quired many useful arts—chiefly in learning to spin and weave.
Their blankets, woven in looms, are of great excellence, and
frequently bring from $25 to $100. They cultivate the soil ex-
tensively, raising large quantities of corn, squashes, melons,
&c. Colonel Baker, in 1859, estimated their farms at 20,000
acres, evidently too large an estimate, as their agent's report
for 1875 places the cultivated lands at only 6,000 acres. Their
principal wealth, however, is in horses, sheep, and goats, hav-
ing acquired them at an early day and fostered their growth,
so that they now count their horses by the thousand, and
their sheep by hundreds of thousands. Notwithstanding the
excellence of their manufactures, their houses are rude affairs,
called by the Spaniards *jackals,* and by themselves *hogans*—
small conical huts of poles, covered with branches, and in win-
ter with earth. Like the Apaches, they have made incessant
war on the Mexicans, who have made many unsuccessful
attempts to subjugate them. The expeditions against them
on the part of the United States by Doniphan in 1846, Wilkes

ATHABASCAS—NAVAJOS. **27**

in 1847, Newby in 1848, and Washington in 1849, were practi-
cally failures. Colonel Sumner established Fort Defiance in
1851, but was forced to retreat, and all other attempts to sub-
due them were defeated until the winter campaign in 1863, when
Colonel Carson compelled them to remove to the Bosque Re-
dondo, on the Pecos River, where 7,000 were held prisoners by the
Government for several years. In 1868 a treaty was made with
them under which they were removed to Fort Wingate, and
the following year back to their old home around Fort Defi-
ance and the cañon De Chelly, where a reservation of 5,200
square miles was assigned them. The latest count puts their
number at 11,768—3,000 of whom are said to come directly
under the civilizing influences of the agency. Schools are not
well established yet, but few of their children attending, and
then very irregularly. Although they produce largely, yet
they are dependent upon the Government for two-thirds of
their subsistence. They dress well, chiefly in materials of
their own make, and covering the whole body.

List of illustrations.

1027. MANULITO.
 The great war-chief of the Navajos. Has been en-
 gaged in many combats, and his breast shows the
 scars of a number of wounds received in battle; was
 in command of the Indians during their siege of Fort
 Defiance.

1028. JUANITA.
 The favorite one of five wives of Manulito, the
 chief.

1029. MANULITO SEGUNDO.
 Son of Manulito and Juanita.

1030. CAYATANITA.
 A brother of Manulito's, and captain of a band of
 warriors.

1031. BARBAS HUERO. *Light Beard.*
 Chief councillor of the tribe, and an earnest advo-
 cate of a settled peace policy.

1032. CABRA NEGRA.
 A captain, and a sub-chief.

culture of exploration—even if they sought to imitate its style—and closer to the common culture of the middle classes.[43] This becomes clearer when one notes how the "views"—especially those of O'Sullivan and Bell—insist on including agents of the exploration, figures of geologists or topographers "at work" but also and above all simple observers, who are posted in the landscape as the "embedded" representatives of the American nation. It is this function of *representers of the exploration effort* and its procedures, rather than that of assistants in the technical sense, that is foregrounded by the few accounts left to us by the photographers themselves.[44] And it is because these images could be used, as Martha Sandweiss points out, to illustrate the *story* of the exploration (fig. 14) even more than its science that in 1874–75 various newspapers called for the output of the "government photographers" to be distributed more widely. As the *New York Times* wrote on the subject, "everyone can understand a picture," and this production should not be reserved for a "select few."[45] Beginning in 1874–75, first the duo of Hayden and Jackson and then the Powell and Wheeler surveys responded to this demand by distributing growing numbers of series of stereoscopic views, albums, illustrated brochures, and catalogues of photographs available for purchase. In the case of the stereoscopic views, which had extended captions on the back (see fig. 6, p. 40) and were published in thematic series, this distribution satisfied a number of needs at once—popularization, a taste for collecting, and a desire for the romantic and picturesque.[46] As for the large-format images that were made to be exhibited, the fact that they were presented at the big expositions of the period (Vienna 1873, Louisville 1873, Philadelphia 1876, Paris 1878) and the great success they enjoyed there demonstrate that their visual eloquence and even their artistic merit were clearly perceived. These various "cultural" interpretations are thus indispensable to understanding the photographic communication of the exploration effort; they fail, however, to illuminate its specifically political dimensions.

The period from 1867 to 1880 has been called both Reconstruction and the Gilded Age. It was a period of normalization in the South, rapid settlement in the West, and rapid expansion of industrial capitalism, which also saw an explosive growth of printed and visual communication, with new types of images, promotion, publicity, tourism, commodification, popularization, and what the historian Daniel J. Boorstin has called "pseudo-events."[47] The social, political, and even media-oriented uses of photography emerged very early in the United States. Didn't Abraham Lincoln say that he owed his election to his "camera

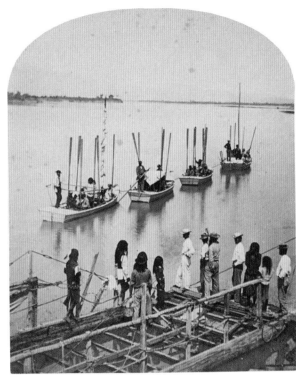

14

Timothy H. O'Sullivan
The Start from Camp Mojave, Arizona, 1871
Stereograph, 10 × 18 cm
Musée du Quai Branly, Paris

man," Mathew B. Brady? This double historical context suggests (at least) two political readings of the photographic corpus of exploration. The most obvious one consists of the idea that the visual communication of the surveys, in keeping with the expansionist logic that underlay them, served to stimulate the conquest and development of the West. Whether intentionally or not, the surveys fulfilled this propaganda aim, although they did so in a manner that was mostly diffuse, in particular by tending to replace the ideological discourse of settlement with the cultural discourse of popularization. The links of Hayden, Wheeler, and even King to the railroad companies and to mining activity (which are illustrated by many of O'Sullivan's images) suggest the extent to which the surveys are interwoven with the development of the West. If propaganda there was, however, it lay above all in the way the images distributed by the exploration sought to present the dou-

43 The best analyses of the relationship between the logic of the survey and that of the photographers are those of Trachtenberg 1989; Sandweiss 2002, 181–206; Kelsey 2003 and 2004; and Snyder 2006. The forthcoming book by Kelsey (2007) is a brilliant formulation of the "style" of archival landscape photography. **44** See Jackson [1940] 1986; John Samson, "Photographs from the High Rockies," *Harper's Monthly Magazine* 39 (September 1869): 465–75; William Bell, "Photography in the Grand Gulch of the Colorado River," *The Philadelphia Photographer* 10 (1873): 10. **45** "The Hayden Survey," *New York Times*, April 27, 1875, 1; cf. also the article "Government Photography" cited in note 34, which formulated the same demand. **46** On the consumption of stereoscopic views see Sandweiss 2002, 161–64, 183–86 and Sandweiss 2006. Kelsey 2003, 712, relativizes the quantitative importance of the distribution of stereoscopic views with regard to the Wheeler survey. **47** See Boorstin 1962; Trachtenberg 1982.

Le docteur Hayden, géologue des États-Unis. — Dessin de E. Ronjat, d'après une photographie.

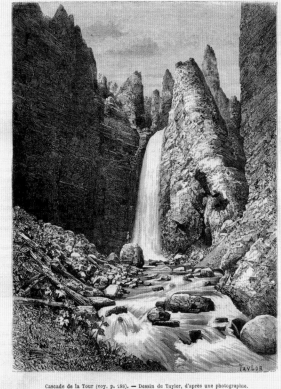

Cascade de la Tour (voy. p. 193). — Dessin de Taylor, d'après une photographie.

15/16

Le Tour du Monde,
nouveau journal des voyages
28 (1874), 292–93
École Normale Supérieure, Paris.
Bibliothèque des Lettres

bly false and, moreover, contradictory vision of a West at once pacified and pristine, dominated by open spaces the explorers alone were privileged to see. In this corpus—despite a number of notable exceptions—one rarely encounters the Native Americans in a natural setting, still less in a traditional social one, and never, or hardly ever, in the repressive setting of the reservations;[48] as for the West of the pioneers, it is virtually absent. By presenting a West subdued and transformed into a spectacle, exploration (especially the Hayden survey) thus assisted in the birth of tourism in the landmarks of the West—Yosemite, Yellowstone, and later the Grand Canyon and the Indian Southwest.[49]

Another level of propaganda must also be emphasized, however, and it is linked to the intragovernmental competition that prevailed throughout the period of the great surveys, a period marked by the rapid rise of the practices of boosterism. In this respect, it is interesting to note that more often than not, historians of photography have underestimated or ignored Jackson's retrospective judgment of the era of the great surveys, a judgment that was enlarged upon by the historian William H. Goetzmann in 1966. According to this view, the American explorers' unprecedented investment in photography responded to the constant need for self-promotion in the struggle for influence between the Departements of the Interior and War and the prospect—constantly revived in the course of the 1870s—of the formation of a centralized geological department.[50] A first important episode played out in 1872–73 around the creation of Yellowstone Park. It has repeatedly been said, without particularly solid documentary evidence, that the distribution of Jackson's photos to members of Congress "made the Park," that is, that they sufficiently dazzled the legislators to convince them to establish the first National Park. What the archives show, however, is that the massive distribution of these images to all kinds of politicians and capitalists, all the way to the president, increased *after the law was passed,* with the Hayden survey seeking to present itself as a kind of tourist information office for Yellowstone.[51] It was from this moment on that the Hayden survey transformed itself into a kind of public relations agency (which received a constant stream of requests for employ-

48 See also Mick Gidley's essay in this catalogue. In its details, the Wheeler survey, faithful to its military logic, sought to suggest the persistent hostility of the tribes of the Southwest (Kelsey 2003, 715–17), while the Hayden survey tended to promote the opposite idea. 49 On the more general relations between exploration and the beginnings of tourism in the United States see Davidson 2006. 50 See Jackson [1940] 1986, 186–97; Goetzmann [1966] 1972, 521–29. The importance of this subject has been underestimated by recent museography. Kelsey has used the example of the Wheeler survey to demonstrate how important it is (Kelsey 2003, 712–14). On the Hayden survey, see also Hales 1988, 69, 89 and Cassidy 2000. 51 See Bossen 1982; Brunet 1994, 175–79; Sandweiss 2002, 200–01. The Hayden archives (Hayden Survey Records, Letters Received...) show that the number of distributions and letters of thanks increased in 1873. In particular, they show a number of gifts to President Ulysses S. Grant and his entourage. The portfolio of Jackson preserved at the Musée Nicéphore Niépce, whose spine is engraved with the name of Grant and which has a bookplate with the name of his son-in-law Algernon Sartoris, may be one of these gifts.

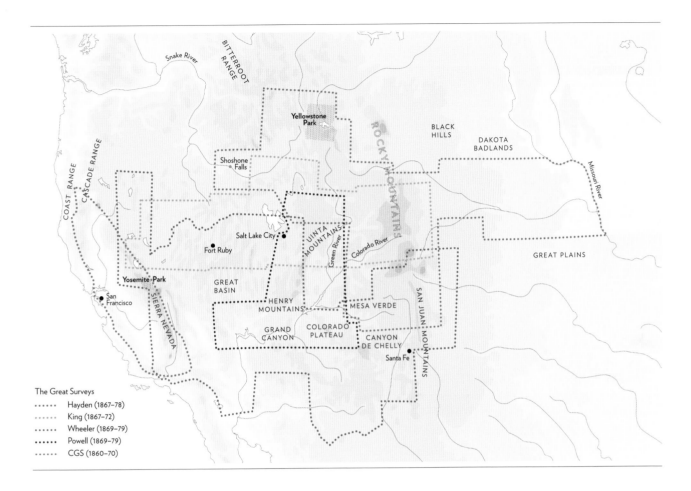

The Great Surveys
..... Hayden (1867–78)
..... King (1867–72)
..... Wheeler (1869–79)
●●●●● Powell (1869–79)
..... CGS (1860–70)

ment for this or that nephew or cousin), including a service for distributing images and catalogues of images whose "releases" ran into the tens of thousands through 1879. Similarly, it was in the context of heightened Congressional attention to the redundancy of exploration activities beginning in 1874 that General Andrew Atkinson Humphreys, the official in charge of the surveys at the War Department, asked the Wheeler and especially King surveys to accelerate production (the King survey had thus far been particularly stinting with such distributions). The photographic rivalry of the surveys—which in the case of Hayden and Wheeler degenerated into virtual trench warfare—became notorious at this time.[52]

This rivalry is partially responsible for the rich American holdings preserved in French public collections, even if one cannot ignore the early passion of a few collectors (see fig. 7) and the enlightened curiosity of numerous scholars. If the Civil War prompted the Second Empire to nurse dreams of a collapse of the American union, the French (and Europeans) never ceased to be curious about the Americas, from the era of Buffon to that of Elisée Reclus.[53] While the American contribution to the Paris Universal Exposition of 1867 was disappointing, it aroused a level of interest that resulted in a resurgence of French voyages and publications on America. It is at this time that great French Americanists such as Louis Simonin and Alphonse Pinart journeyed to the American West to retrieve the material for publications on the Amerindians and the first sets of American anthropological photographs of the future Musée de l'Homme.[54] It is also at this time—in 1869— that the Hachette company purchased photographic prints from Hayden to illustrate the publication of Simonin's voyage in its flagship review *Le Tour du Monde* in the form of electrotype plates.[55] At the same time, the effects of the heightened competition of the surveys between 1873 and 1877 were clearly felt in France. It is at

52 A number of satirical Washington newspapers pilloried Hayden for this (see Kelsey 2003, 713). His rival, Lieutenant Wheeler, kept numerous newspaper clippings on the subject ("Wheeler Scrapbook," Bancroft Library, University of California, Berkeley). **53** A geographer and an anarchist, Élisée Reclus traveled to the United States several times and donated numerous American photographs to the Société de Géographie (Society of Geography) (see Fierro 1986). **54** See appendix, Musée du Quai Branly, 124–25. **55** Hayden Survey Records, Letters Received from Foreign Countries, France; the Hachette company and in particular Édouard Charton, the director of the *Tour du Monde,* were in periodic negotiations with Hayden beginning in 1869.

17

George M. Wheeler
Title page of *Vues photographiques de l'Amérique*, 1874
Société de Géographie, Paris

18

William H. Jackson
Flyleaf of *Photographs of the Principal Points of Interest in Colorado. . .*
(Washington, D.C.: Department of the Interior,
United States Geological Survey of the Territories, 1876)
Société de Géographie, Paris

this moment that Hayden, closely followed by Wheeler, began to initiate increasingly frequent contacts, proposals, and mailings to French institutions. In 1874 the Société de Géographie, which was one of the main French learned societies of the time, received a first edition of Jackson's catalogue of photographs and commented on the role of photography in the Hayden survey.[56] At the same time, the *Tour du Monde* published an extensive illustrated report on Yellowstone that sang the praises of Hayden (figs. 15 and 16), while the recently formed Club Alpin Français received a copy of Hayden's *Sun Pictures,* followed by one of Jackson's portfolios.[57] The year 1875 would represent a high-water mark in exchanges between the Société de Géographie and the surveys thanks to the Internation-

al Congress of Geographical Sciences, which took place in Paris. In Washington, Hayden met Pinart and then James Jackson, a young geographer of English descent who would later become the archivist of the Société de Géographie and the true founder of its fantastic collection of photographs. He promised to make it a regular practice to send them his publications, a method he was in the process of applying to an impressive number of learned societies throughout France and Europe in an obvious attempt to gain sympathy and protection.[58] He was imitated by General Humphreys, the official in charge of the King and Wheeler surveys—the latter took attention to foreign clienteles to the point of enclosing trilingual explanatory brochures with the series of images it published

56 *Bulletin de la Société de Géographie;* 6th ser., 7 (January–June 1874): 501; Loiseaux 2006, 174. See also Société de Géographie, 124. **57** Adolphe Joanne to Hayden, December 3, 1876, Hayden Survey Records, Letters Received from Foreign Countries, France; *Bulletin trimestriel du Club Alpin Français* 1 (4th trim. 1876): 364, which signals receipt of the Jackson/Hayden portfolio of 1875. **58** Hayden Survey Records, Letters Received from Foreign Countries, France; this file contains a very large number of thank-you letters from French scholars and learned societies (including the natural history museums or societies of Cherbourg, Douai, Lyons, Marseilles, and Semur) to Hayden for sending them his publications and in some cases series of photographs.

regularly after 1873 (fig. 17). And it was on the occasion of the Geographical Exposition of 1875, or in the following months, that the Société de Géographie received (and would finally be given) the extraordinary albums and portfolios of the Hayden, King, and Wheeler surveys, which number today among its "treasures."[59] In late 1875, Hayden and Wheeler were both appointed foreign correspondents of the Société de Géographie,[60] a title neither would fail to exploit in the United States. In 1877, Major Powell would in turn mail to the Société de Géographie a magnificent series of very large views of Hopi villages by Hillers. This was the beginning of a new round of photographic mailings, this time ethnographic and intended for the anthropology section of the Muséum d'Histoire Naturelle and for the commission charged with organizing the large exhibition of photographs that would accompany the Paris Universal Exposition in 1878.[61] As Olivier Loiseaux writes, "the Société de Géographie was kept continuously informed, almost in real time, of the results of these four great surveys."[62] While this level of attention was rooted in part in the active curiosity of the Society's members, it also served the considered political interest of the American explorers themselves, who in 1878 were obsessed with the imminent disbanding of the exploration effort and the appointment of a United States Geologist, a title each of them hoped to obtain for himself. The title of United States Geologist—which Hayden assumed in his dedications of the extremely rare albums of Jackson's work addressed to the Société de Géographie (fig. 18), the Club Alpin Français, or the Muséum—would go to King in 1879 and then in 1880 to Powell, the first two directors of the United States Geological Survey and probably the two least politically minded of the explorers. The opinion of the geologist Henri Coquand cited as an epigraph to this essay, like others preserved in the surveys' correspondence, suggests that the many French beneficiaries of the Americans' generosity were virtually unaware of the hidden agenda of such munificence, which the United States Geological Survey would perpetuate on a smaller scale. But that opinion also shows that in this period, the American federal government provided itself—albeit thanks to a state of administrative semi-anarchy—with the photographic means for a remarkable communications policy that had no equivalent in France or any other country.

As mentioned earlier, this policy did not begin with photography, nor did it ever have one exclusive aim. Jefferson already knew that exploration would serve at once to fulfill strategic objectives, to gain familiarity and familiarize others with America's nature and peoples, and finally to "upgrade" America's young science to prevailing international standards. In 1879, with the creation of the United States Geological Survey and the Bureau of Ethnology, that science reached maturity. The formidable enterprise of exploration, which is too often exclusively reduced to the ideological goals of expansion, was thus the novel and original vehicle for a scientific policy not foreseen by the Constitution. This policy without a program also had diplomatic aspects. Indeed, long before the Cold War, it even prefigured a form of foreign cultural policy, of which the Wheeler survey's deliveries of stereoscopic views give a general idea. But what is even more striking from our point of view is that it also served as a form of support to the arts—and photography in particular—and this despite the fact that it would take a century for museography to recognize the true value of this photographic investment.[63] Today the survey photographs are the most bankable items on the early American photography market. A cynical reading of this rediscovery would see it as nothing more than capital speculation in search of investment opportunities. But that reading doesn't hold up before the images themselves, which are strangely beautiful, technically impressive, and poetically suggestive, with their combination of self-effacement and discreet self-inscription on the part of their author-operators, bearers of "visions" that were at one and the same time their own, those of their geologist employers, and those of an entire society. The silence of the views, which neither their authors nor those who commissioned them ever really discussed, fuels our inquiry into the relations between their status as collective myth, the historical information one can look to them to provide, and the peculiarities they contain in terms of gazes, practices, and mise-en-scènes. This same silence also moves us to continue to investigate this unparalleled historical phenomenon, in which a government more concerned to stimulate settlement than to subsidize the arts financed, almost by accident, a *collective creation* that would go on, first, to establish itself as the template of the Westerns and a visual memory of the West, and then as the master corpus of its classical age.

This text and, more generally, my contribution to the exhibition are the most visible extension of my doctoral thesis to date. I welcome this opportunity to continue the ideas addressed in that thesis which I defended at the École des Hautes Études en Sciences Sociales (Paris) in 1993 under the direction of Pierre-Yves Pétillon to whom I extend yet again my sincere gratitude for having supported such a long project so faithfully. For their precious comments and suggestions in the development of the exhibition and the editing of the text, I would like to thank Bronwyn Griffith, Sophie Lévy, Francesca Rose, Christine Barthe, Sylvie Aubenas, Françoise Heilbrun, Olivier Loiseaux, Jean Kempf, Robin Kelsey, Mick Gidley and Pierre Brunet as well as the members of the research group "Histoire des images en Amérique du Nord" (Université Paris Diderot–Paris 7). Finally and especially, I extend my deep acknowledgement to the Terra Foundation for American Art, its Board and the staff of the Musée d'Art Américain Giverny for their trust and their generosity.

59 See Loiseaux 2006, 203. **60** *Bulletin de la Société de Géographie*, 6th ser., 11 (January–June 1876), 103. **61** Letters from Émile Cartailhac and G. de Montillet to Hayden, 1877, Hayden Survey Records, Letters Received from Foreign Countries, France. **62** Loiseaux 2006, 177. **63** From this point of view, the expression "government patronage," used by Naef and Wood 1975, 50, and widely criticized afterward, is not entirely inappropriate.

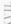

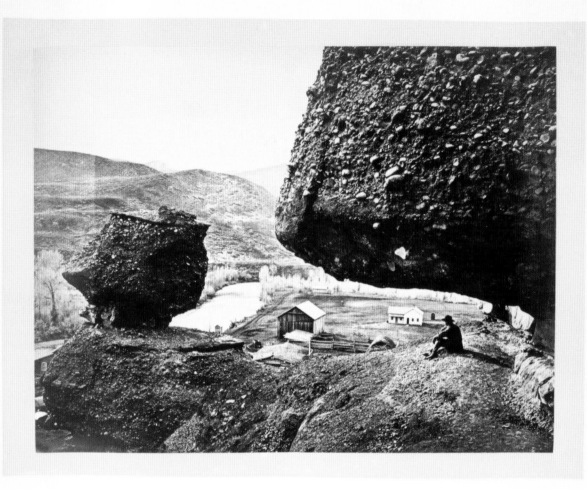

HANGING ROCK
Echo City

Andrew J. Russell
"Hanging Rock, Echo City, Utah" in Ferdinand V.
Hayden, *Sun Pictures of Rocky Mountain Scenery,
with a Description of the Geographical and Geological
Features, and some Account of the Resources of the Great West;
Containing Thirty Photographic Views Along the Line
of the Pacific Rail Road, from Omaha to Sacramento*
(New York: Julius Bien, 1870), pl. 17
Club Alpin Français, Paris

Timothy H. O'Sullivan
Tertiary Bluffs, Echo Canyon, 1869
Albumen print, 20×28 cm
Société de Géographie, Paris

Clarence King
"Echo Canyon, Utah" in *Report of the Geological Exploration
of the 40th Parallel*, vol. 2, *Descriptive Geology*
(Washington, D.C.: Government Printing Office, 1877), pl. 11
Chromolithograph
Société de Géographie, Paris

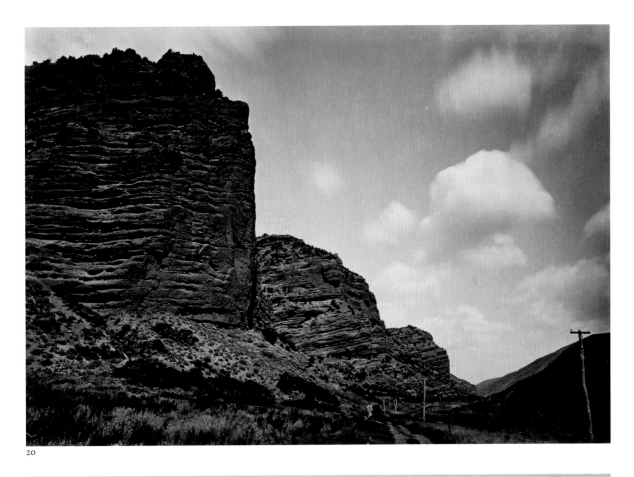

20

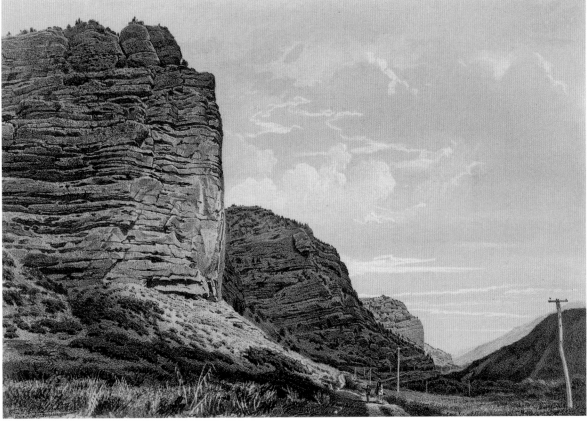

21

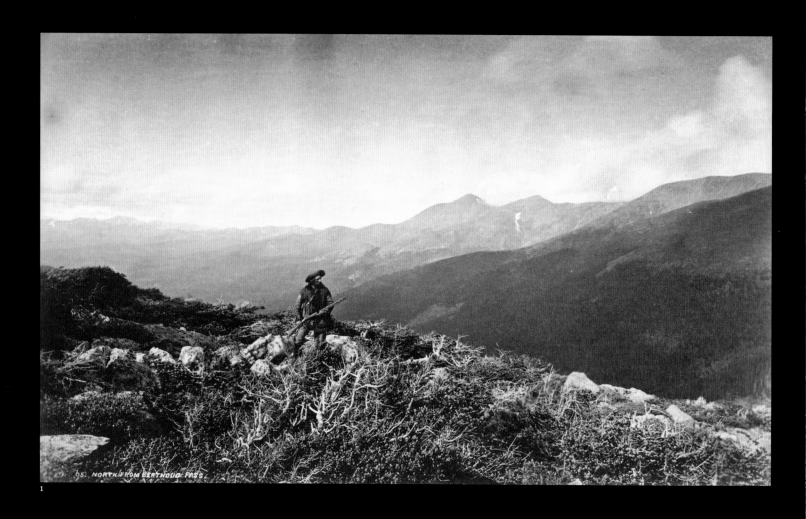

65. NORTH FROM BERTHOUD PASS.

1

OUT WEST AND IN THE STUDIO

Official Photographs of Indians during the Great Survey Era

MICK GIDLEY

THE GREAT TRANS-MISSISSIPPI surveys of the 1860s and 1870s were investigations of the vast lands acquired by the United States through the Louisiana Purchase from France (1803), as a result of the Mexican-American War (1846–48), through the Gadsden Purchase from Mexico (1853), and via various other claims and annexations (see map, p. 9). Like the pioneering Lewis and Clark Expedition of 1804–06, with its directives from Thomas Jefferson that the Corps of Discovery make detailed scientific observations of the peoples, weather, rivers and natural resources of the terrain to be traversed, the later surveys led by Clarence King, Ferdinand V. Hayden, George M. Wheeler and John W. Powell were deliberate, scientific, and "objective." They were a practical expression of government support for Euro-American colonization of western territories. They were not centrally co-coordinated, however, and sometimes this led to rivalry and confusion. Each survey had its own plan, more or less precisely conceived, usually negotiated between an agency of the American government and the expedition leader, and sometimes with specific instructions.[1]

In 1867 King was thus authorized "to direct a geological and topographical exploration of the territory between the Rocky Mountains and the Sierra Nevada mountains, including the route or routes of the Pacific railroad." Powell, whose sponsored and official exploration began in 1871, with his second expedition to boat down the Colorado River, was sufficiently preoccupied by his own special interest in Indians (he later founded the Bureau of Ethnology) to instruct photographer John K. Hillers to conduct orderly observation of the dress, homes, and customs of the native peoples encountered by the expeditions.[2] And, of course, the findings of the surveys—whether maps of water courses, records of rainfall, measurements of mountains, observations of geological formations and fossil remains, or depictions of indigenous ceremonial customs—were published in official reports, most of which were usefully illustrated. The majority of these reports were workaday publications, often constituting series in their own right, but some were large-scale—even lavish—productions that inevitably emphasized their visual content.

Photography was part of the surveys because of its capacity to render the physical world with terrific accuracy and in considerable detail. In the 1860s and 1870s, for technical reasons photography was not able to capture a sense of movement or, of course, color in the way that painting and drawing could, but precisely because of the mechanical nature of the medium and

1 Bartlett 1962 and Goetzmann [1966] 1972 are standard accounts of the surveys. See also the essay by François Brunet in this catalogue. 2 General A. A. Humphreys to King, 21 March 1867, as quoted in Trachtenberg 1989, 120; and for Hillers' work for Powell, see Fowler 1972.

William H. Jackson | *North from Berthoud Pass*, 1874
Albumen print, 11×19 cm | Denver Public Library, Western History Collection

its assumed objectivity, the surveys were keen to employ such photographers as Timothy H. O'Sullivan, William Bell, William H. Jackson, and John K. Hillers alongside artists who worked with brushes, pens and pencils. Like the compass and quadrant, the camera rapidly came to be viewed as, in the words of one scientist of the time, "an indispensable part of the apparatus of field work"—a regular survey instrument.[3] It is a noticeable feature of the published reports that many of their illustrations include a camera somewhere within the picture (see, for example, cat. p. 90).

At the same time, there were limits to the actual "objectivity" of the surveys and their reports. The surveys were each galvanized by the forceful and often eccentric characters of their energetic leaders, and their progress was at least affected by personnel and policy changes in government. They were group endeavors, reliant upon a gamut of different figures, some with strong personalities, styles and preferences of their own, and their variable outcomes resulted from a range of disciplinary methodologies and, inevitably, different levels of skill. The models of achievement were the physical sciences and archaeology, but alongside the geologists, the agriculturalists, the biologists and the cartographers, the expedition teams included men trained in art or steeped in literature. Most significantly, the surveys were both prompted by and part of the effort to annex, explore and exploit the land. They sought to discover the past, whether geologically or archaeologically, but they were oriented to the possibilities of the American future. An emblematic photograph in this regard is Jackson's *North from Berthoud Pass* (fig. 1), in which space is fused with time: an apparently old-time scout, wearing headgear shaped in reminiscence of the tricorn hats of the era of the founding fathers, is so framed as to appear to "advance" into darker, hitherto uncharted lands which, in a triangular way, open up before him. The image—which depicts Harry Yount, who was then a hunter for the Hayden party and would become one of the first Yellowstone Park rangers—denotes a particular site, but it is also a near-definitive romantic evocation of the westering experience.

Perhaps not surprisingly, over time many of the images produced by the survey photographers came to be shorn of their complex origins and were seen either as totally a-political artifacts or as straightforward illustrations of the virgin land, Indian life, or new settlement. Indeed, whatever their subject matter, once cut away from the purposes and practices of the surveys, images such as Jackson's *North from Berthoud Pass* tended to float free of history, as if actually composed as objects for purely aesthetic contemplation. Needless to say, such images—like others by O'Sullivan, Bell, Hillers and such comparable figures as Alexander Gardner and Carleton E. Watkins—*are* beautiful. Witness, for example, the views of the Anasazi ruins in the walls of the Canyon de Chelly taken by O'Sullivan (cat. p. 69) and Hillers (cat. p. 68): in each one the vantage point is such as to stress the grandeur of the canyon setting and the sheltering protection that had been given to the ancient cliff-dwellers by the cleft in the rock face. In other words, it would be only a half truth to view this survey work, in the manner of some critics, primarily as transcription of *subject matter*. In general, *form*—both individual style and as reflective of wider cultural assumptions—is an important feature of the survey photographs, and will be treated in this light here.

The survey pictures—looked at in broad focus, so to speak—present the West in a number of overlapping, but sometimes contradictory, ways. The Great Plains appear with an emphasis on scale, openness and aridity, and the semi-desert with the inhospitable aspects most prominent, so that viewers are made aware, in almost a tactile sense, of extremes of climate and terrain; certainly, they have to register the isolation of white settlements—whether or not actually depicted—and must gauge their tenuous links with "civilization." Above all else, in many images the viewer becomes critically conscious of a sense of staggering space. A good example is Bell's *Looking South into the Grand Canyon* (cat. p. 61), where the canyon sides are nearly diagrammatic and the more distant sights within the frame move towards the nebulous. Other examples—and countless more could be mentioned—are Watkins' views of Yosemite, especially those that double space by the use of river reflections (see cat. p. 53), or deliberately point the camera upwards, as in *Cathedral Mountain* (fig. 2). The sense of space is sometimes exacerbated by the sheer size of the prints themselves: some mammoth, a few positively panoramic. They are sublime renderings of harsh splendor.

As noted, during the heyday of the surveys, photography was not at its best in the depiction of action, and its duotone nature brought out more uncompromisingly than could painting the sculptural, abstract qualities of landforms. In particular, some critics have seen certain of the survey landscapes, especially by O'Sullivan, as virtual illustrations of the workings of the theory of Catastrophism, accepted by King and others, that the physical universe came into being not through millennial evolution but by a series of repeated cycles of convulsive movement and stability, registered by marks left on the earth; hence, for example, O'Sullivan's tufa domes (figs. 9 and 10) or railroad

3 The quotation is from Professor William Brewer, who pioneered the Geological Survey of California, which employed Carleton Watkins as a photographer ahead of other surveys, and appears in Hague 1904, 324. There is a range of publications on the photography produced by the surveys. Items that must be mentioned are (in chronological order) Naef and Wood 1975; Trachtenberg 1989, "Naming the View," ch. 3, 119–63; Brunet 1994; Sandweiss 2002, esp. ch. 5. I have also consulted Taft 1964; Current and Current 1978; and works devoted to specific photographers, such as Hales 1988; Fowler 1972 and 1989.

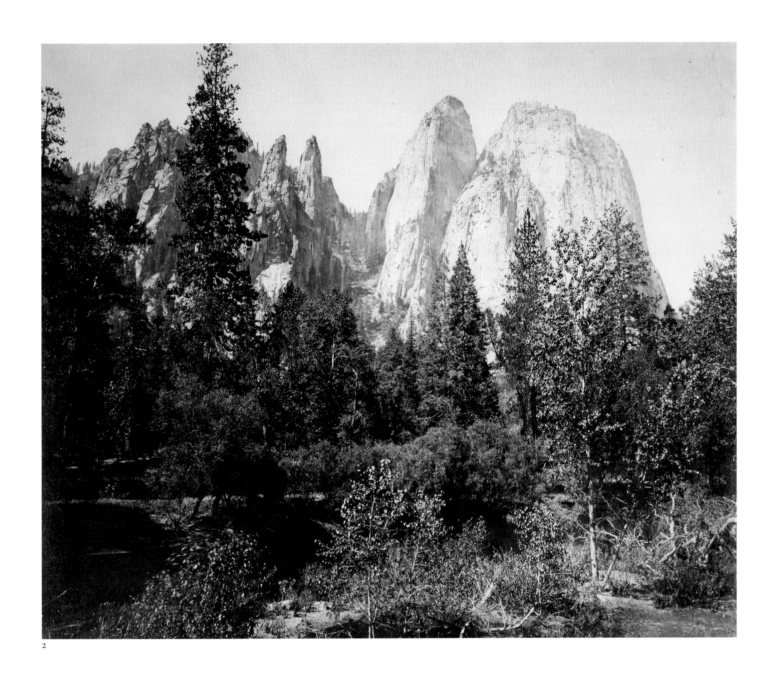

2

Carleton E. Watkins
Cathedral Mountain, Yosemite, 1865
Albumen print, 53×42 cm
Bibliothèque Nationale de France,
Paris. Département des Estampes
et de la Photographie

photographer Andrew J. Russell's famous *Hanging Rock* (p. 30), so framed as to give the illusion that the man sitting beneath the huge overarching rock might unwittingly be in danger.[4] The very stillness of such photographs gives the impression that careful camera workers habitually represented the West as a series of awesome arenas, settings for spectacular undertakings, possibly for ultimate conflicts. (Indeed, the landscape elements identified here, when taken over by movie makers, would become tropes of the western, the most inherently conflict-based genre in film history.)

And, of course, during the very period in which the survey pictures were made, native peoples—who, if they had a concept of land "ownership" at all, typically believed in communal land use—were as resistant to the pressures of white expansion as their resources allowed, sometimes violently. These were the years when the boundaries of most western reservations were fixed—until further delimited after the Dawes Act of 1887. These were the years of the Plains Wars, most obviously the Lakota and Cheyenne victory over General Custer's Seventh Cavalry at the Battle of the Little Bighorn in 1876 and the subsequent relentless U.S. Army onslaught. This was the era in which conflict was perpetuated through education: many Indian children were removed from their homes and sent to boarding schools where tribal languages, dress and customs were forbidden; Richard Pratt, who headed the Carlisle Indian Industrial School, unwittingly caught the severity of the policy in his famous catch phrase: "Kill the Indian to save the man."[5] The conflict touched the surveys most directly in 1871, when Fred Loring, a member of Wheeler's expedition, was killed by Indians a few days after O'Sullivan made a stereo image of him, and in 1877, when the military pursuit of Chief Joseph's Nez Percés—who were fleeing towards Canada after a series of holding battles—was partly waged in the Yellowstone National Park recently surveyed by Hayden.

Yet, at the same time, there are images of sublime sites—most obviously the Grand Canyon, Shoshone Falls, and Yellowstone—and, even, of Indian sites—especially ancient ones, such as the White House ruins in the Canyon de Chelly (see cat. p. 68 and 69), or Mesa Verde, or the long-inhabited Hopi and Zuni pueblos (fig. 3)—that appear to invite visitation. In fact, as earlier commentators have noted, some of the captions attached to images demonstrate the surveys' awareness of the potential appeal of these sites to tourists. The West *is* "wild" in the survey pictures, but it is also becoming ever more accommodating. Indeed, exploitation, up to and including tourism, would be land-based: hunting and trapping, then grazing, and

then, of course, agriculture. But exploitation would also be industrial. The surveys themselves often literally paralleled the expanding railroad networks and relied upon them for transportation and supplies. Mining of all sorts was already established when the surveys were being conducted; their geologists reported on its progress and their photographers recorded it (see, for example, cat. p. 81 and 85). It is noteworthy that, as early as 1867, even quite deep underground mining was sufficiently underway to become an appropriate subject—if a technically tricky one—for O'Sullivan.[6]

Farming and industry needed people, so westward migration was considered desirable. And with the population of the eastern seaboard increasing through both rises in the birth rate and waves of immigration from Europe, expansion of predominantly white settlement into the frontier regions was declared inevitable, an aspect of the nation's "manifest destiny" to occupy all the land opening west to the Pacific. In one of his formal reports, Hayden even envisioned expansion into the *whole* of North and Central America: "Out of the portions of the continent which lie to the northward and southward of the great central mass, other Territories will, in the meantime, be carved, until we shall embrace within our limits the entire country from the Arctic Circle to the Isthmus of Darien."[7] Many of the survey leaders and members were military figures who brought to the West strategies for victory learnt during the recent Civil War. Undoubtedly the surveys were a quest for knowledge, but underlying this aspect of their endeavor was an ideology of land exploitation.

Photography, as I will be at pains to show here through analysis of selected examples, is always a handmaid of culture. As deployed in the surveys, it enacted as best it could the overtly stated missions of the expeditions—whether geological, military, economic, anthropological or artistic. Needless to say, it would also be wrong to see it as fulfilling only a survey's main goal: even at the time, the reports often stressed the *various* functions or roles performed by photographs. Hayden, for example, in his *Preliminary Report of the United States Geological Survey of Wyoming...*, claimed in one instance that "Mr. Jackson, with the assistance of the fine artistic taste of Mr. [Sanford] Gifford, secured some most beautiful photographic views [of the Wind River mountain range], of value to the artist as well as to the geologist."[8] The key point is that, whatever else it did, photography also inevitably reflected the expropriative ideology that underwrote the nation's westward expansion.

Obviously, if the surveys so codified the expansionist ideology of the nation's dominant (white) group, Native Americans,

4 For the influence of Catastrophism, see especially Naef and Wood 1975, which also reproduces the Russell image (pl. 90), and Trachtenberg 1989. **5** See Pratt 1964 and for the Indian wars of the 1860s and 1870s, see Brown 1971. **6** The main sequence of O'Sullivan's subterranean mining pictures is conveniently reproduced in Goetzmann 1966 [1972], 622–27; Trachtenberg 1989, 144–54, comments interestingly. **7** Hayden 1871, 7. For more on the ideology of "white" and national expansion, see such works as Limerick 1987 and the influential essay collection edited by Cronon, Miles, and Gitlin 1992. **8** Hayden 1871, 37. For more on the links between photographers and such artists as Sanford Gifford, Thomas Moran, William Henry Holmes and Frederick Dellenbaugh, see Naef and Wood 1975, and Hales 1988.

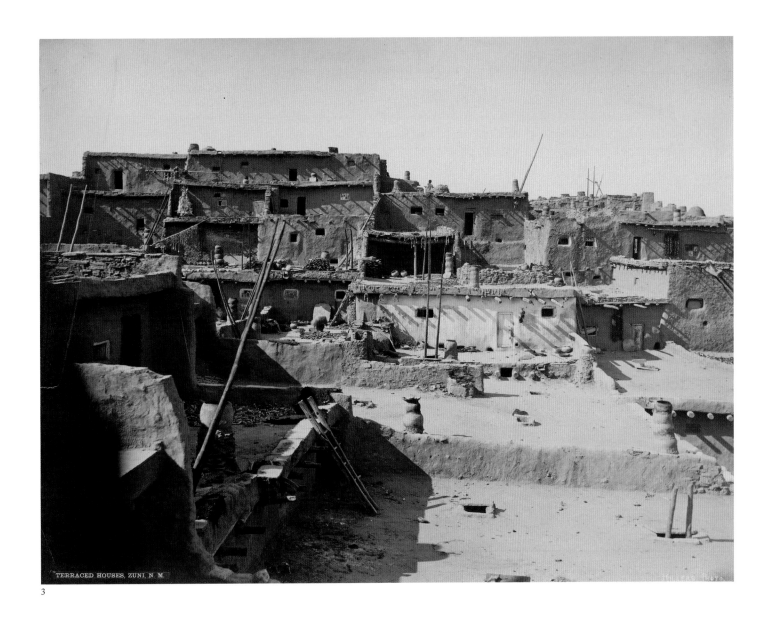

3

John K. Hillers
Terraced Houses, Zuni,
New Mexico, 1879–80
Albumen print, 25×33 cm
Société de Géographie, Paris

standing in the way of expansion, constituted a presence that could indeed be oppositional, and was always awkward. Cyrus Thomas, in his agriculturalist's return for Hayden's 1871 report on Wyoming and contiguous territories, was typical in his cold-blooded assessment of the future prospects for Indians, predicting their eradication if they would not submit to schooling in irrigation and agriculture: "If extermination is the result of non-compliance [with enforced agricultural training], then compulsion is an act of mercy." Wheeler not only accepted the inevitability of extermination, but appeared to *call* for it, speaking of the "mistaken zeal" of "the peace-at-any-cost policy": "while the fate of the Indian is sealed, the interval during which their extermination as a race is to be consummated will doubtless be marked . . . with still many more murderous ambuscades and massacres."[9] Sometimes, in the photographs, the continued and awkward aboriginal presence is *visually* very much the case.

It is not that the photographs habitually present fierce warriors, as envisaged by Wheeler; indeed, almost the opposite. Consider Hillers' portrait of *Ku-ra-tu, Kaibab Paiute Woman* (fig. 4), in which the young woman leans back against a wall of rock: her body language seems to speak of discomfort, as if she is squirming away from the intrusion of the camera and, possibly, its white operator. O'Sullivan's *Sleeping Mojave Guides* (figs. 5 and 6), in which expedition geologist Karl G. Gilbert sits pensively in the middle ground while three Mojaves lie somnolent on the sandy floor of the desert below him, is at least equally ambiguous. The image graphically communicates Gilbert's dominance of *his* surroundings, including the Indians. (Someone ignorant of the picture's title might see the Indians as dead. . .) That is, the observer may intuit what was so often the situation: the Indians depicted were merely incidental to the "real" action—in this case Gilbert's thoughtful attempt to *understand* the land; in such photographs they are, literally, marginalized, rather like the allegorical Indian figures in early maps of the New World. At the same time, it is also possible to read the image differently, as a study of the degree to which native peoples were so deeply in concert with their physical environment that, despite its apparent harshness, they could sleep directly, flesh to sand, on the earth itself. Seen in this light, the photograph seems a pre-figuration of O'Sullivan's later *View on Apache Lake, Sierra Blanca Range, Arizona* (cat. p. 98). Here, the Apaches, although simply sitting on their heels or standing, leaning on their rifles, are a necessary element in the composition, most notably in that one figure, squatting on a rock in the centre, forms the inevitable focus for the viewer's first gaze. *View on Apache Lake*, with its still, reflecting pool surrounded by cottonwoods, is, in effect, an image of Indians at home in, totally at one with, their own environment.[10]

Similar ambiguities are evident in the official images of Native American visitors to Washington. Such encounters, both political and photographic, already had a history by the time of the western surveys, and it was not merely a coincidence that in the 1860s and 1870s there were efforts in Washington to survey, catalogue, and exhibit the accumulated hoard of Indian images, an activity in which the first pivotal figure was Antonio Zeno Shindler, an entrepreneurial Washington portrait photographer who contracted with the Smithsonian Institution to produce a definitive catalogue in preparation for an 1869 exhibition there. Between the East and the West, there was much interchange: Gardner, for instance, photographed both sites along the Kansas Pacific Railroad and Indian delegations to the capital, and Hillers, too, was active in both spheres. Perhaps the most notable overlap in personnel was that Jackson, still apparently working for the United States Geological Survey, became well-known for his efforts in Washington during the 1870s to compile "descriptive" catalogues of Indian photographs, and in these catalogues he included both field work and studio portraits gathered in from various sources, including the British businessman and amateur ethnologist William H. Blackmore who, in turn, had both purchased certain photographers' extant Indian work and commissioned new portraits from them. Fortunately, many of the extraordinary complexities of this history have been fairly recently unraveled by Paula Richardson Fleming in *Native American Photography at the Smithsonian*, in which she reproduces virtually the entire file of images catalogued up to 1869.[11]

Fleming thus includes some beautiful "old" portraits, such as Nacheninga, or "No Heart of Fear," an Iowa who posed for Thomas Easterly of St. Louis in 1849 and who deliberately put on a grimace to represent the look of wisdom deployed formally in council meetings. She also includes Ta-tow-ou-do-sa, or "Prairie Chicken," also known as "Gives to the Poor" (1868), a Pawnee tribal policeman taken by Jackson, pistol in hand, as if ready for action, and *Psi-ca-na-kin-yan or "Jumping Thunder"* (cat. p. 109), a studio portrait of a leading Yankton Sioux chief photographed by Shindler himself. These images—like more disturbing ones, such as the displayed skulls of dead Indian men and women killed on the Plains in the early 1860s—never, in Fleming's text, escape history. Their contexts, such as treaty

9 Thomas in Hayden 1871, 263–64, and Wheeler, in his 1889 *Report upon United States Geographical Surveys West of the 100th Meridian* as quoted in Stegner 1954, 389 n. 7. **10** For further commentary on exemplary non-studio photographs of Native Americans, see Gidley [1989] 2007b; it may be that Hillers' portrait of Ku-ra-tu was the basis for a *Frank Leslie's Weekly* image discussed in detail in this essay. It is worth noting that the caption supplied for the stereo card version of O'Sullivan's *Sleeping Mojave Guides* image—*Caught Napping*—immediately creates a lighter tone (see fig. 6). **11** See Fleming 2003. For commentary on the Jackson catalogues, see also Brunet 1994.

John K. Hillers | *Ku-ra-tu, Kaibab Paiute Woman*, c. 1872
Stereograph, 11.5 × 18 cm | Société de Géographie, Paris

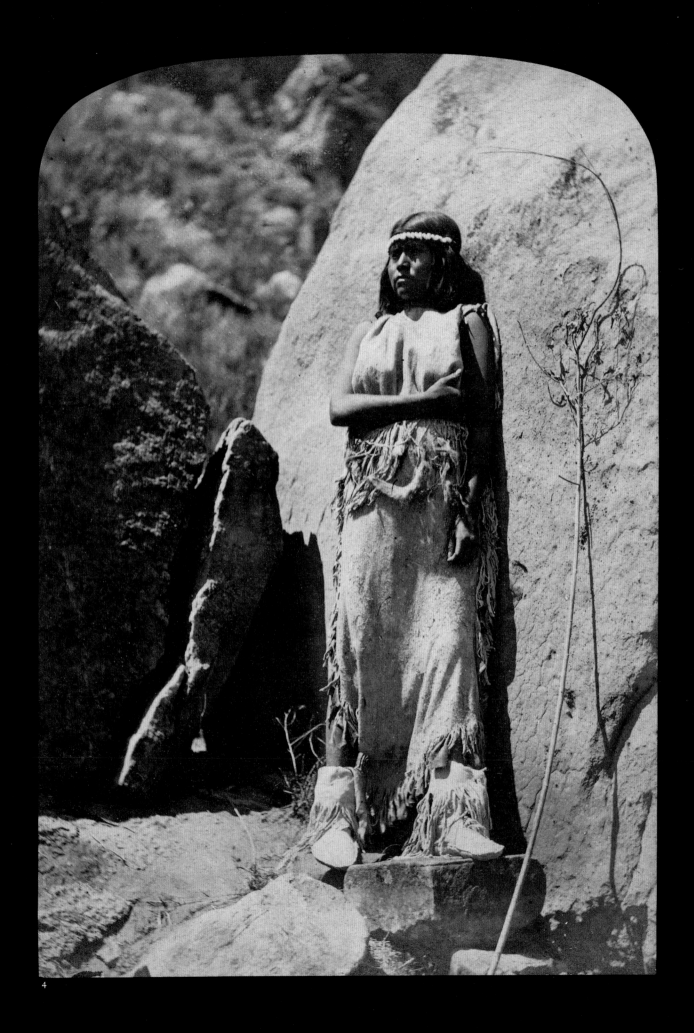

4

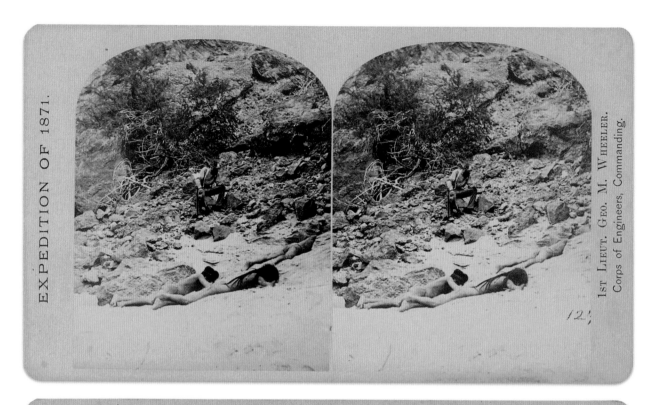

Timothy H. O'Sullivan
Sleeping Mojave Guides, Arizona, 1871
Stereograph, 10 × 18 cm
Musée du Quai Branly, Paris

delegations to Washington, are elaborated. Their institutional functions are explored and explicated as fully as possible. And, in the course of this contextualization, further narratives, sometimes previously told in part or for their own sake (such as Blackmore's collecting activities), unfurl in a fuller and authoritative manner. Perhaps the most illuminating of these are Shindler's elusive biography and the history of the 1869 Smithsonian exhibition, probably the very first museum exhibition primarily devoted to photography. The significance of the latter is that—complete with its images of now too-often-forgotten Native American figures paradoxically displayed in the leading state-sponsored museum at the height of the Plains Wars—it constitutes a truly *national* story: a national story into which both the western survey Indian images and the eastern portraits of Indians were enfolded.[12]

In the remainder of this essay, we will engage with this heritage more closely, as it extended through the 1870s and into the 1880s, by examining a number of specific images that, if space permitted, I would claim are exemplary. Some of the questions to be asked—and in this order—are: Is it profitable, even possible, to think of survey photographs that feature Indians as separable from "landscape"? If the native figures in landscapes and/or portraits are presented differently to white figures, how is this so? What, if anything, of specifically *native* cultures may be learnt from these images? Some critics—indebted to the now embedded view of nineteenth-century ethnology and its aids, such as photography, as intrinsically imperialistic—have implied that virtually all the Indian subjects of the official pictures were victims: defeated others whose images served only the needs of the dominant society for a record of the previous inhabitants.[13] But is this really so?

Although the survey photographers were aware of then-current notions of genre, there is no evidence that they tried, specifically, to adhere to such categorization; in fact, they generally attended to a series of miscellaneous assignments according to their leaders' instructions. When survey field pictures feature Indians—as in the case of those by Hillers and O'Sullivan discussed above (figs. 4, 5 and cat. p. 98)—it might be profitable to think of them not so much as landscapes *per se* as what I call "topographical portraits": images in which precisely what is at stake is the *relationship* between the people and the land around them. And when this relationship is examined in comparison with that between white figures and the land, there does seem to be a difference. White figures often transmit scale—as in Jackson's *North from Berthoud Pass* (fig. 1) or in the two views of

ruins in the Canyon de Chelly by Hillers and O'Sullivan (see cat. p. 68 and 69)—but more fundamentally they *look*: they look at the scene the photograph depicts. They thus serve as surrogate observers within the frame for the viewer outside it, gazing in. That is, they contemplate the mysteries and scientifically accessible meanings of Nature (and, sometimes, the Past). Some critics, remembering such injunctions as Ralph Waldo Emerson's famous call for "an original relationship with the Universe," have interpreted this role as a logical consequence and corollary of mid-nineteenth-century America's consuming interest in Transcendentalist philosophy. By contrast, Indian figures in these photographs are often simply *part* of Nature.[14] As we have observed, being in concord with Nature can be interpreted "positively," but it may have other connotations: in essence, in landscapes with a white figure a sense of empathy between the viewer and the figure is established that frequently seems absent in views with native figures. This necessarily means that—while white figures insert themselves into the landscape on "our" behalf—Indians are represented as "others" (an issue to which we must return).

In certain photographs ethnographic data is transmitted as an almost unconscious component of the image. From Hillers' *Terraced Houses, Zuni, New Mexico* (fig. 3), for instance, the viewer absorbs, despite the visible absence of inhabitants, something of Zuni communal life and building practices: the numerous rooftop entrances, ovens and ladders make it possible to ascertain that Zuni was populous and thriving. And such information is sometimes made *explicit* in accompanying captions, especially those for photographs in stereo card format (see fig. 6). In others, the viewer cannot fail to see that there is a didactic function. For example, in Hillers' *Kindling Fire by Friction* (fig. 7) the very purpose of the photograph is explicit: as a still image it demands narrativization, and a few words of actual or mental captioning would provide it.

Something similar may be said of O'Sullivan's *Aboriginal Life among Navajo Indians* (cat. p. 115). Here—as the precise wording of the title intimates—what is communicated is more than one piece of ethnographic detail, such as the rudiments of fire-making in the Hillers image. The photograph may focus upon weaving, but in structure as well as content—note the encompassing nature of the frame, and the way the figures within it seem to be juxtaposed to one another—it takes in the basics of Navajo material culture and grants the viewer a feeling of looking into an ongoing larger *pattern* of life. It *is* possible to learn something of specifically native cultures from some of these images.

12 The images by Easterly and Jackson appear in Fleming 2003, 247 and 177. If Fleming's book tells a national story, including the initial reception of western survey pictures on the eastern seaboard, it also has *international* ramifications, brought out in the current exhibition by François Brunet's catalogue essay and, of course, in the conception and selection of the exhibition as a whole. **13** There is more theoretical writing on "imperial eyes" than can be cited here; typical are the essays in Gidley 1992, *Representing Others*; for a more nuanced view, see Conn 2004, especially ch. 5, on anthropology; and for photography of Indians in particular there are useful items in a special issue of *Visual Anthropology*, see Joanna Cohan Scherer, ed., *Visual Anthropology* 3, no. 2 (1990). **14** For more on the notion of the "topographical portrait", see Gidley 2005. Interesting discussion of Transcendentalism and contemplation may be found in Novak 1980, and in Hansen [1989] 2007.

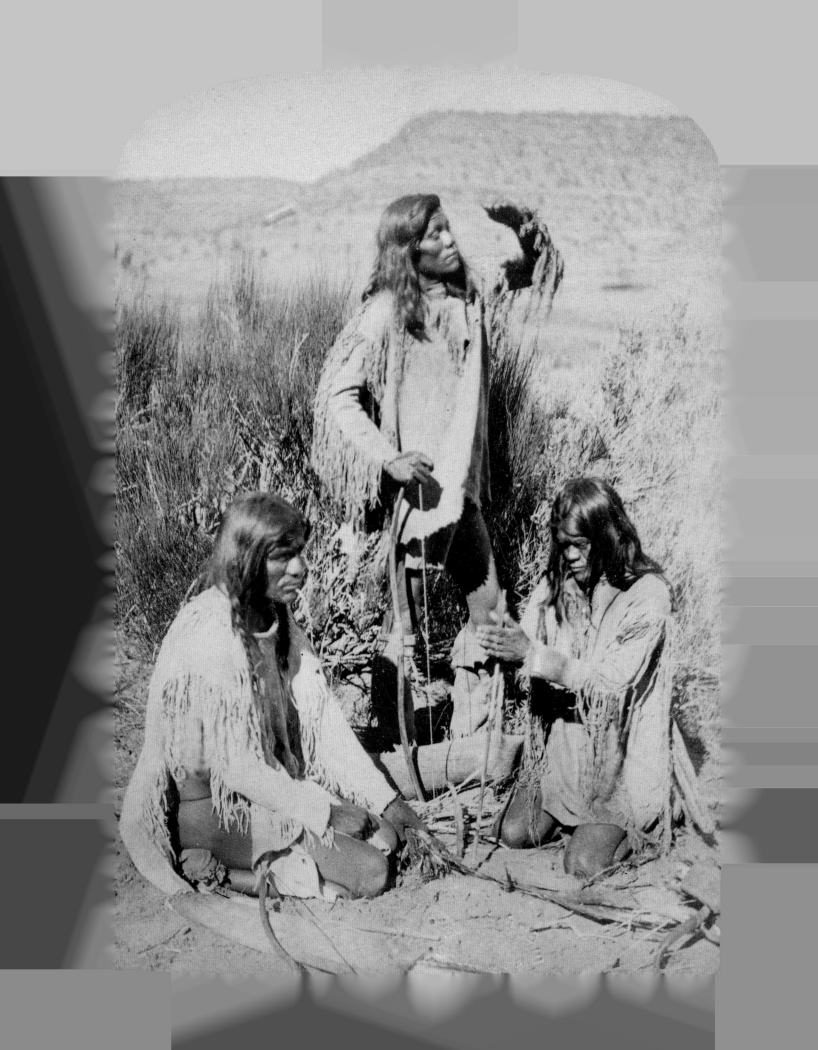

Colin Taylor, who gained an expert knowledge of Plains material culture, especially of the symbolism of designs used in clothing, testified that a group portrait of Southern Cheyenne chiefs, probably taken in 1863 by a studio in Leavenworth, Kansas while the chiefs were en route to Washington, was "particularly interesting for its wealth of ethnological detail," which he enumerated. Similarly, the clothing, hairstyles, pipes and peace medals displayed in the studio portraits, often quite dramatically, have given rise to much anthropological and historical commentary.[15]

However, this feature of the studio portraits has another side. In all portraiture there is a tension between the attempted rendition of a person's utter individuality and a categorization of that person's place in (or even against) society. Richard Brilliant, writing about the use of Native American figures in painted portraits, has pointed out that, when compared with sitters treated according to the ordinary conventions of portraiture, they very much veer towards the categorization side of the tension. They become stylized "Indians," "ethnographic types," and are represented with much more emphasis on "the externals of appearance, especially costume [and] hair treatment."[16] This observation definitely also holds true for certain of the survey-era studio portraits. It is, perhaps, most obvious—as the title, too, might indicate—in Shindler's *Indian Type* (cat. p. 106), but it is also applicable to Gardner's studio work, in particular the paired full-length portraits of the Yankton Sioux leader Long Foot (cat. p. 102 and 103). Especially seen together, they act as a cold-eyed examination of Long Foot's "Indian" features and accoutrements, rather than as an evocation of him as an individual, with a history and aspirations of his own. There is no doubt that there was a gross imbalance of power in the photographic encounter between whites and Indians, and an image such as this ensures that viewers acknowledge the fact: we realize that it is actually a typological study in which Long Foot is the victim of an objectifying stare.

But, despite the imbalance of power and the low status of Indian subjects politically—as "enemies" or as actual or potential subservient peoples—the view that Native Americans were invariably othered and simply stereotyped by the photographic encounter is, in the end, by itself, too reductive. First, there are records of Indians totally resisting the photographic encounter itself. In 1873, during one of the Hayden surveys, for example, Jackson was first frustrated in his efforts to make portraits among Ouray's Utes, despite the chief's own acquiescence, and then prevented from taking a panoramic view of their encampment at the Los Pinos agency: "As I attempted to focus, one of [the Utes] would snatch the cloth from my head; or toss a blanket over the camera; or kick out one of the supporting legs."[17]

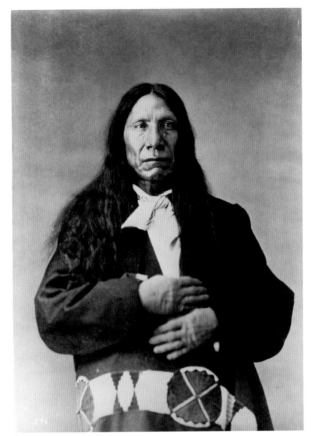

8
Alexander Gardner
Makhpyia-luta, "Red Cloud," 1872
Albumen print, 12.7×10.2 cm
National Anthropological Archives,
Smithsonian Institution, Suitland, Maryland

Second, when mainstream photographers during the period succeeded in their efforts to capture Indian subjects, it was not *universally* the case that their images supported the dominant culture's view of indigenous peoples. Edward S. Curtis, perhaps *the* single most influential photographer of Indians, worked at the turn of the twentieth century, when all the stereotypes of Indians—as "Noble Savages," a "Vanishing Race," and the like—had been long codified. He recalled an incident in which a Hopi man had snatched up a shield that was not ethnographically characteristic of his people and insisted on brandishing it for the camera. Curtis told the story to illustrate the childishness of his subjects, and their lack of understanding of the demands of his project to produce an accurate record for his multi-volume *The North American Indian* (1907–30). But the episode could be seen quite differently.

15 Taylor 1980, 21, quotation below reproduction of photograph. Like Fleming, Viola 1981 provides commentary on some of the studio images. **16** Brilliant 1991, 106–07. **17** See Jackson [1940] 1986, 225–27.

John K. Hillers | *Kindling Fire by Friction,* c. 1872
Stereograph, 11.5×18 cm | Société de Géographie, Paris

It could be that this Hopi man knew what he was doing, and that his actions were subversive of the larger narrative being told about him and his people.[18] The essays *by* Native Americans on a range of historical photographs collected by Lucy Lippard for *Partial Recall* (1992) argue, indeed demonstrate, that many different stories can be told.

Certainly, once we are prepared to look, we can find numerous instances where Indian subjects seem to have at least inflected, and sometimes positively undermined, the dominant story. For example, a further gloss on the pose adopted by Ku-ra-tu in Hillers' portrait of her (fig. 4) is that she was questioning a view of herself as a "child of nature" by, literally, *showing* discomfort in her seemingly natural surroundings. Similarly, Jackson's portrait of the Pawnee policeman with a gun is probably less straightforward than it seems. In the early reservation period many tribes instituted gatherings on and around July 4, knowing that their agents could hardly refuse such apparent acknowledgement of the American national holiday, but what these tribal get-togethers actually celebrated—in horse races, gambling, and, often, ceremony—was the particular tribe's own survival, their persistence and life as peoples. Jackson's subject may have been a policeman, but in the image he is an Indian with a gun, visually indistinguishable from similarly posed figures definitely captioned as "hostile". (Eadweard Muybridge's 1873 *A Modoc Brave on the Warpath* constitutes a counter example of the Indian with a gun: it was taken during the Modoc War, and in it—presumably because the maneuver made the image seem more newsworthy, even sensational—Muybridge presented an *army* Indian scout as if he were hostile.)[19]

Not surprisingly, scholars such as Martha A. Sandweiss and Carol J. Williams have recently suggested ways in which viewers may register a fuller native *presence* in historical photographs; they show, with documentation, that native peoples not only often presented themselves to the camera as they chose, but they also sometimes commissioned images independently—or used ones they had acquired—for purposes of their own, and even on occasion determined the dissemination of the resultant pictures. In other words, Indian subjects not infrequently exerted sufficient agency in and through their portrayal—in clothing, pose, or gesture—to force viewers today to speculate upon their motivations. (And later, from about the end of the nineteenth century, Indian individuals themselves, such as Richard A. Throssel, who was of Cree, Métis and Scottish descent, began to wield cameras.) They were not always and everywhere merely victims of the white photographic gaze.[20]

Indeed, I would argue that in certain images what might be termed the "ontological presence" of individual Native American figures is registered very fully, making a claim on the viewer's attention. Paradoxically, that claim may be at its most profound when these figures—however much the subject of prying anthropological examination—gave themselves fully to the camera (if not to its operative)—that is, to the *photograph*. Witness the face and demeanor of the unnamed *Indian Type* captured by Shindler (see cat. p. 106). Despite his obvious typologization—the emphasis on his elaborate Plains hairstyle, ceremonial pipe, bead-work and peace medal—this man has a humanity that impresses all the more because it is elusive: he also looks "away" or beyond us, as if in introspection, and—while we can learn about his paraphernalia—we cannot "know" *him*.

This sense of active presence is just as emphatic in the case of Shindler's *Psi-ca-na-kin-yan or "Jumping Thunder"* (cat. p. 109). He sits with pride, and appears at ease. He has dressed—and perhaps even performs—for the camera. But not *only* for the camera: that is, Jumping Thunder's act of subversion was truly to be himself, for himself. The performative aspect of identity is, in itself, worth consideration. We noted above that Nacheninga put on a facial grimace, usually adopted during council meetings, for Thomas Easterly. The caption in the Shindler catalogue says that he did this at the request of his agent, and this may have been so. But it is also obvious that it was an expression that betokened thoughtfulness, gravitas; in essence, Nacheninga, representing his people in negotiation with a new power in the land, put himself forward as someone to be taken seriously. This is also emphatically the case in most of the numerous photographic portraits of the Lakota leader Red Cloud, who first came to prominence as a leader of the victorious Sioux attack in the so-called Fetterman Massacre of 1866, took a decisive role in the negotiation of the Fort Laramie Treaty of 1868, and thereafter frequently acted on behalf of and spoke for the Oglala Sioux of the Pine Ridge Reservation until his death in 1909.[21]

The portraits of Red Cloud were almost all official images made in an "official" context, and it is highly likely that for Red Cloud himself they were part of an ongoing dialogue—a negotiation—with Euro-American culture: constituents of a continuum that also embraced his role as a treaty maker. It is worth pausing to peruse one of the crucial early pictures taken in 1872 by Gardner for (and in the presence of) William H. Blackmore (fig. 8). Because of Red Cloud's impassive expression, and more particularly because of the gloves he is wearing, which in their placement draw attention to the beadwork at his waist on the blanket he appears to be holding up around him, this picture could be read as a somewhat objectifying typologization. But the image is also striking and "strange". It is interesting that

18 For more on Curtis, see Gidley, 1998 (the Hopi episode is told on pp. 100–01). In *Partial Recall* (Lippard 1992), Lippard includes several instances, some captured in photographs, of Indian hostility to the camera. **19** The Muybridge image, with commentary, is reproduced in Sandweiss 2002, 243–44. **20** Sandweiss 2002; Williams 2003. For Throssel and others, see Alison 1998. **21** See Goodyear 2003.

Jackson, in describing it for his catalogue, restricts himself to noting the chief's age and height, but then addresses not so much externals but what they might mean: "his face, which is of a dark red, is indicative of indomitable courage and firmness, and his full, piercing eyes seem to take in at a glance the character of friend or foe." Such an affect must have been most useful to Red Cloud. He could be measured, but he was *not* someone whites could easily get the measure of in a deeper sense.[22] Several of the other leaders in delegation pictures—so often wearing or carrying tokens of high office—give the same impression.

The communication of full humanity is not merely attributable to the artistry of fine photographers such as Gardner, Shindler and Easterly. What I have called ontological presence is registered so powerfully in particular images that it overcomes, so to speak, the camera's imperialistic gaze, almost regardless of whoever operated it. One of the leaders in the group photograph of Southern Cheyennes taken by a now-anonymous journeyman studio photographer evoked above is Black Kettle, a chief who survived the notorious Sand Creek massacre in 1864 only to be killed by Custer's troops in their unprovoked attack on his Washita River camp four years later. His anonymously authored group portrait has its significance partly because of the acknowledgement of leadership and authority that the taking of it represented at the time, and partly because it enables identification in the present.

It is not possible to reach a conclusively unambivalent view of the photography of Native Americans during the era of the great surveys. Or, rather, it would be, at best, an oversimplification to do so. Photography was the expanding eye of the nineteenth century. The surveys brought more of "America"—peoples as well as landmass, flora, and fauna—before the camera than had ever happened before. This was no mere automatic process, or simply an effect of technological advance: it was the result of deliberated policy. The survey era was a period of acute camera consciousness. And Native Americans, such as the Lakota chief Red Cloud, if not on an equal footing with whites, shared in it. Crazy Horse, a fellow Lakota—the war leader at the Battle of the Little Bighorn—refused to be photographed at all, and Sitting Bull, the Lakota spiritual leader at the time of the battle, insisted on retaining reproduction rights to his own pictures when he later joined Buffalo Bill Cody's Wild West Show. Less prominent native people, as we have seen, found other ways to insist on their photographic rights. Sometimes we do not even know their names, but when we look at their images now the humanity they share with us makes a mute appeal.

22 Goodyear 2003, 25, quotes Jackson but reads this image as objectifying, calling its Red Cloud a "specimen".

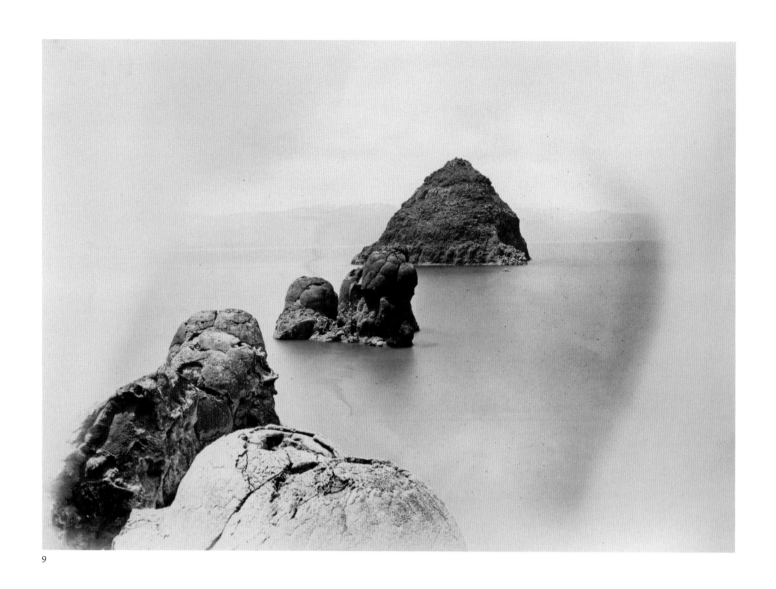

9

Timothy H. O'Sullivan
Tufa Domes, Pyramid Lake, Nevada, 1867–68
Albumen print, 20×28 cm
Société de Géographie, Paris

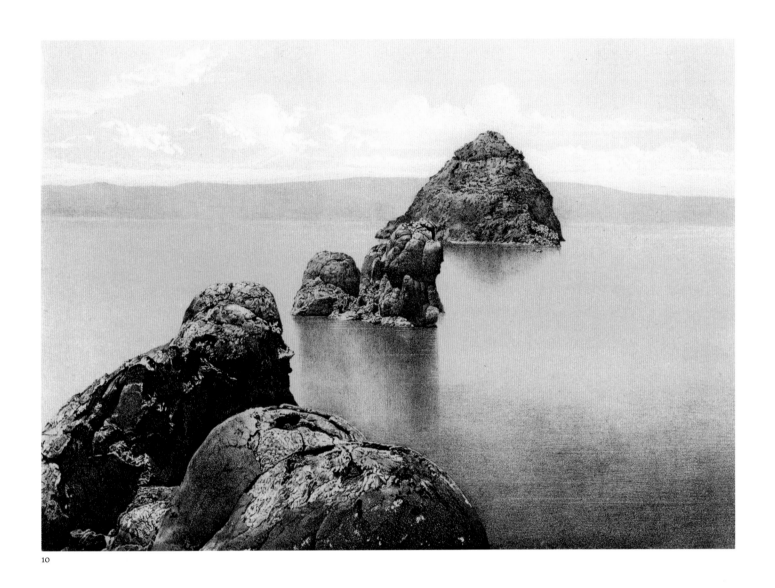

10

Timothy H. O'Sullivan
"Pyramid and Tufa Domes, Pyramid Lake, Nevada"
in *Report of the Geological Exploration of the 40th Parallel*,
vol. 1, Clarence King, *Systematic Geology* (Washington, D.C.:
Government Printing Office, 1877), pl. 23
Société de Géographie, Paris

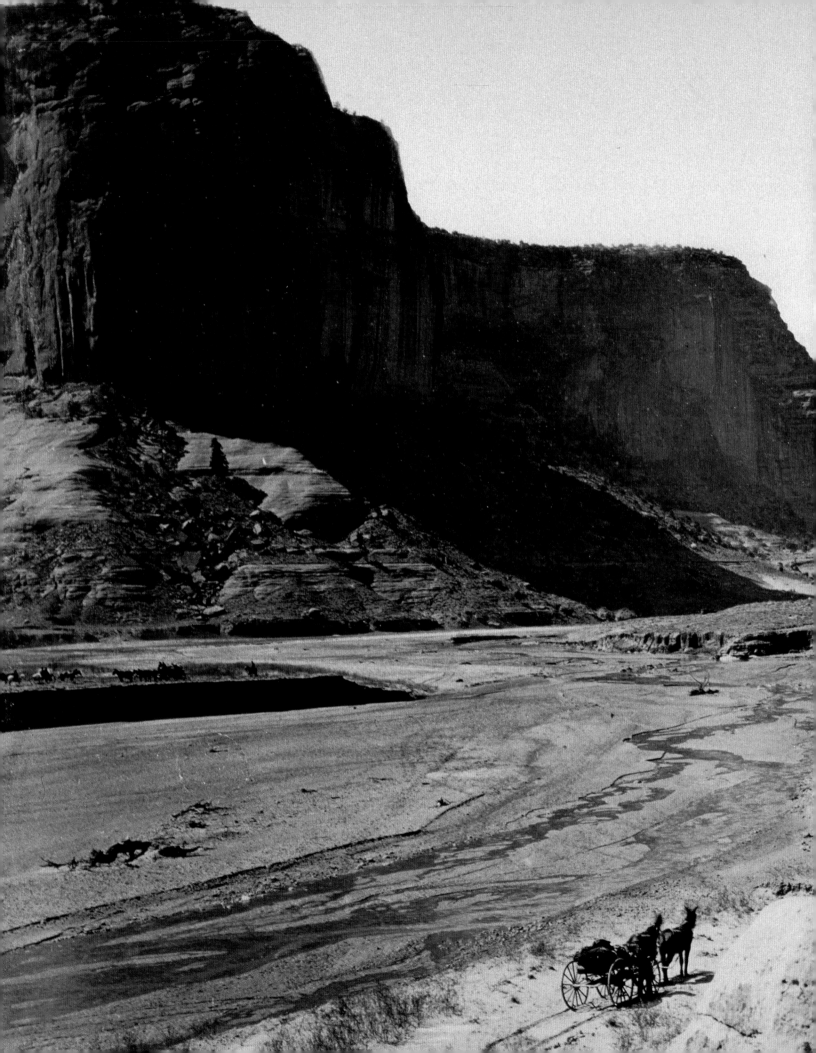

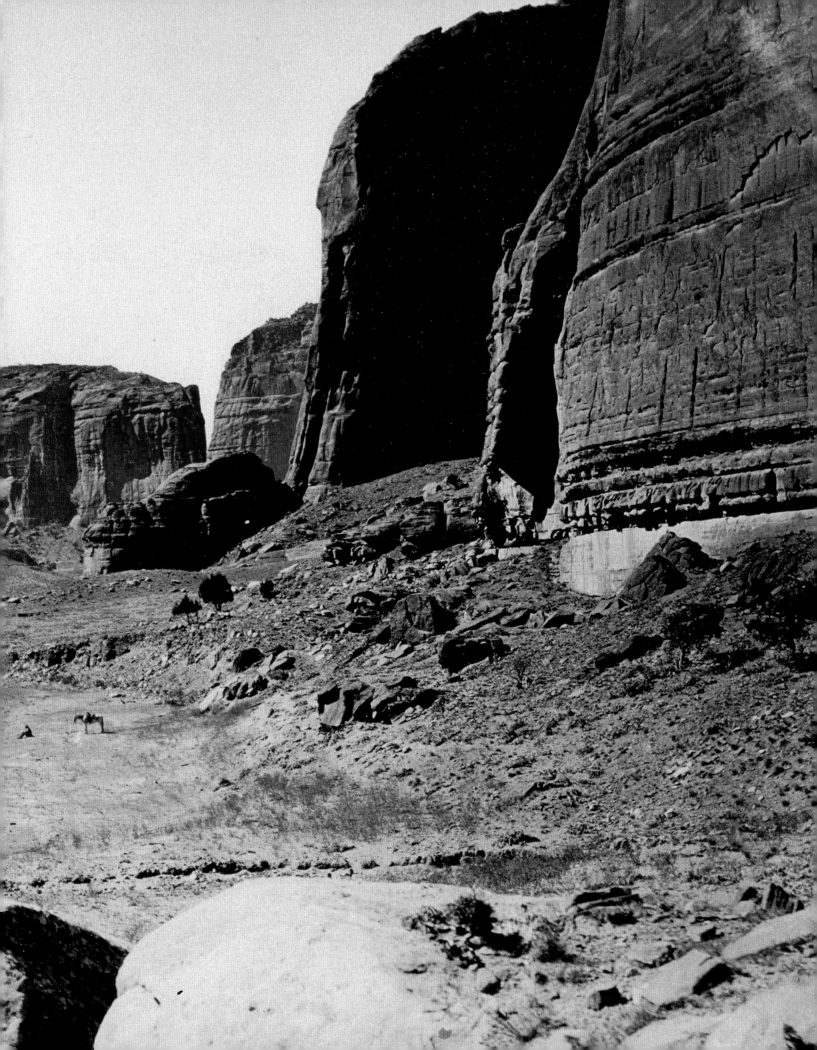

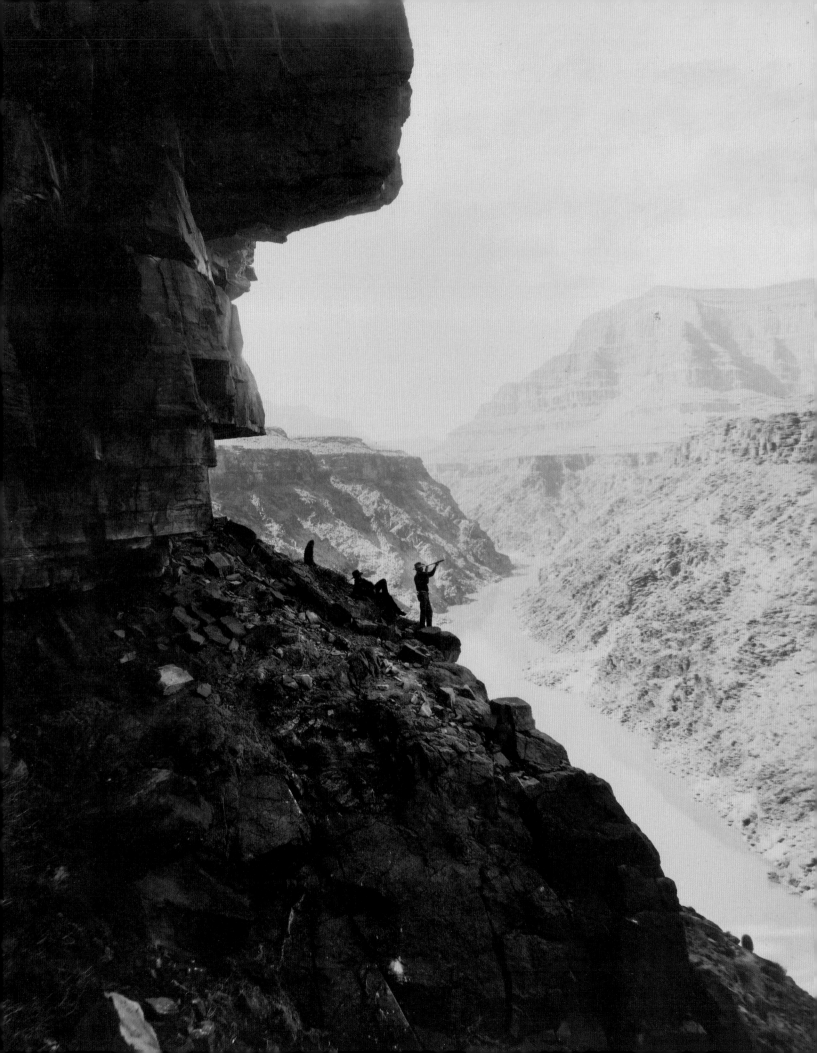

WIDE OPEN SPACES

It is at the very moment when the nation's photography magazines were lamenting the weakness of American landscape photography that William H. Jackson, Timothy H. O'Sullivan, William Bell, and John K. Hillers, following the example already set by Carleton E. Watkins and his California rivals, became masters of the collodion landscape. With glass plates as large as 18 × 25 inches, one can imagine the dimensions of the camera and development equipment (since the wet collodion process required that the plates be processed immediately) that had to be carried on muleback to the tops of cliffs and the bottoms of ravines. The images could be even larger and the effort required to produce them even greater in the case of the panoramas that stretched across multiple plates. Such an investment in landscape would have been inconceivable without the logistical support of the missions. The explorers, who did not have a great deal to say about the scientific usefulness of the "views," demonstrated their symbolic importance by reproducing them in their reports and exhibiting them in a variety of forms. In this way American and European audiences discovered Yosemite, Yellowstone, the Grand Canyon, the ruins of the Canyon de Chelly and Mesa Verde, and Shoshone Falls, all of which sooner or later became national parks or monuments and all of which the exploration photographers helped to "sanctify" by emphasizing the breadth of their spaces and the dizziness of their plunging vertical lines. This visual atlas of the "wonders" of the West was one of the principal stakes of the photographic competition among the surveys, which did not hesitate to compete on the same terrain, as they did, for example, in the Grand Canyon. One gets the impression that the photographers came to enjoy this process of conquering visual space, despite the often difficult conditions. Watkins and Jackson described their art as consisting in the "care" required to realize these views, in the trouble they took to avoid sand, dust, excess humidity and heat, and transportation accidents, and the effort they made, alone or in the company of their scientist partners, to prospect—as Bell writes—for "a spot from whence three or four [views] can be had." This dual obsession with the requisite care and with finding the ideal vantage point defines the art of these photographers, whose work was imitated by the makers of westerns before it went on to be scrutinized by the critics, who detect within it a "native" tradition marked by a fondness for nature and a close attention to light.

William H. Jackson
*Grand Canyon du Colorado (Arizona)**
[*Grand Canyon of the Colorado, Arizona*] (detail), 1883
(cat. p. 60)

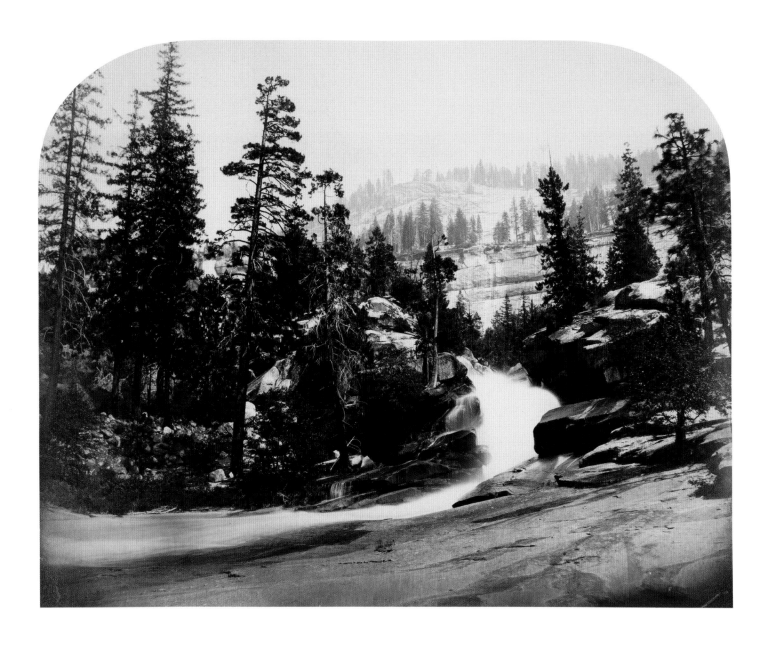

YOSEMITE

Carleton E. Watkins
Cascade, Nevada Falls, Yosemite, c. 1861
Albumen print, 42×53 cm
Bibliothèque Nationale de France, Paris.
Département des Estampes
et de la Photographie

Carleton E. Watkins
El Capitan, Yosemite, 1860s
Albumen print, 53×42 cm
Bibliothèque Nationale de France, Paris.
Département des Estampes
et de la Photographie

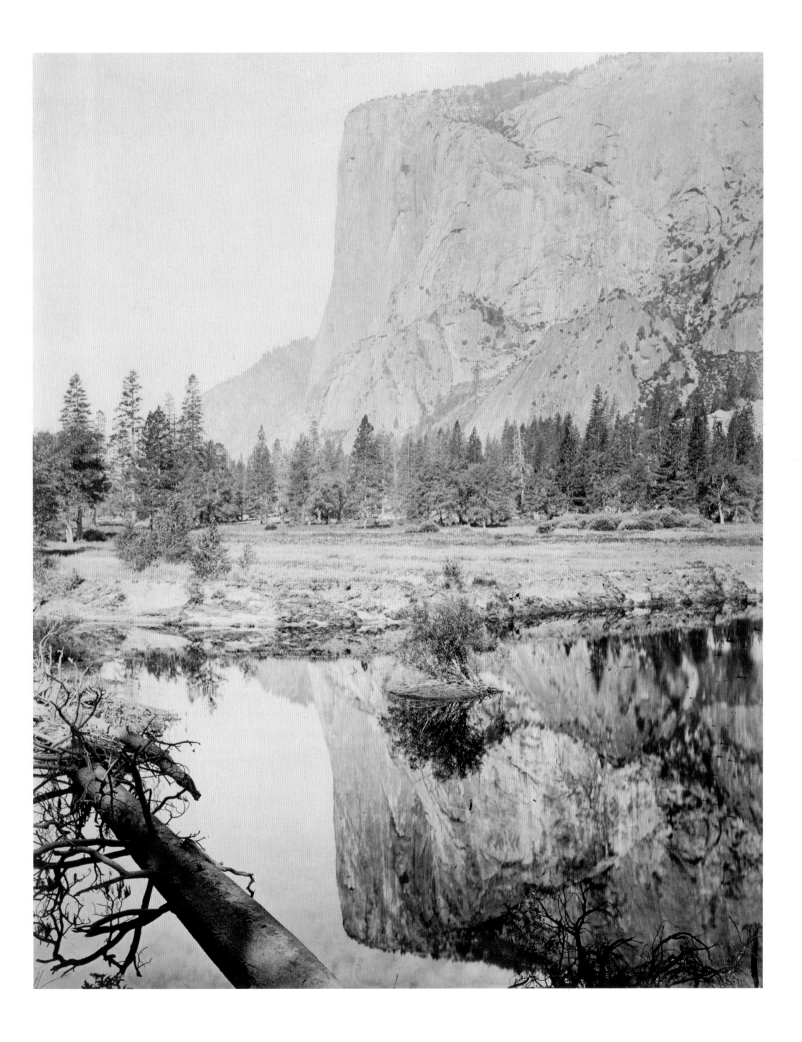

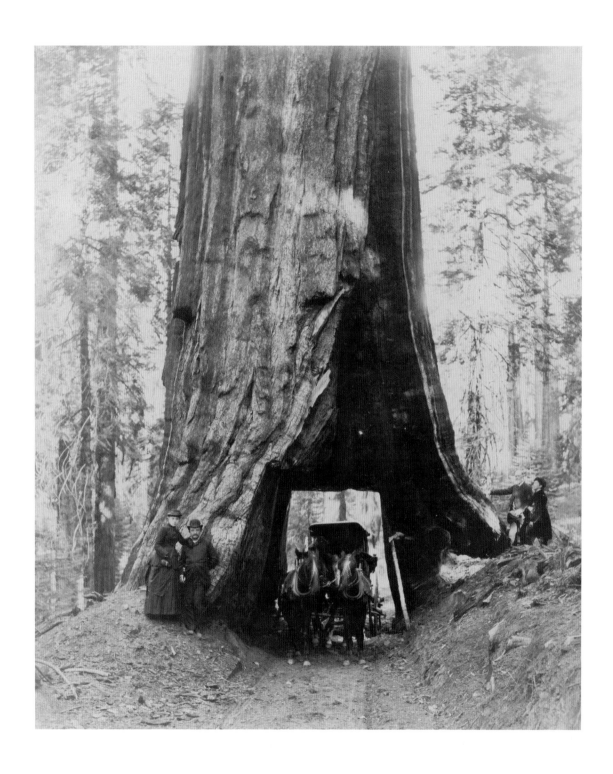

Carleton E. Watkins
Route creusée dans le tronc d'un séquoia gigantesque,
*forêt de Mariposa (Californie)** [*Wawona–28 Feet Diameter,*
275 Feet High–Mariposa Grove], c 1865–80
Albumen print, 49.2 × 40 cm
Musée d'Orsay, Paris. Gift of Mr. Robert Gérard, 1987

Carleton E. Watkins
*Vue générale de Glacier Point**
[*View from Glacier Point*], 1865
Albumen print, 19.6 × 12.4 cm
Paris, musée d'Orsay.
Gift of Mr. Robert Gérard, 1987

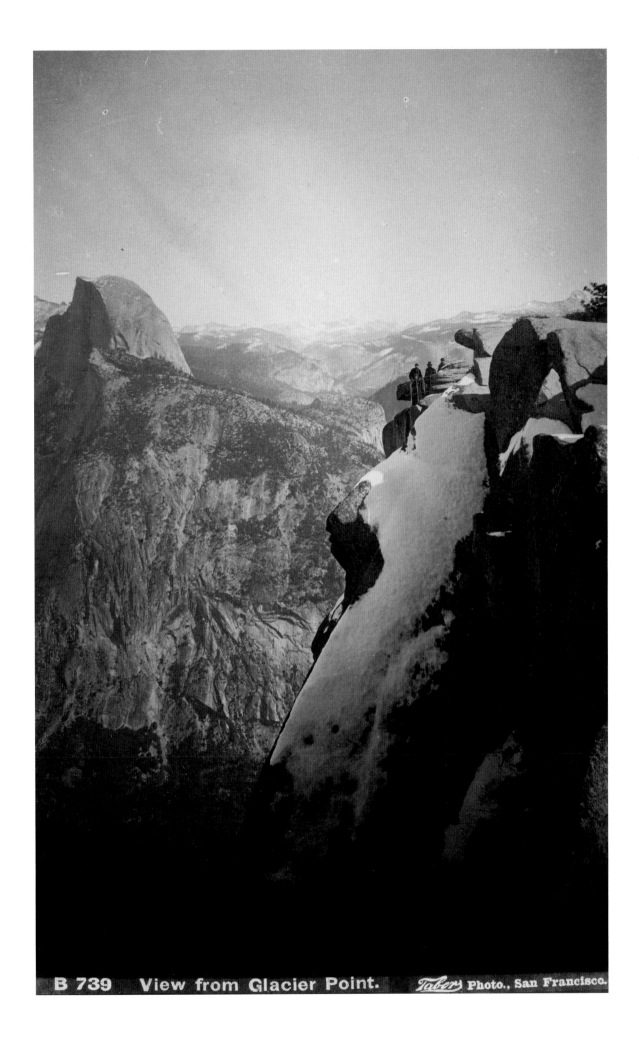

B 739 View from Glacier Point. *Taber* Photo., San Francisco.

YELLOWSTONE

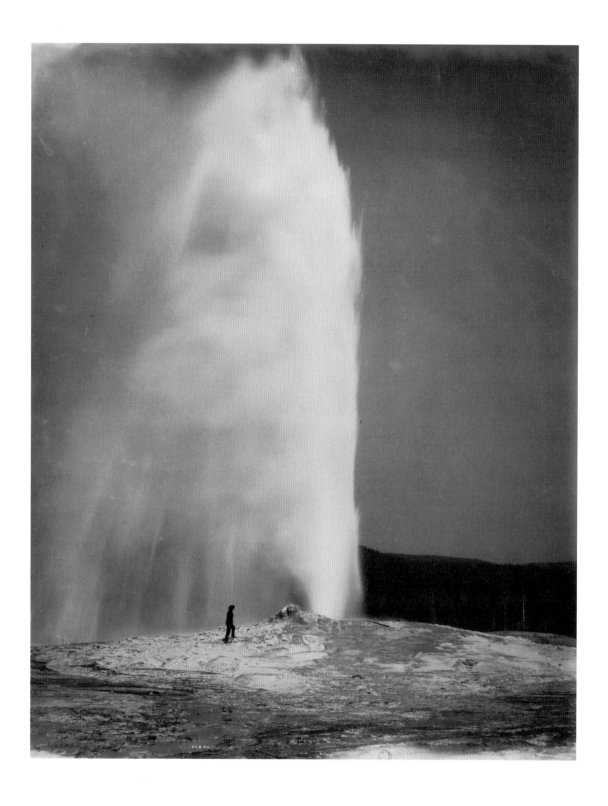

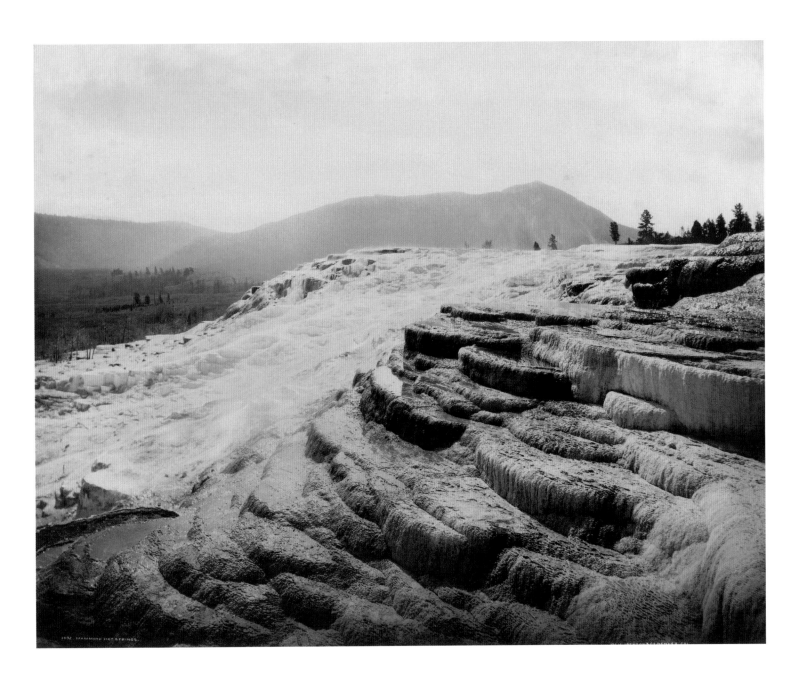

William H. Jackson
*Le Vieux Fidèle, geyser**
[*Old Faithful, Geyser*], 1870
Albumen print, 51.5×41.5 cm
Musée d'Orsay, Paris.
Gift of Mr. Robert Gérard, 1987

William H. Jackson
Sources chaudes "mammouth,"
*parc du Yellowstone**
[*Mammoth Hot Springs*], 1871
Albumen print, 43×53.5 cm
Musée d'Orsay, Paris.
Gift of Mr. Robert Gérard, 1987

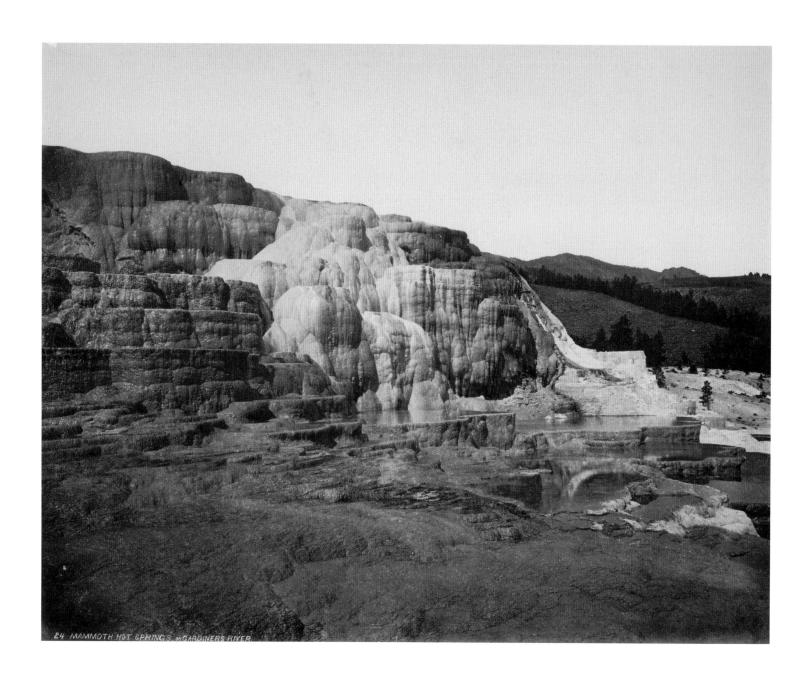

William H. Jackson
Mammoth Hot Springs,
on Gardiner's River, c. 1872
Albumen print, 25×33 cm
Musée Nicéphore Niépce,
Chalon-sur-Saône

58

William H. Jackson
Upper Fire-Hole Basin,
from Old Faithful, c. 1872
Albumen print, 25×33 cm
Musée Nicéphore Niépce,
Chalon-sur-Saône

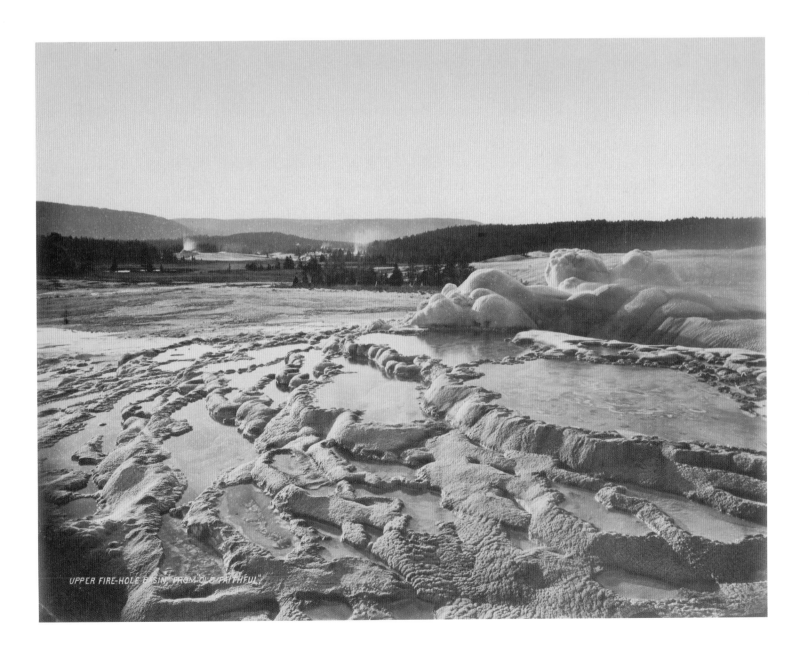

UPPER FIRE-HOLE BASIN, FROM OLD FAITHFUL

GRAND CANYON

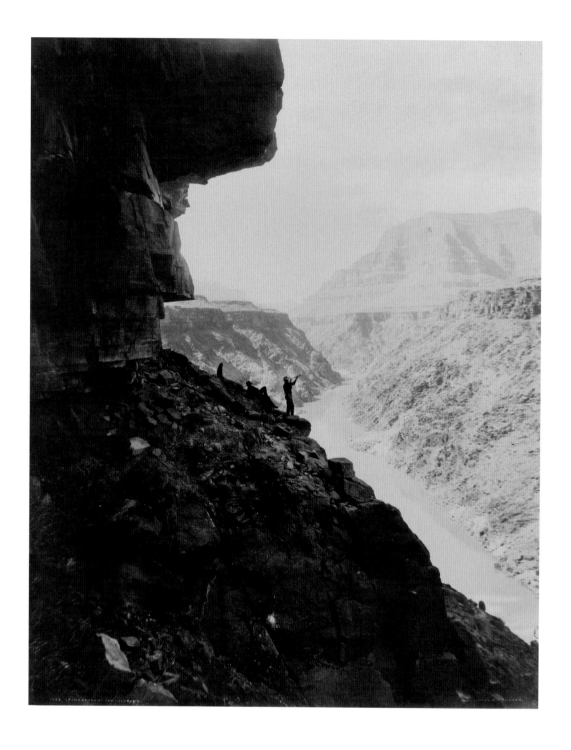

William H. Jackson
*Grand Canyon du Colorado (Arizona)**
[*Grand Canyon of the Colorado, Arizona*], 1883
Albumen print, 53.5×42.5 cm
Musée d'Orsay, Paris.
Gift of Mr. Robert Gérard, 1987

William Bell
Looking South into the Grand Canyon, Colorado
River, Shivwits Crossing, 1872
Albumen print, 27.5×20.3 cm
Musée d'Orsay, Paris

60

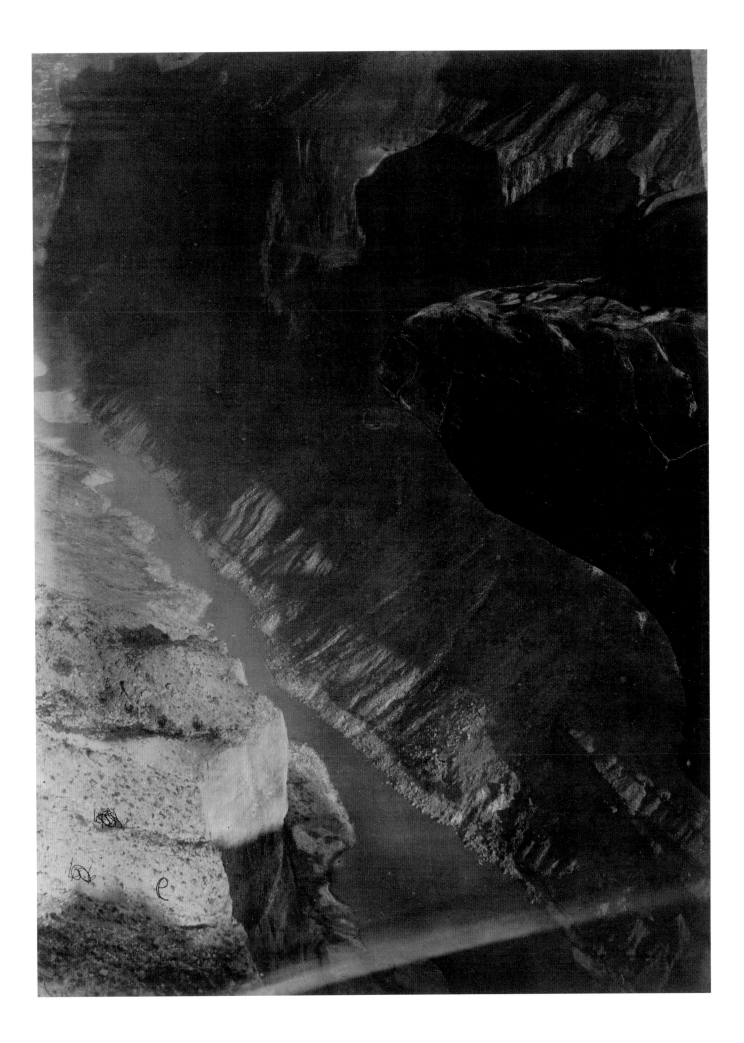

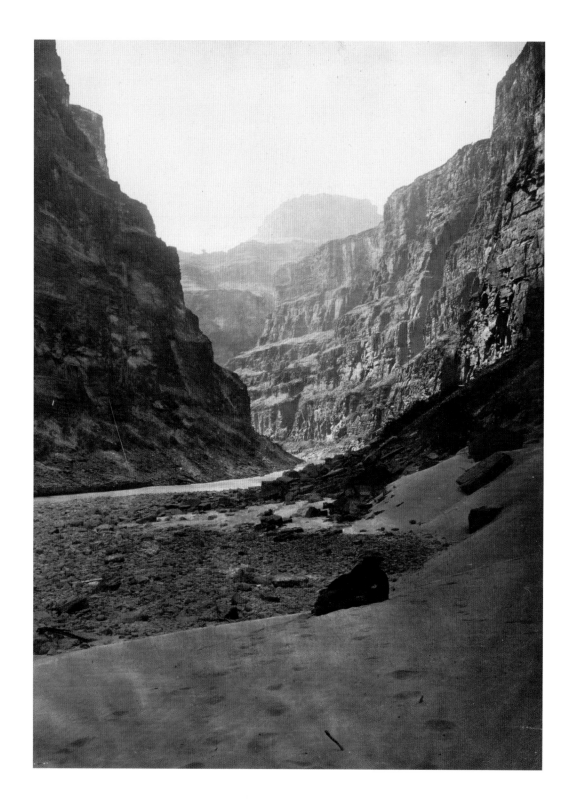

William Bell
Grand Canyon of the Colorado,
Mouth of Kanab Wash, Looking West (no. 52), 1872
Albumen print, 28×20 cm
Société de Géographie, Paris

William Bell
Grand Canyon of the Colorado,
Mouth of Kanab Wash, Looking West (no. 54), 1872
Albumen print, 23×18 cm
Société de Géographie, Paris

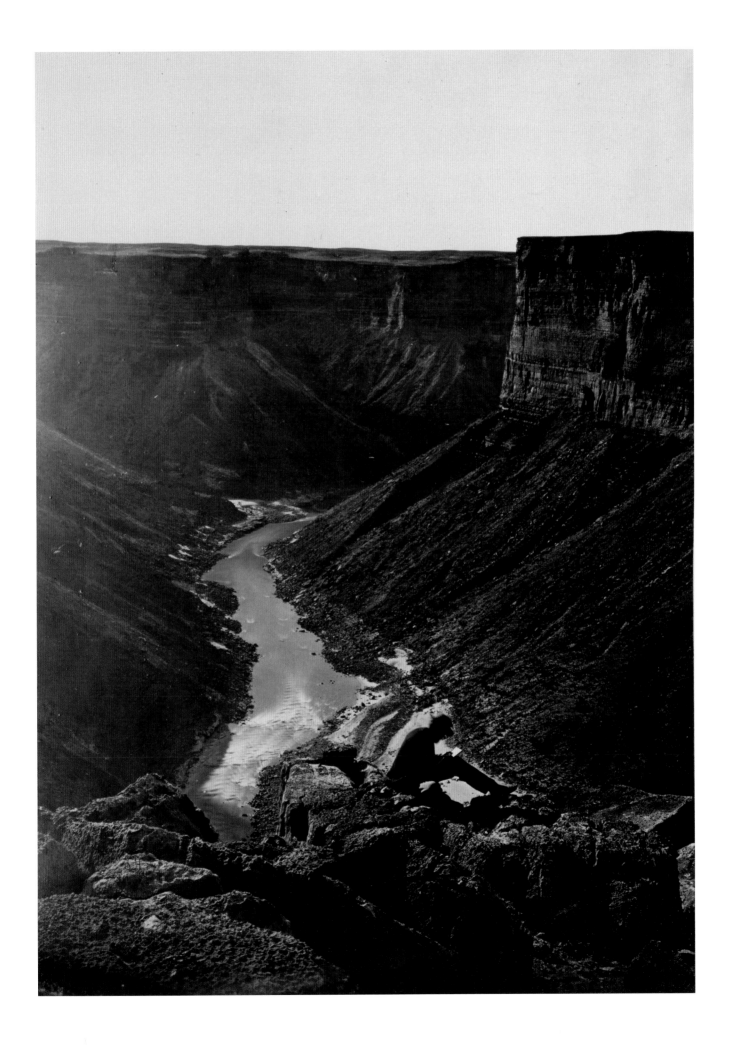

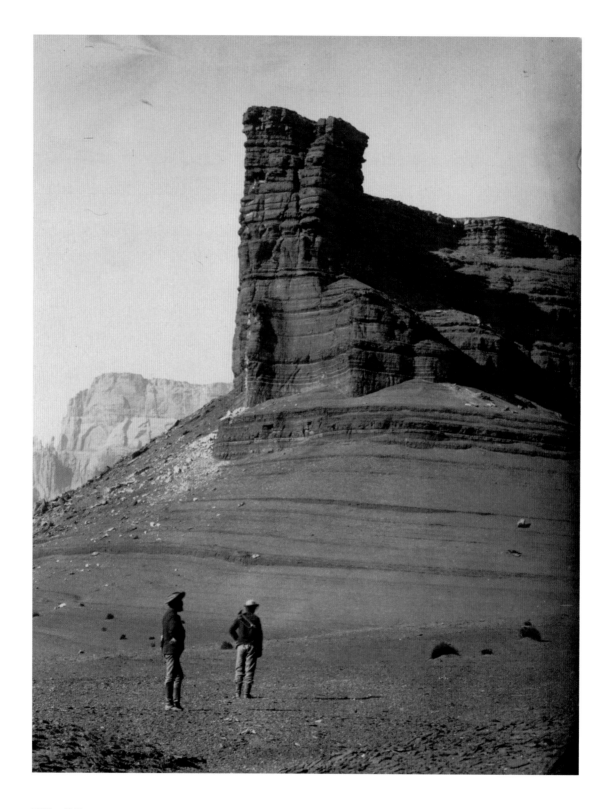

William Bell
Chocolate Butte near Mouth of the Paria, 1872
Albumen print, 23×18 cm
Société de Géographie, Paris

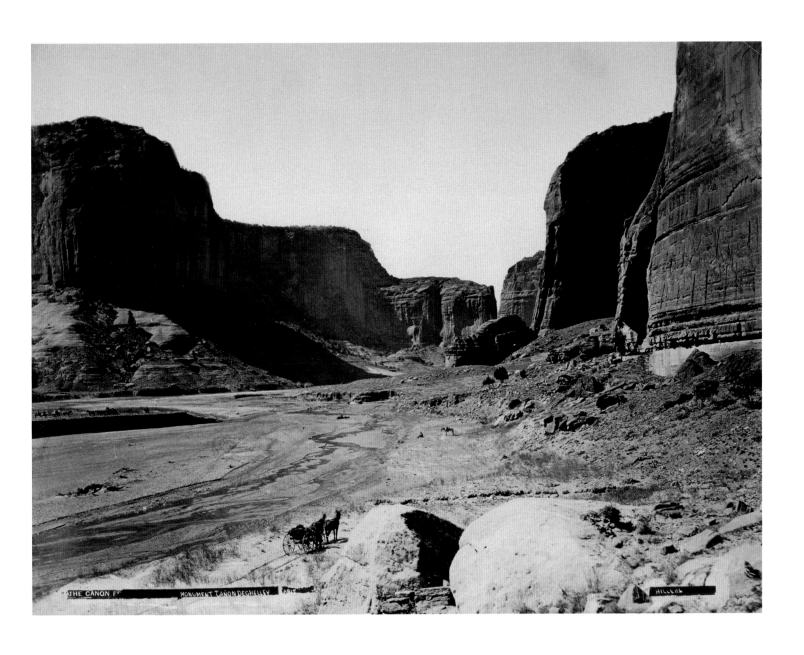

CANYONS DE CHELLY AND DEL MUERTE, ARIZONA

John K. Hillers
The Canyon de Chelly from
Explorers' Monument, 1870s
Albumen print, 25×33 cm
Société de Géographie, Paris

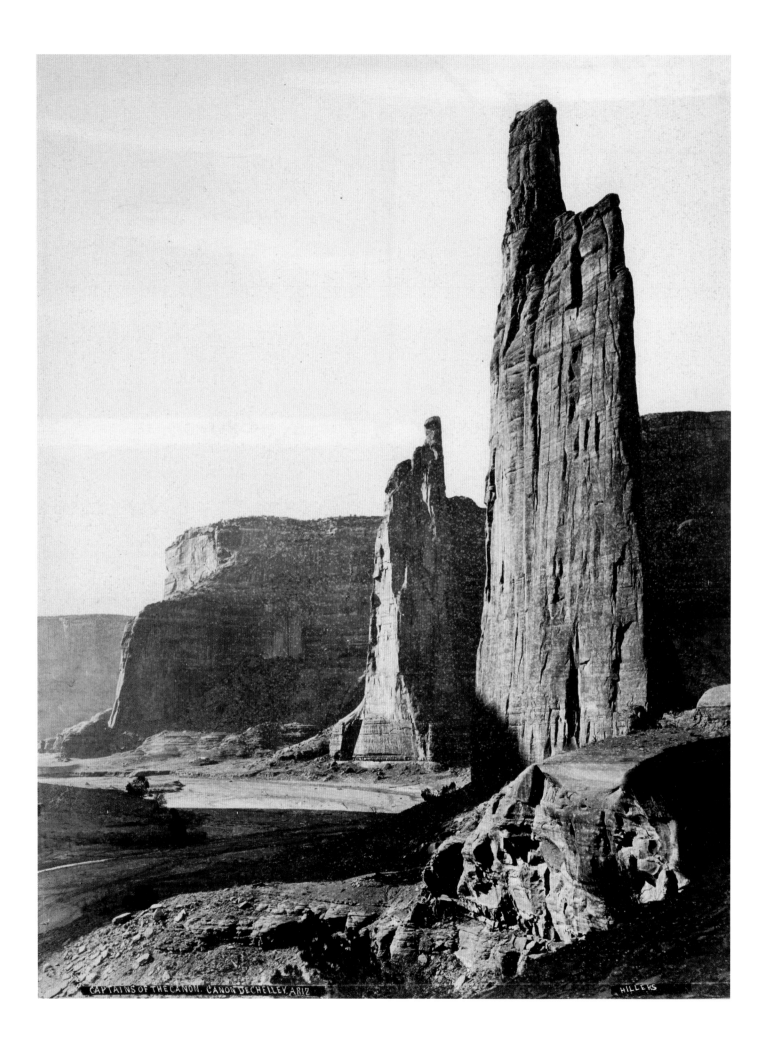

CAPTAINS OF THE CANON. CANON DECHELLEV, ARIZ. HILLERS

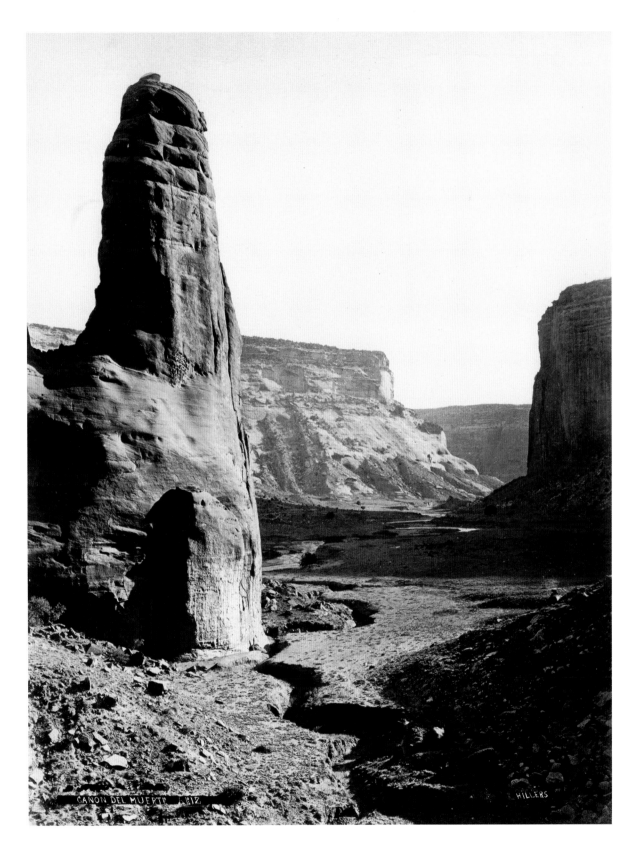

John K. Hillers
Captains of the Canyon,
Canyon de Chelly, Arizona, 1870s
Albumen print, 33 × 25 cm
Société de Géographie, Paris

John K. Hillers
Canyon del Muerte, Arizona, 1870s
Albumen print, 33 × 25 cm
Société de Géographie, Paris

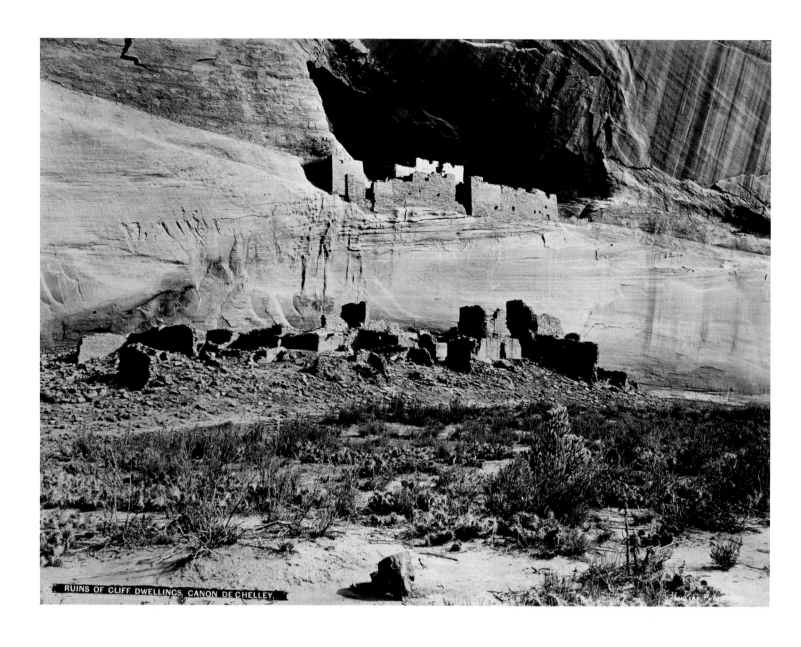

RUINS OF CLIFF DWELLINGS, CANON DE CHELLEY.

John K. Hillers
Ruins of Cliff Dwellings,
Canyon de Chelly, 1870s
Albumen print, 25 × 33 cm
Société de Géographie, Paris

Timothy H. O'Sullivan
"Ancient Ruins in Canyon de Chelly, New Mexico.
In a Niche 50 Feet Above Present Canyon Bed," 1871,
in George M. Wheeler, *Photographs Showing Landscapes,*
Geological and Other Features, 1874
Albumen print, 28 × 20 cm
Médiathèque du Quai Branly, Paris

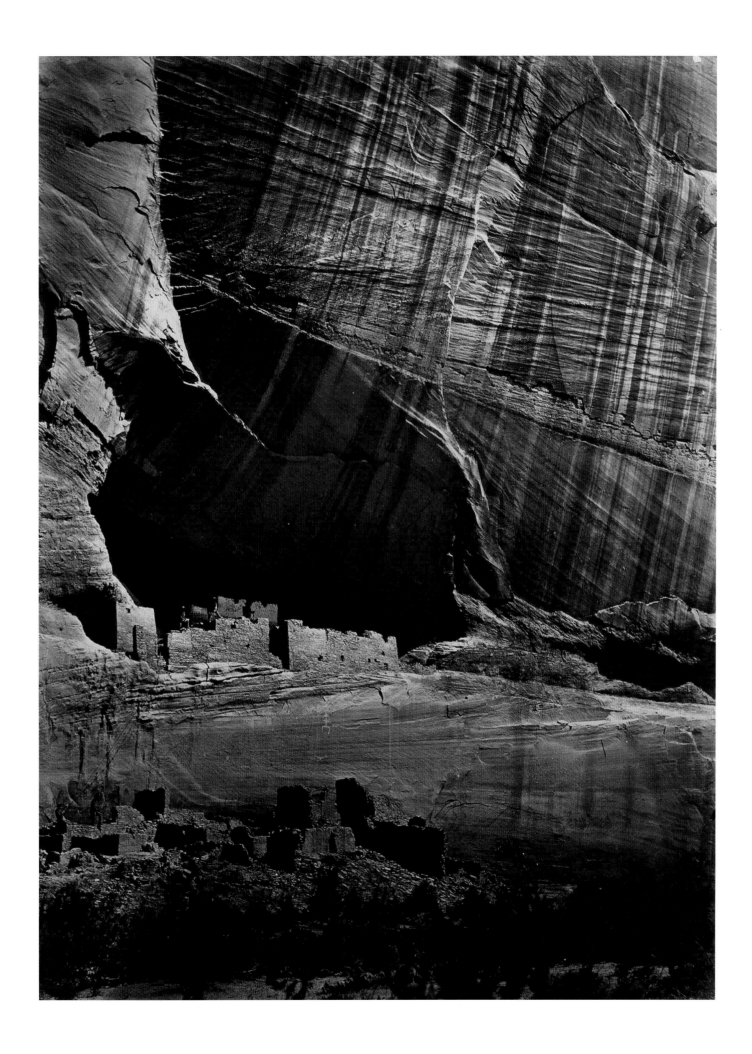

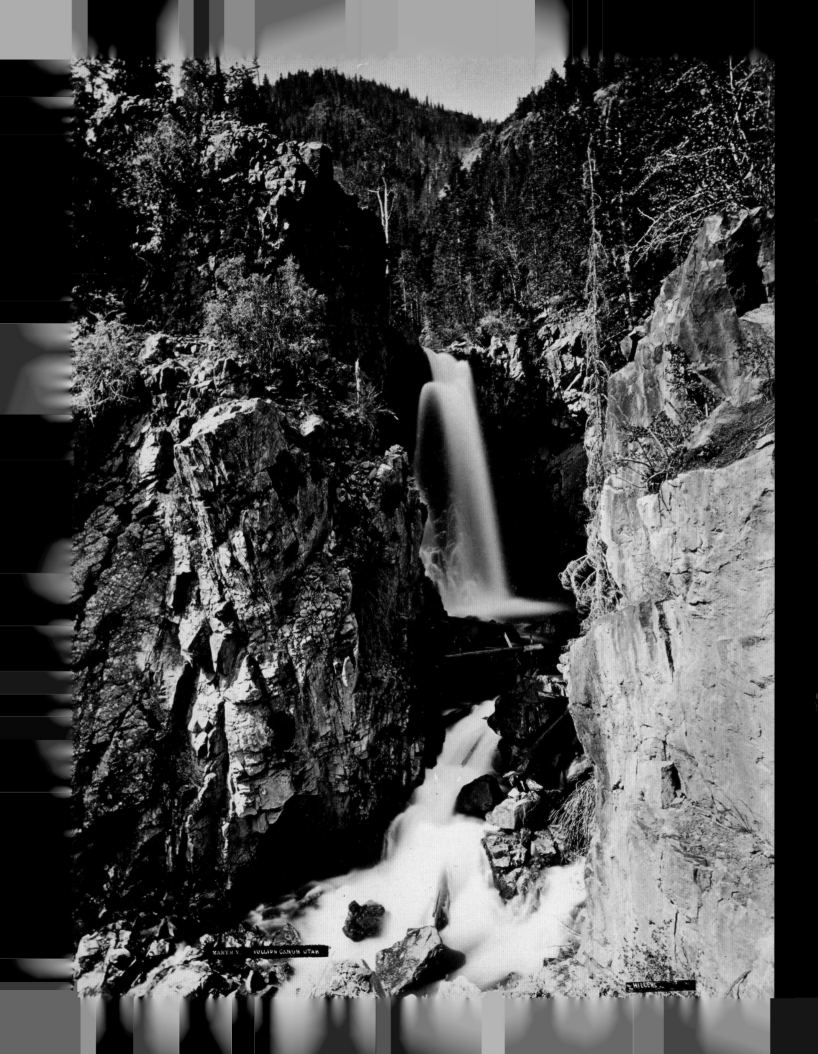

MARYS V... BULLION CANON UTAH

HILLERS.

FEATURES OF THE LANDSCAPE

In addition to wide shots that capture the grandeur of open spaces, the exploration photographers regularly produced detailed motifs and more circumscribed views. These details may have been responses to specific requests on the part of the geologists, who, like Grove K. Gilbert, valued photography's ability to render "the systematic heterogeneity of the material" and "wonderfully convoluted" surfaces. But the exegesis of the snarled rocky masses of Nevada's volcanic sites and the endless variations of Yellowstone's limestone sedimentation did not prevent the photographers from pursuing pictorial qualities as well, which are often quite striking. Beginning in the 1870s and throughout his long career, William H. Jackson photographed Yellowstone's "Mammoth" Hot Springs dozens of times. Some of these images reflect a heightened sense of the "fantastic" aspect of nature, while others border on abstraction. This pursuit was also rooted in a curiosity, widely shared by cultivated audiences, surrounding the mysteries of geomorphology, a speculative field that included the question of the age of the North American continent as well as the presence of the divine within the landscape. While it is true that this geological question excludes human history and above all that of the Native American civilisations, the exploration photographers also captured archaeological motifs, including a series of close-ups of pictograms by William Bell. These point to another question of the day, regarding the origins of the North American populations. Finally, the explorers' photographs reflect a repeated search for bodies of water —lakes, streams, rivers, and waterfalls— that conveniently belies the old vision of the West as a "great desert" (a vision that was revived in the 1870s by the realization of the dryness of the Southwest) while also supplying lovers of the picturesque with refreshing views that were then perpetuated by postcards. Especially appealing to us is the creamy, even "chocolaty" appearance of the bodies of water, an effect of the long exposures that creates the impression that photographic technology had come to reinforce the myth of the West as a land of milk and honey.

John K. Hillers
Mary's Veil, Bullion Canyon, Utah, 1870s
Albumen print, 33 × 25 cm
Société de Géographie, Paris

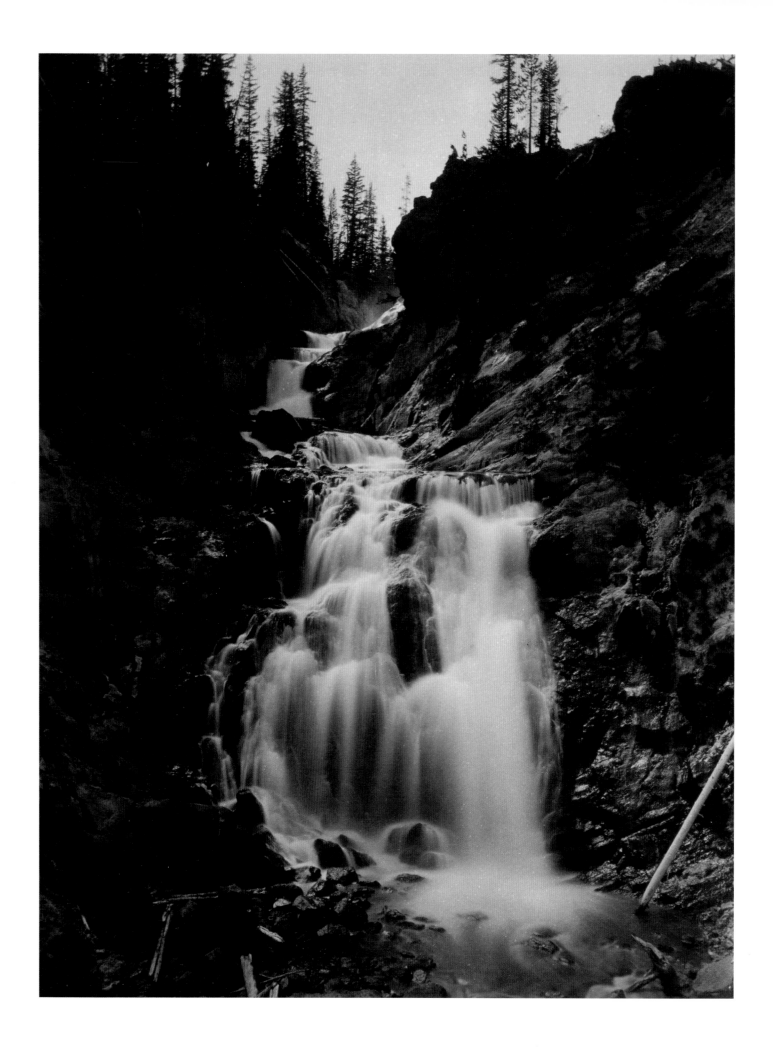

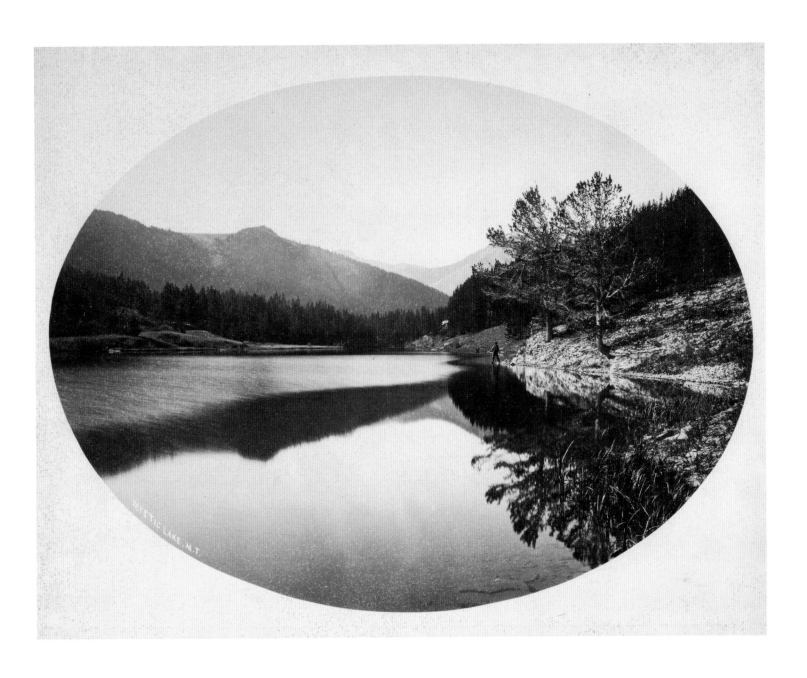

William H. Jackson
Little Firehole Falls, 1870s
Albumen print, 33 × 25 cm
Société de Géographie, Paris

William H. Jackson
Mystic Lake, Montana, c. 1872
Albumen print, 25 × 33 cm
Musée Nicéphore Niépce,
Chalon-sur-Saône

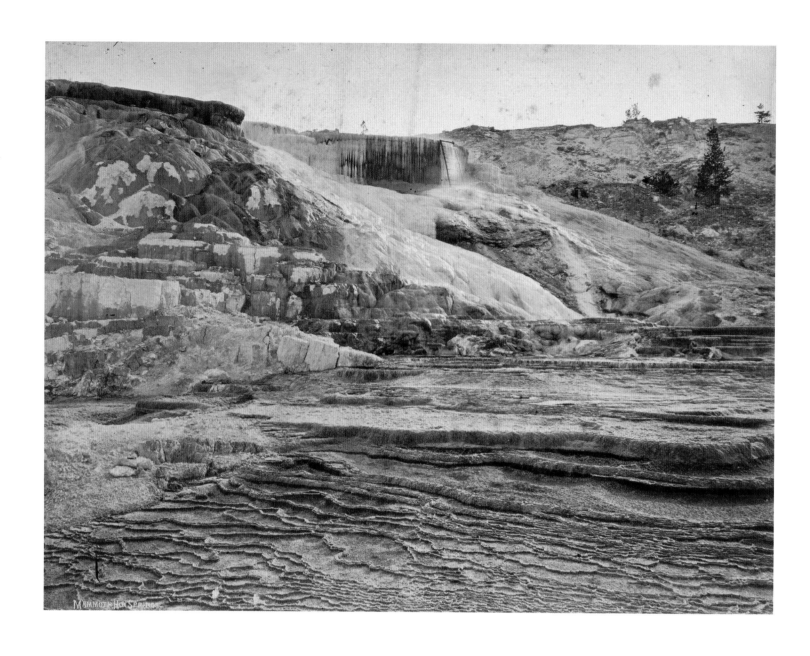

William H. Jackson
Mammoth Hot Springs, c. 1878
Albumen print, 25×33 cm
Société de Géographie, Paris

William Bell
Chocolate Mesa, Rocker Creek, Arizona, 1872
Albumen print, 18×20 cm
Société de Géographie, Paris

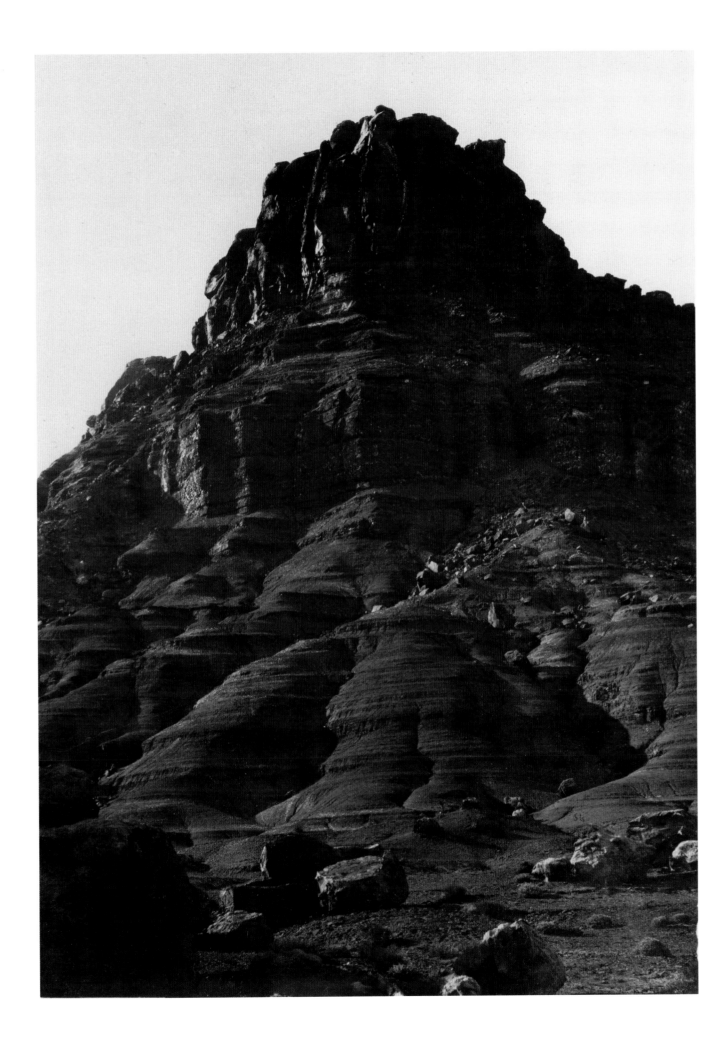

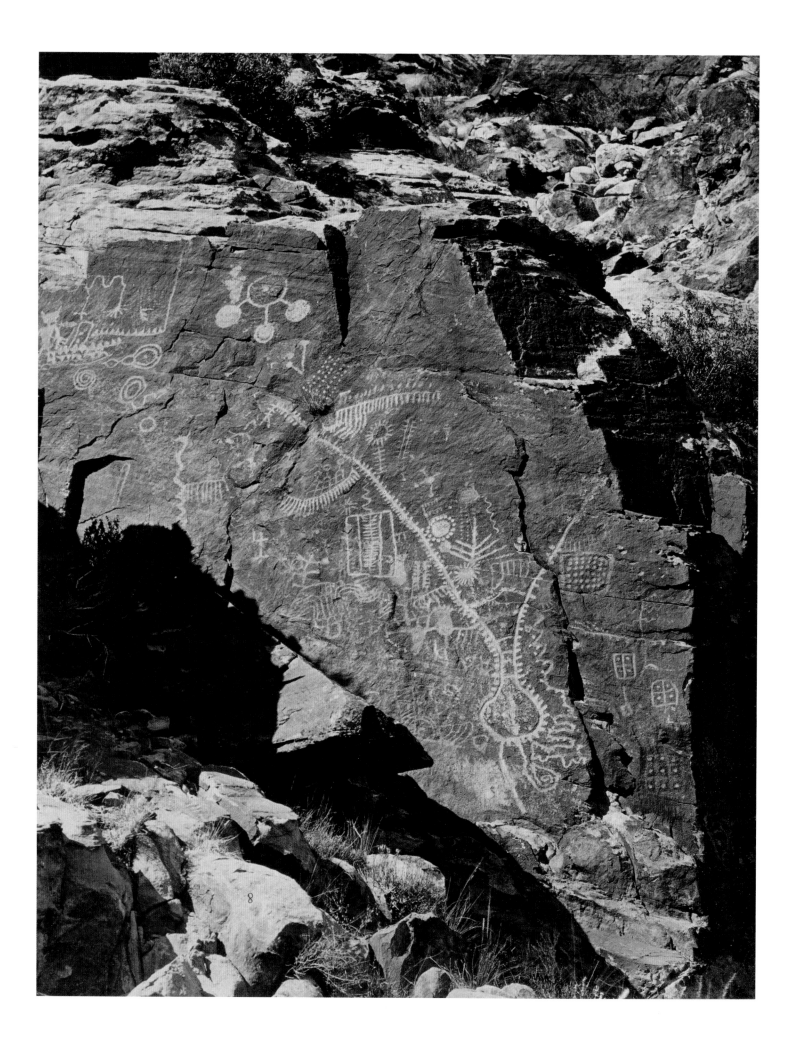

William Bell
Hieroglyphic Pass,
Opposite Parowan, Utah, 1872
Albumen print, 23×18 cm
Société de Géographie, Paris

Timothy H. O'Sullivan
Rock Carved by Drifting Sand, 1871
Albumen print, 20×27.5 cm
Musée d'Orsay, Paris

Timothy H. O'Sullivan
Tertiary Conglomerates, Weber Valley, Utah, 1869
Albumen print, 20 × 28 cm
Société de Géographie, Paris

Timothy H. O'Sullivan
Mauvaises Terres, Washakie Basin, 1872
Albumen print, 20×28 cm
Société de Géographie, Paris

Timothy H. O'Sullivan
Columnar Basalt, Mouth of Grand Wash, 1871
Albumen print, 20×28 cm
Société de Géographie, Paris

Timothy H. O'Sullivan
Opening of Brooklyn Mine,
Pahranaget Lake District, Nevada, 1871
Albumen print, 20×28 cm
Société de Géographie, Paris

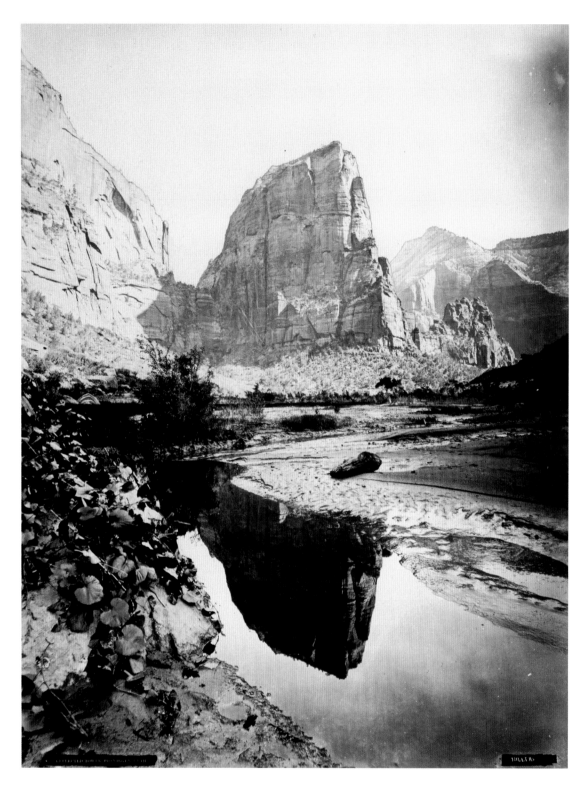

John K. Hillers
Reflected Tower, Rio Virgen, Utah, 1870s
Albumen print, 33×25 cm
Société de Géographie, Paris

John K. Hillers
Shini-Mo Altar, from Brink of Marble Canyon,
Colorado River, Arizona, 1870s
Albumen print, 33×25 cm
Société de Géographie, Paris

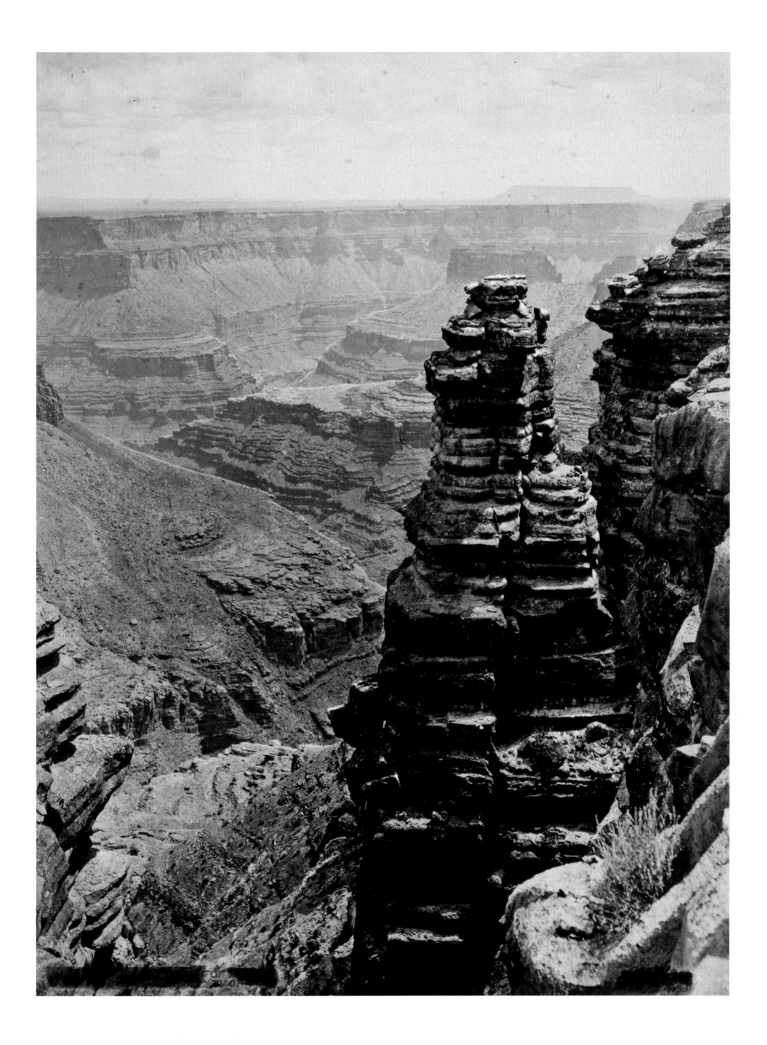

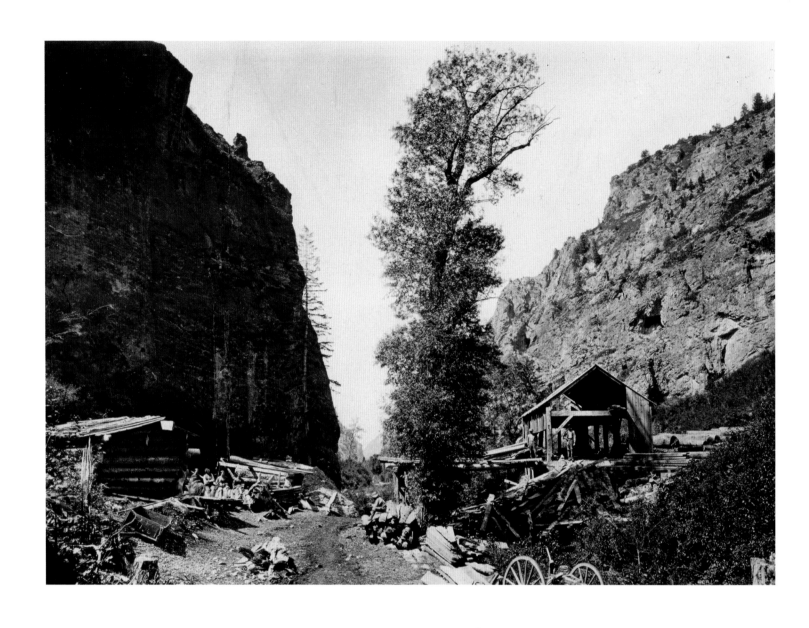

Timothy H. O'Sullivan
Wahsatch Mountains, American Fork Canyon, 1869
Albumen print, 20×28 cm
Société de Géographie, Paris

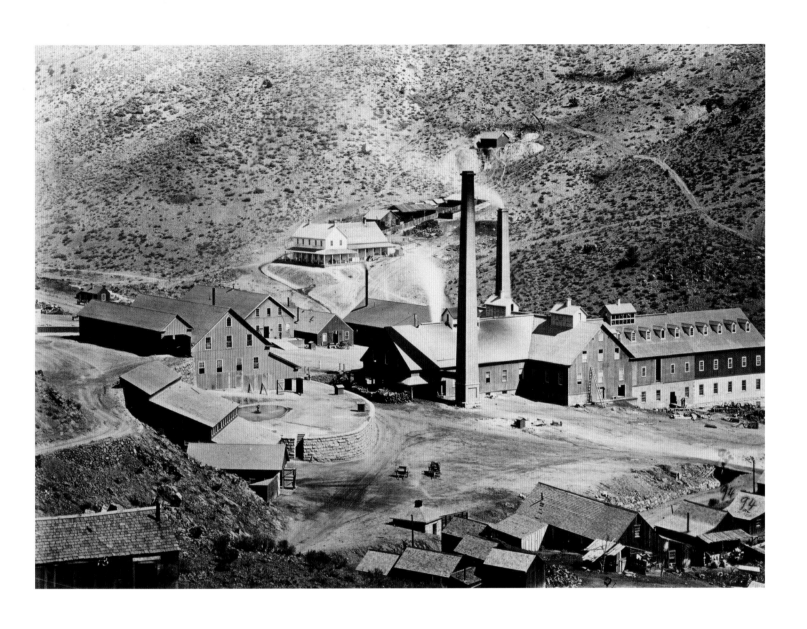

Timothy H. O'Sullivan
Gould & Curry Reduction Works, 1867–68
Albumen print, 20×28 cm
Société de Géographie, Paris

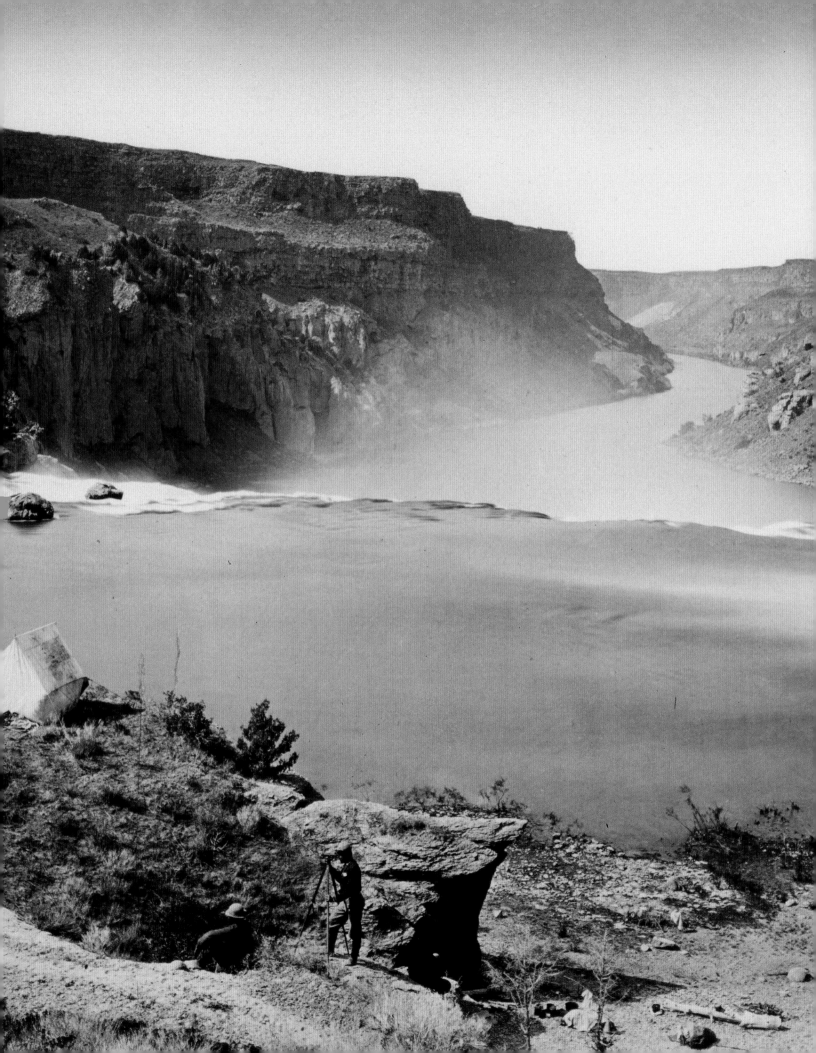

TIMOTHY H. O'SULLIVAN

A Photographer at Work

Timothy H. O'Sullivan is today the most famous and most enigmatic of all the exploration photographers. When he was rediscovered in the 1930s, viewers saw his bare landscapes as an early manifestation of the modernist aesthetic. Since the 1970s that interpretation has been joined by others, the most famous of which detects in these often hostile, unfriendly, and above all rocky landscapes affinities with the fondness of the geologist Clarence King for the Burkian sublime and the theory of geological "catastrophes." Since these speculations are largely impossible to prove in the absence of writings by the photographer, it is only by reading the images themselves that we are able to approach the enigma of O'Sullivan, as Rick Dingus has done, for example, by using the "rephotographic" method to show that O'Sullivan tilted his horizons. His practice also presents no shortage of other peculiarities. Like his colleagues O'Sullivan worked in series, but he did so more systematically, not only realizing panoramas and shot/countershot but also circumambulating sites, as he did at Shoshone Falls for example, where he went for King in 1871 and for Wheeler in 1874 (see cat. p. 94–95). He also varied the lighting of a given site, taking up to six different views in the course of a single day (see cat. p. 96–97).

This dynamic vision of places, which reconstructs their three-dimensionality, is often paired with a narrative dimension. Thus, a number of O'Sullivan's landscapes are inhabited by figures of observers or witnesses, whose potential function as markers of scale pales beside their capacity as lay representatives of the exploration effort or even as metonymies of America in the West. With this practice of inserting "extras" into his images, O'Sullivan demonstrated both a certain sense of humor and a pronounced narcissism, as if he were seeking to compensate for the seriousness and relative anonymity required of the government photographers. Even in the absence of confirmed self-portraits, we still recognize him in many of his images—him, his shadow, or his double (as represented by his assistant or the ostentatious presence of his equipment in the shot)—for example aboard the small boat called *Picture* that the Wheeler survey assigned him for the ascent of the Colorado. Thus, the very archetype of the "documentary" photographer blocked any univocal reading of his work in advance, by inserting into the field of the image markers of its genesis and the labor it involved.

Timothy H. O'Sullivan
Snake River, Below Shoshone Falls (detail), 1868
(cat. p. 94)

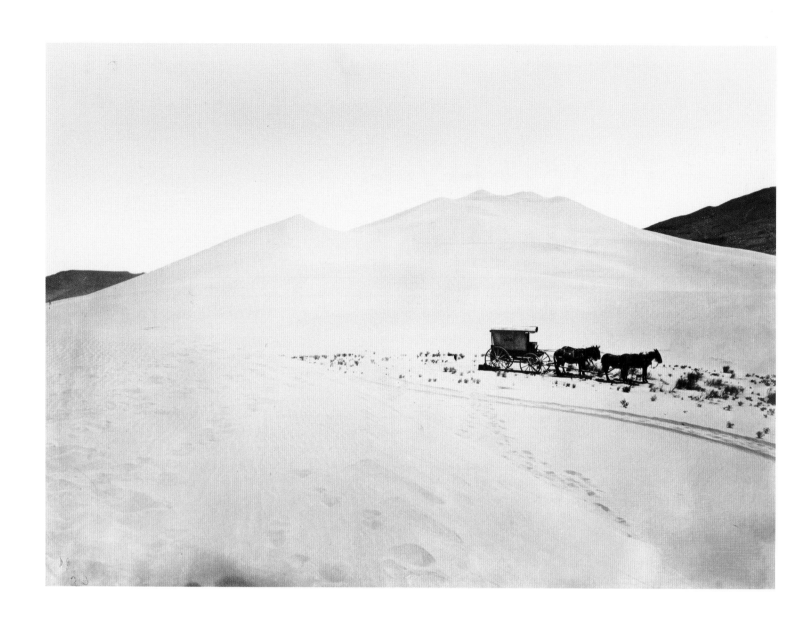

Timothy H. O'Sullivan
Sand Dunes, Carson Desert, Nevada, 1868
Albumen print, 20×28 cm
Société de Géographie, Paris

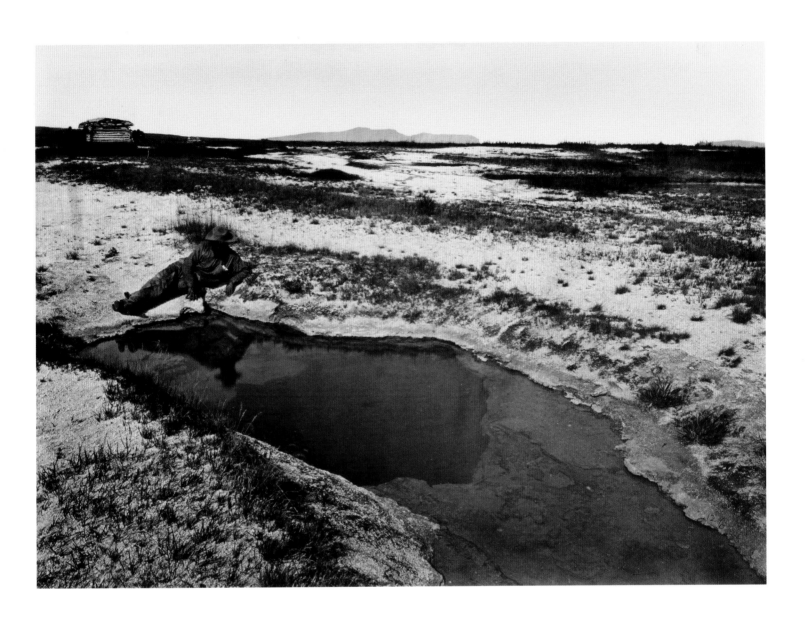

Timothy H. O'Sullivan
Hot Sulphur Spring, Ruby Valley, Nevada, 1868
Albumen print, 20×28 cm
Société de Géographie, Paris

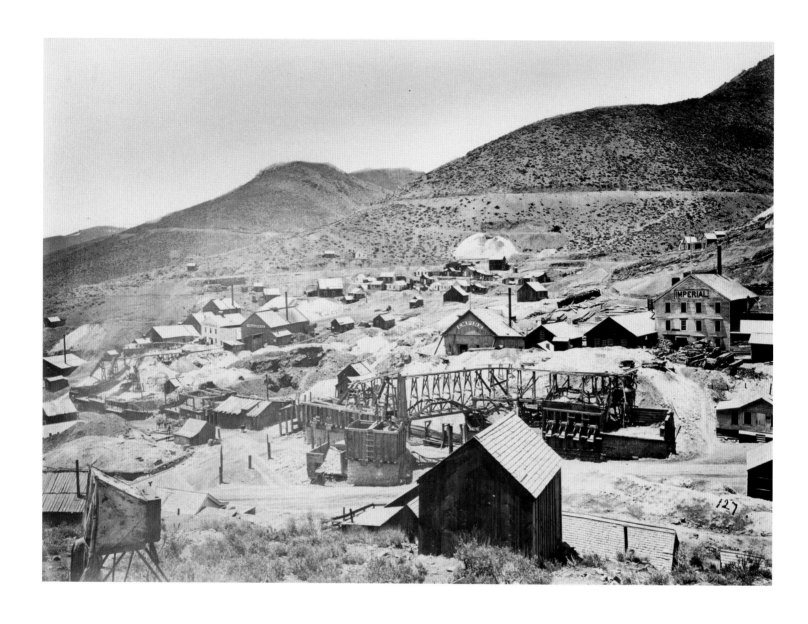

Timothy H. O'Sullivan
Comstock Lode, Gold Hill, 1867–68
Albumen print, 20×28 cm
Société de Géographie, Paris

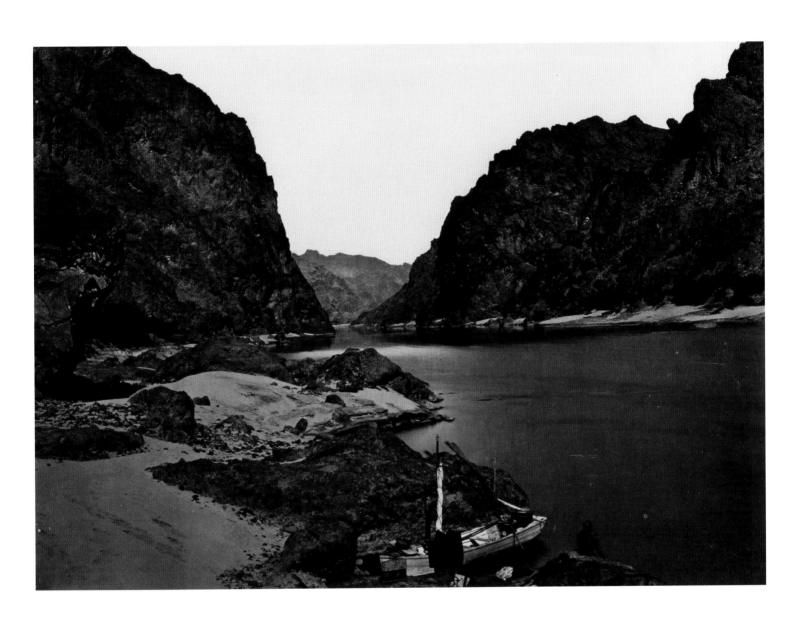

Timothy H. O'Sullivan
Black Canyon, Looking Above from Camp 7, 1871
Albumen print, 20 × 28 cm
Société de Géographie, Paris

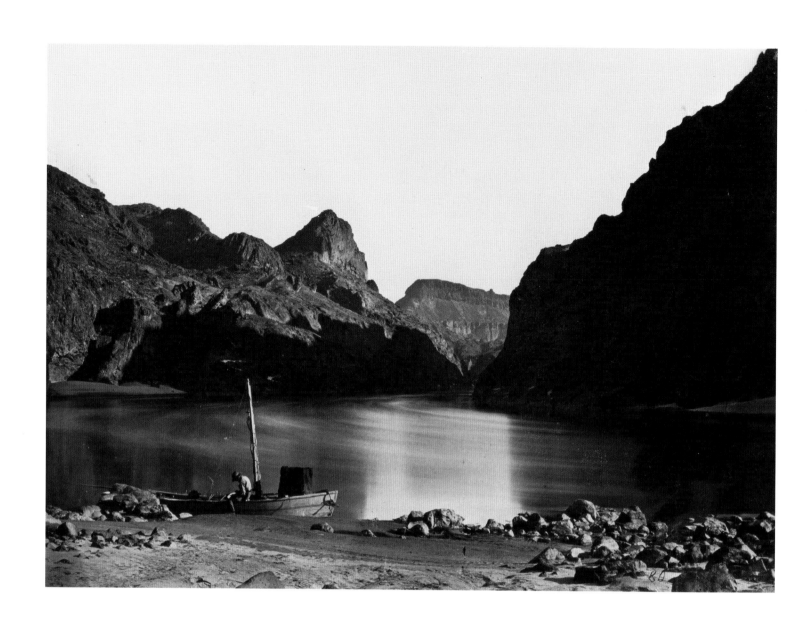

Timothy H. O'Sullivan
Black Canyon, from Camp 8, Looking Above, 1871
Albumen print, 20 × 28 cm
Société de Géographie, Paris

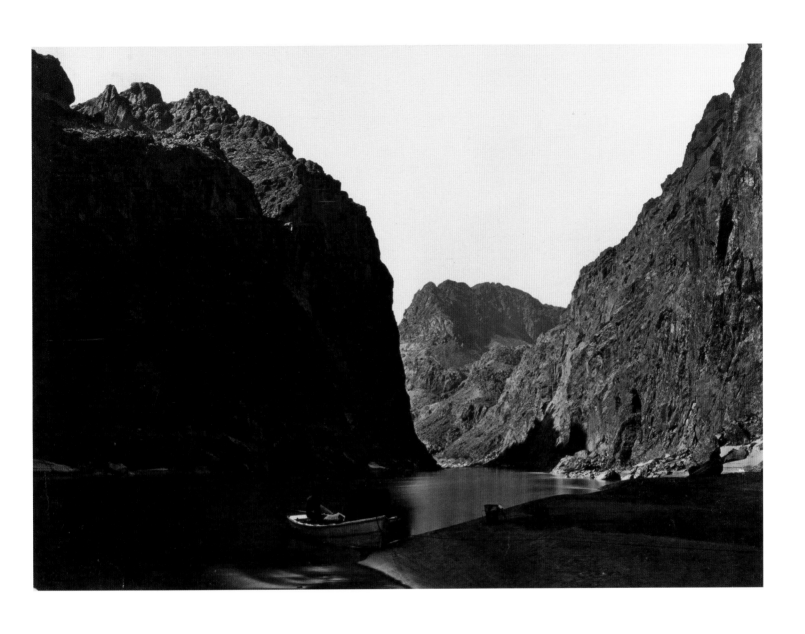

Timothy H. O'Sullivan
Light and Shadow in Black Canyon from Mirror Bar, 1871
Albumen print, 20×28 cm
Société de Géographie, Paris

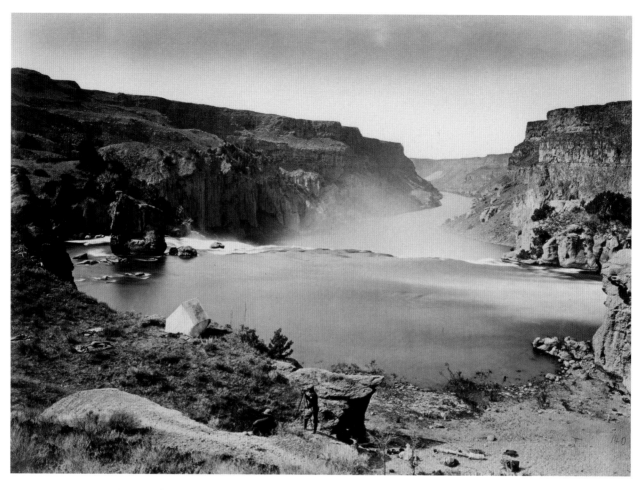

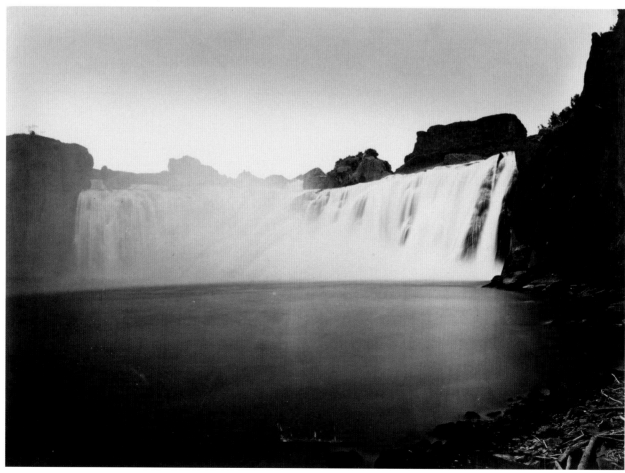

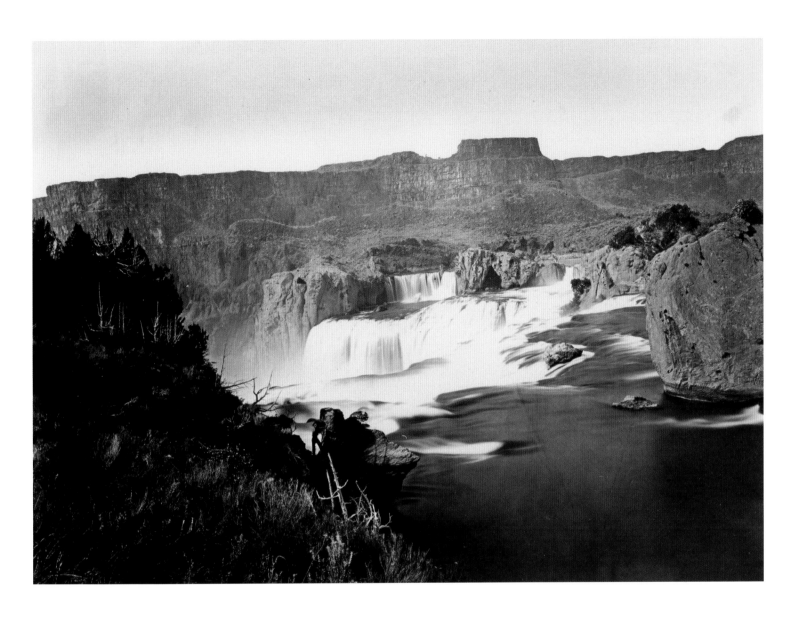

Timothy H. O'Sullivan
*Snake River Canyon, Looking
over edge of Falls,* 1868
(viewpoint 1)
Albumen print, 20 × 28 cm
Société de Géographie, Paris

Timothy H. O'Sullivan
Shoshone Falls, from Below, 1868
(viewpoint 2)
Albumen print, 20 × 28 cm
Société de Géographie, Paris

Timothy H. O'Sullivan
Shoshone Falls, Snake River–210 Feet, 1868
(viewpoint 3)
Albumen print, 20 × 28 cm
Société de Géographie, Paris

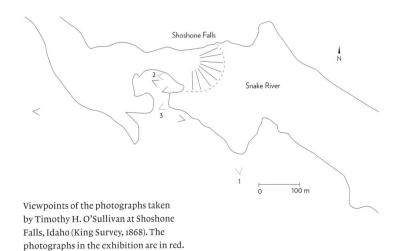

Viewpoints of the photographs taken
by Timothy H. O'Sullivan at Shoshone
Falls, Idaho (King Survey, 1868). The
photographs in the exhibition are in red.

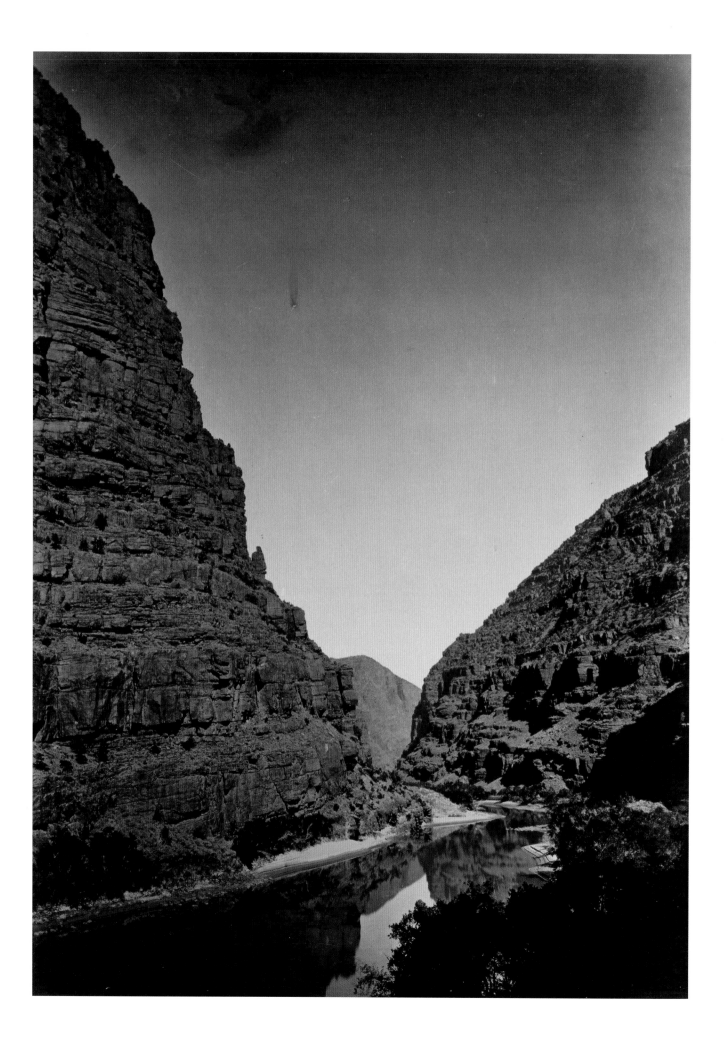

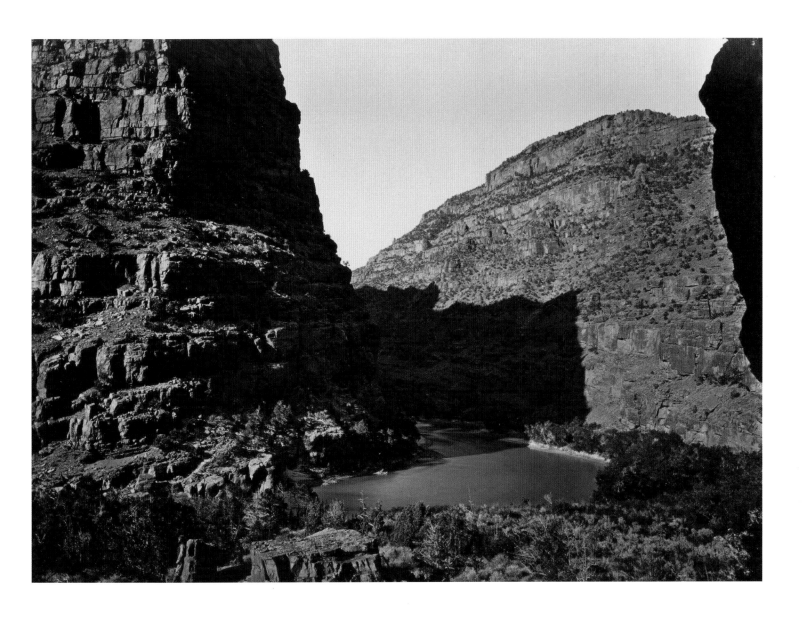

Timothy H. O'Sullivan
Grand Canyon Bottom, Morning, 1872
Albumen print, 28×20 cm
Société de Géographie, Paris

Timothy H. O'Sullivan
Grand Canyon Bottom, Afternoon, 1872
Albumen print, 20×28 cm
Société de Géographie, Paris

IMAGES OF NATIVE AMERICANS

The common perception of a dichotomy between landscapes and faces within the corpus of exploration is not entirely unjustified. Most of the portraits exhibited in this section are products of the practice of "delegation photography," which had its setting in the Washington studios of James McClees, Alexander Gardner, and Antonio Zeno Shindler and thus sanctioned the uprooting of the representatives of the Indian nations from their living environments. While the neutral backgrounds of these portraits attest to their documentary intention, the overabundance of costumes, headdresses, and other accessories indicates the desire to signify an "Indianness" ultimately intended for the museum. It is above all these images—much more testamentary than exploratory—that stimulated the curiosity of the French Americanists. In the same way, the surveys generally avoided combining the exploration of physical spaces with ethnographic observation, as if "Indians" and "landscapes" were two a priori distinct and mutually exclusive categories. Of the four "great surveys," one (the King survey) virtually never photographed the Indians, while another (the Hayden survey)—concerned to offer a welcoming image of the West—more often than not only did so under conditions approaching those of the studio portrait. Nevertheless, there are enough in situ images to support the claim that the explorers were conscious of the bond, however precarious, that existed between populations and territories. The Wheeler survey, which was military in character, seems to have wished to emphasize an at least potential hostility, as in this astonishing confrontation conceived by Timothy H. O'Sullivan, in which the city-dwelling viewer could enjoy the illusion of a dangerous face-to-face encounter with an Apache. This rhetoric served the army's propaganda while also falling in line with a more global "documentary" intention that assigned "the Indian" to the category of antiquity and the picturesque. The only one of the surveys to depart, at least to some extent, from this logic is that of Major Powell, whose photographer, John K. Hillers, embraced his employer's growing compassion for the fate of the tribes of the Southwest. He photographed them in several hundred images, which, however, are affected as well and often treated in a paternalistic and voyeuristic manner. Powell was the only explorer in the 1870s who articulated a realistic vision of the future of the arid Southwest and its native populations. While Hillers's magnificent reports on the pueblos of Arizona and New Mexico, which helped to popularize places like Taos, are generally empty of inhabitants, they reveal an awareness of the richness of the civilizations that were in the process of being swallowed up by conquest.

Timothy H. O'Sullivan
View on Apache Lake, Sierra Blanca Range, Arizona.
Two Apache Scouts in the Foreground, 1873
Albumen print, 28 × 20 cm
Société de Géographie, Paris

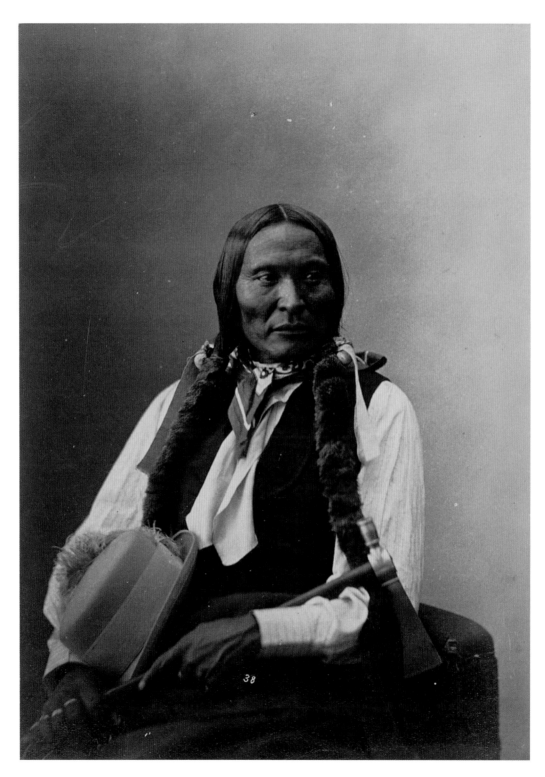

Alexander Gardner
Black Crow, Arapaho, 1860–76
Albumen print, 18.5×13.5 cm
Musée du Quai Branly, Paris.
Gift of Laboratoire d'Anthropologie
du Muséum and Alphonse Pinart

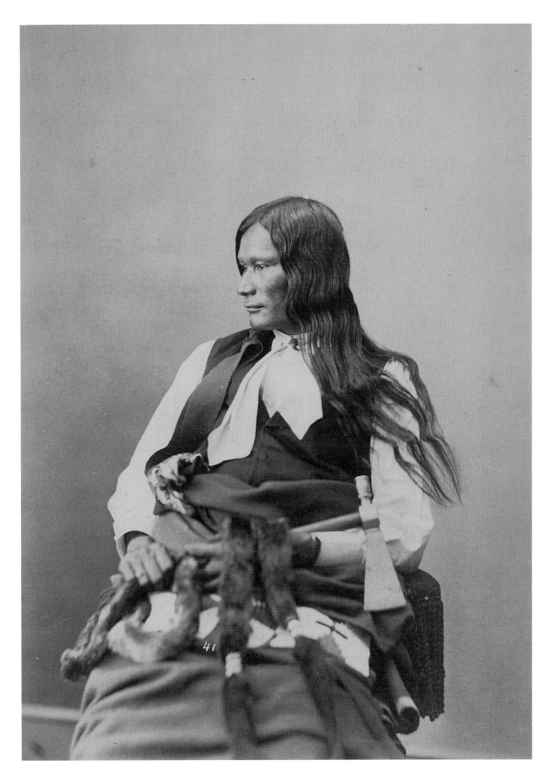

Alexander Gardner
*Chef arapaho du Sud** [*Southern Arapaho Chief*], 1869
Albumen print, 18.5×13.5 cm
Musée du Quai Branly, Paris. Gift of Laboratoire
d'Anthropologie du Muséum and Alphonse Pinart

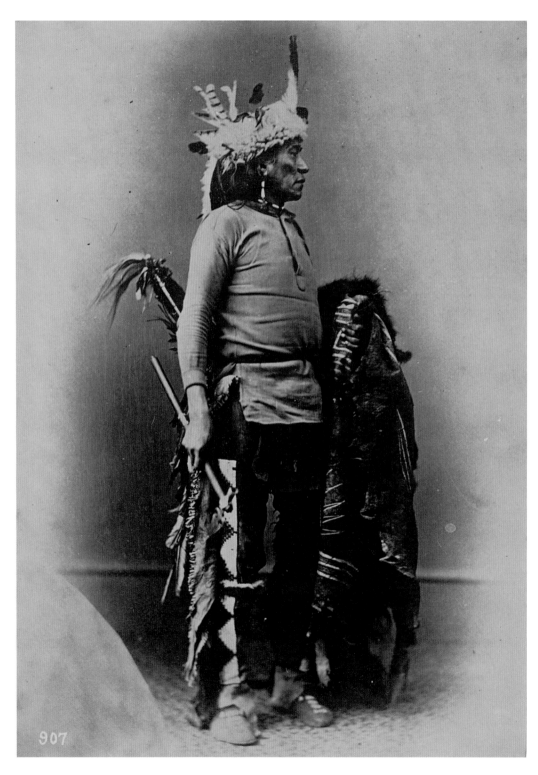

907

Alexander Gardner
Long Foot, Yankton, Dakota, 1867
Albumen print, 18.3×13.3 cm
Musée du Quai Branly, Paris. Gift of Laboratoire
d'Anthropologie du Muséum and Alphonse Pinart

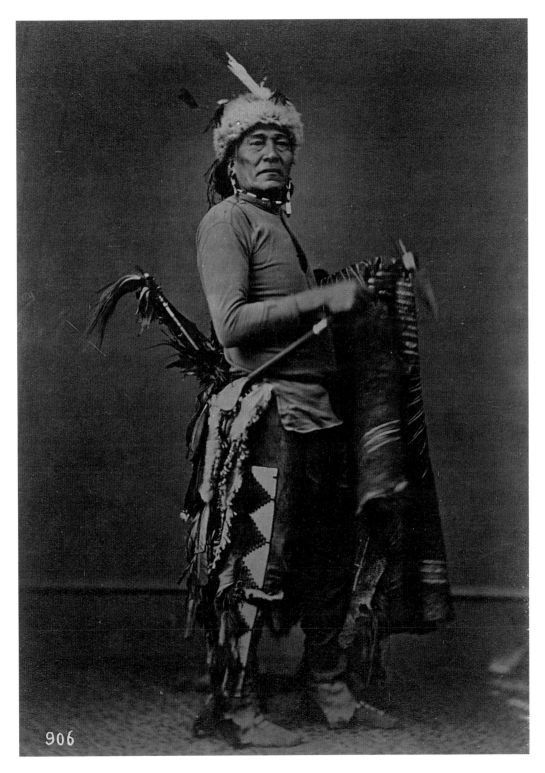

Alexander Gardner
Long Foot, Yankton, Dakota, 1867
Albumen print, 18.3×13.3 cm
Musée du Quai Branly, Paris. Gift of Laboratoire
d'Anthropologie du Muséum and Alphonse Pinart

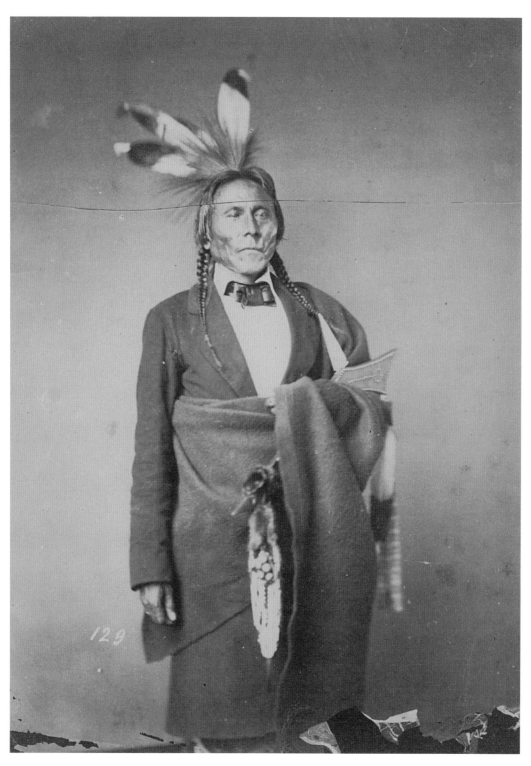

Antonio Zeno Shindler
Hin-han-du-ta, "Red Owl," Arapaho, 1860–76
Albumen print, 18.5×13.5 cm
Musée du Quai Branly, Paris. Gift of Laboratoire
d'Anthropologie du Muséum and Alphonse Pinart

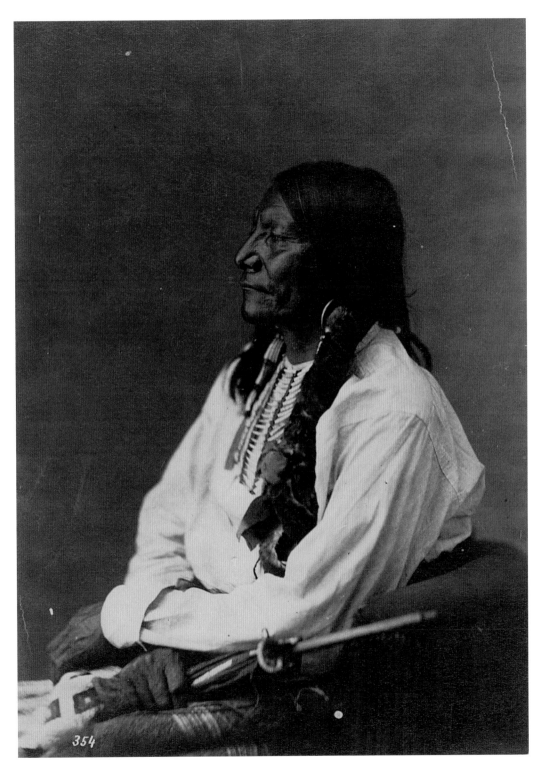

Alexander Gardner
He-gma-wa-ku-wa, "One Who Runs the Tiger," North Dakota, 1872
Albumen print, 18.5×13.5 cm
Musée du Quai Branly, Paris. Gift of Laboratoire
d'Anthropologie du Muséum and Alphonse Pinart

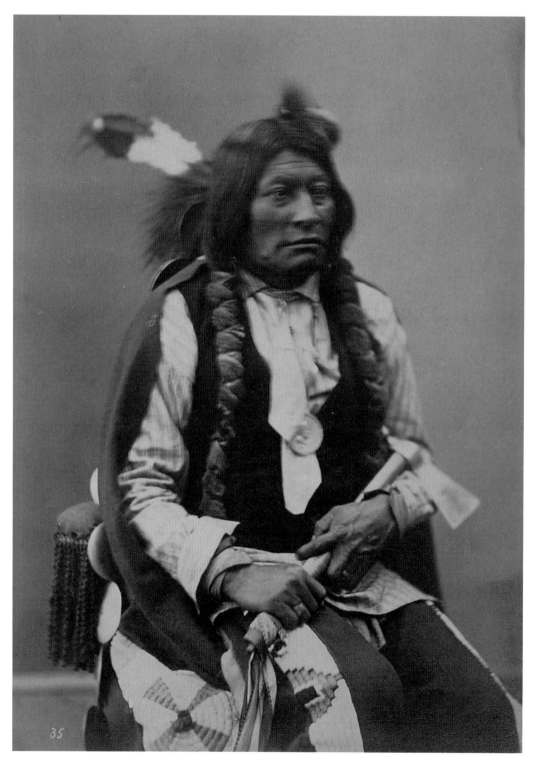

Antonio Zeno Shindler
Indian Type, 1860–69
Albumen print, 18.4×13.2 cm
Musée du Quai Branly, Paris. Gift of Laboratoire
d'Anthropologie du Muséum and Alphonse Pinart

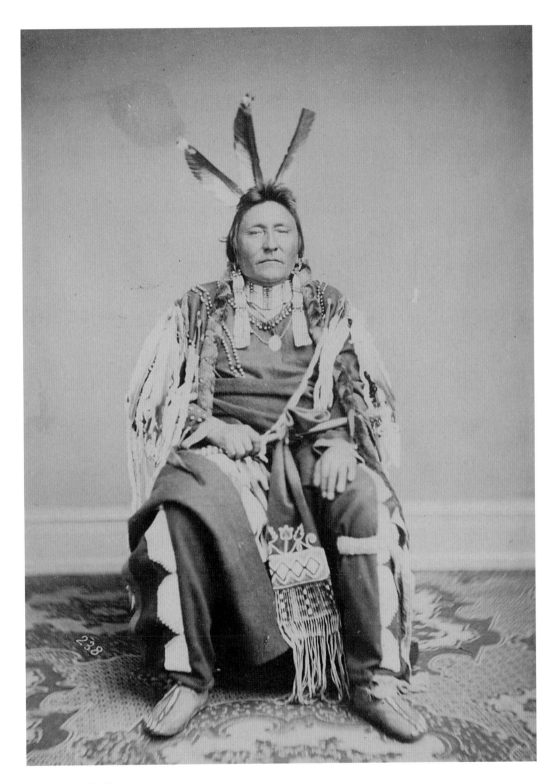

Antonio Zeno Shindler
Se-tan-si-tan, "Yellow Hawk," Sans Arc Chief, Dakota, 1860–69
Albumen print, 18×13 cm
Musée du Quai Branly, Paris. Gift of Laboratoire
d'Anthropologie du Muséum and Alphonse Pinart

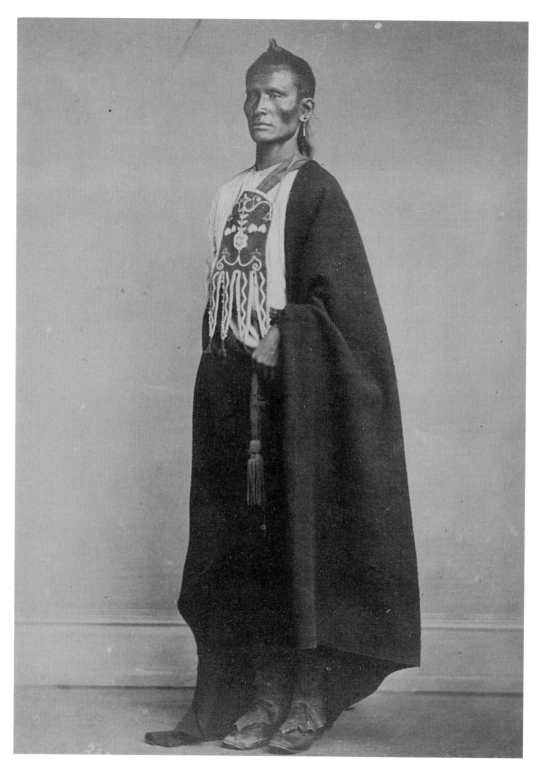

Antonio Zeno Shindler
Wa-jin-ka, "Little Bird," Yankton Sioux Brave, Dakota, 1868–69
Albumen print, 18.4×13.2 cm
Musée du Quai Branly, Paris. Gift of Laboratoire
d'Anthropologie du Muséum and Alphonse Pinart

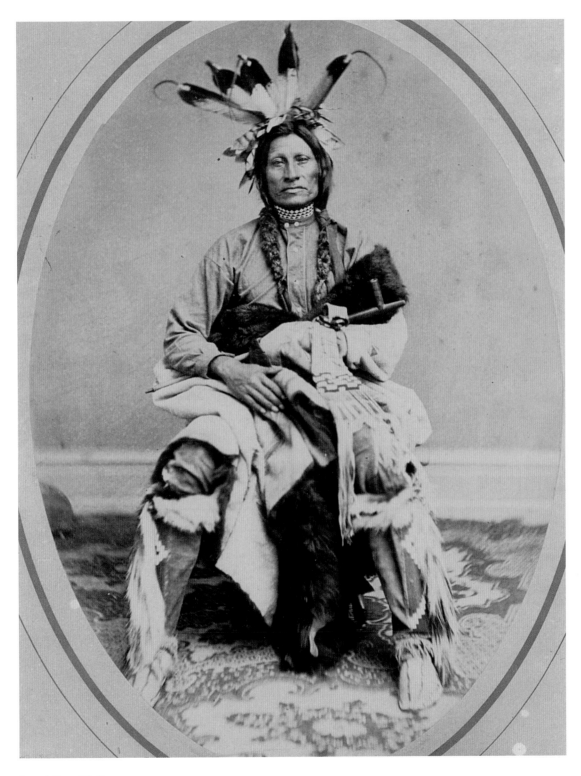

Antonio Zeno Shindler
Psi-ca-na-kin-yan, "Jumping Thunder," Yankton Sioux Chief, Dakota, 1868–69
Albumen print, 18×14.3 cm
Musée du Quai Branly, Paris. Gift of Laboratoire
d'Anthropologie du Muséum and Alphonse Pinart

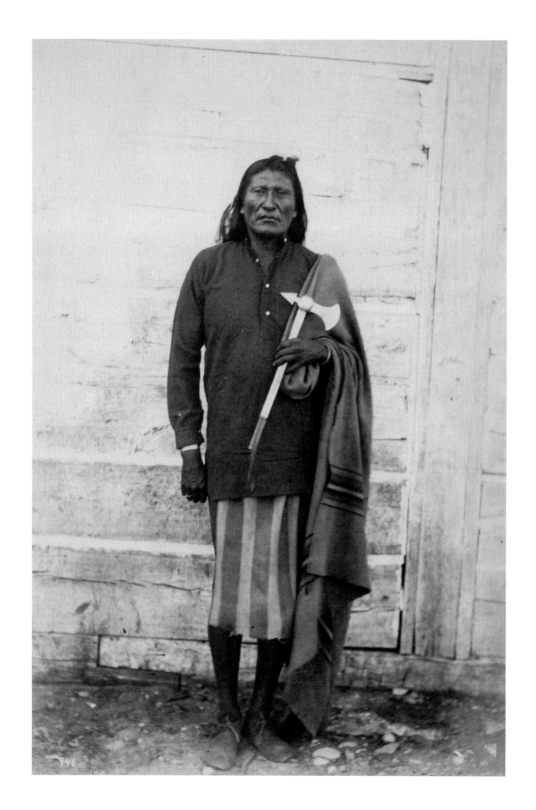

William H. Jackson
Kam-ne-but-se, "Black Foot," 1871
Albumen print, 20.7×13.8 cm
Musée d'Orsay, Paris

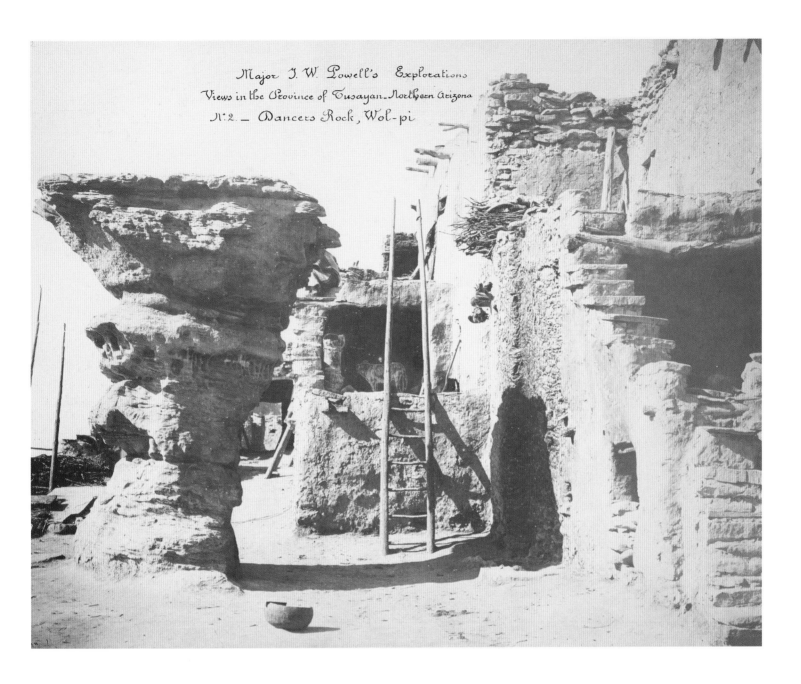

Major J. W. Powell's Explorations
Views in the Province of Tusayan - Northern Arizona
N.º 2. — Dancers Rock, Wol-pi

VILLAGES

John K. Hillers
Dancers Rock, Walpi, c. 1876
Albumen print, 42.5 × 53.3 cm
Société de Géographie, Paris

John K. Hillers
Pueblo de San Juan, New Mexico, 1879–80
Albumen print, 25×33 cm
Société de Géographie, Paris

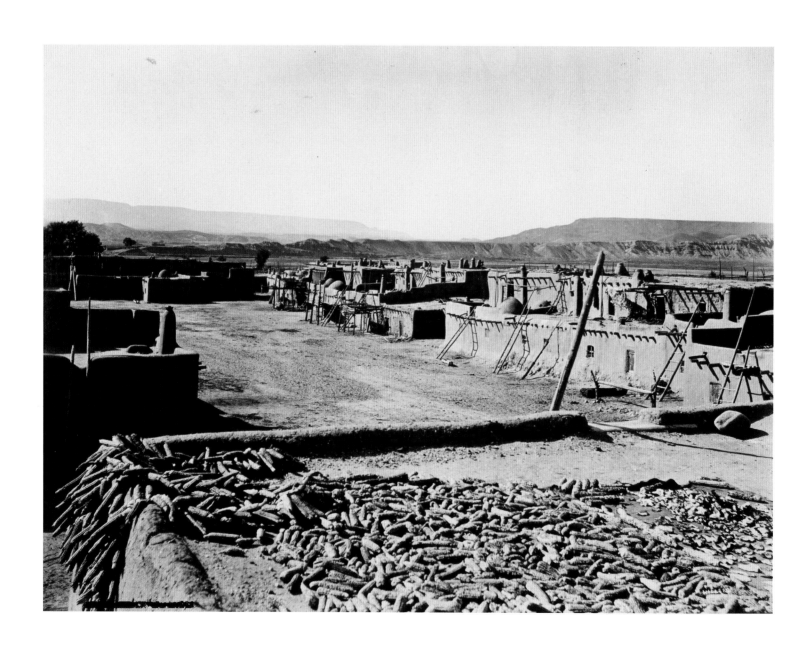

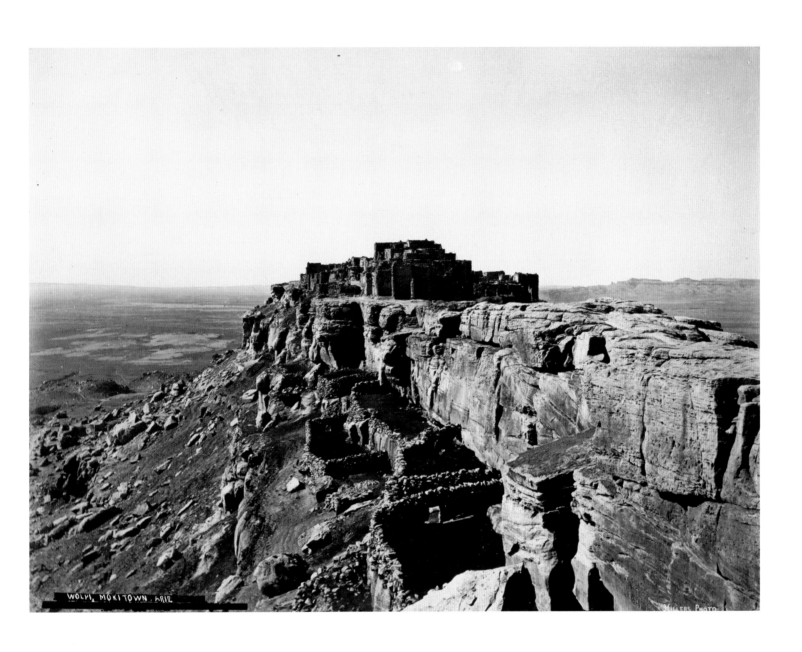

John K. Hillers
Walpi, Moqui Town, Arizona, 1879–80
Albumen print, 25×33 cm
Société de Géographie, Paris

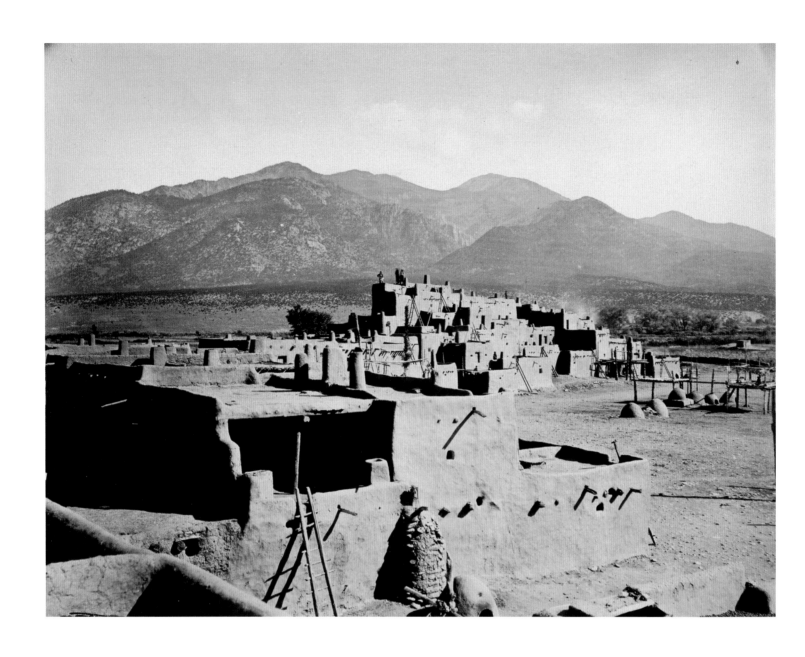

John K. Hillers
Pueblo de Taos, New Mexico, 1879–80
Albumen print, 25×33 cm
Société de Géographie, Paris

Timothy H. O'Sullivan
*Aboriginal Life Among the Navajo Indians,
near Old Fort Defiance, Arizona*, 1873
Albumen print, 28×20 cm
Société de Géographie, Paris

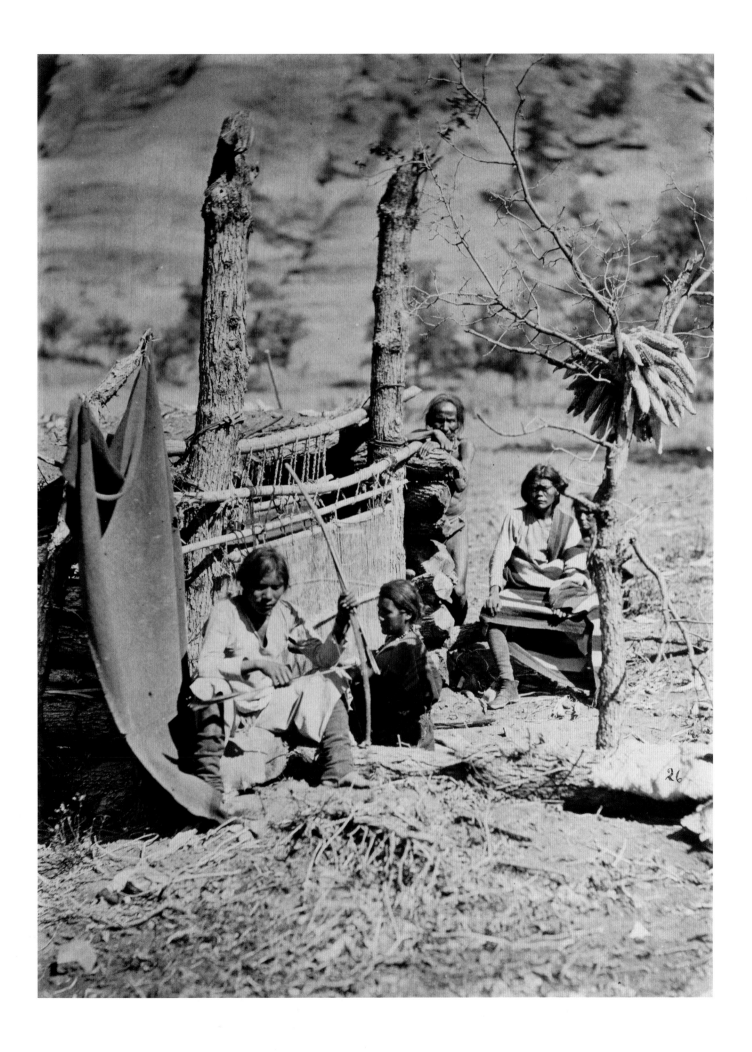

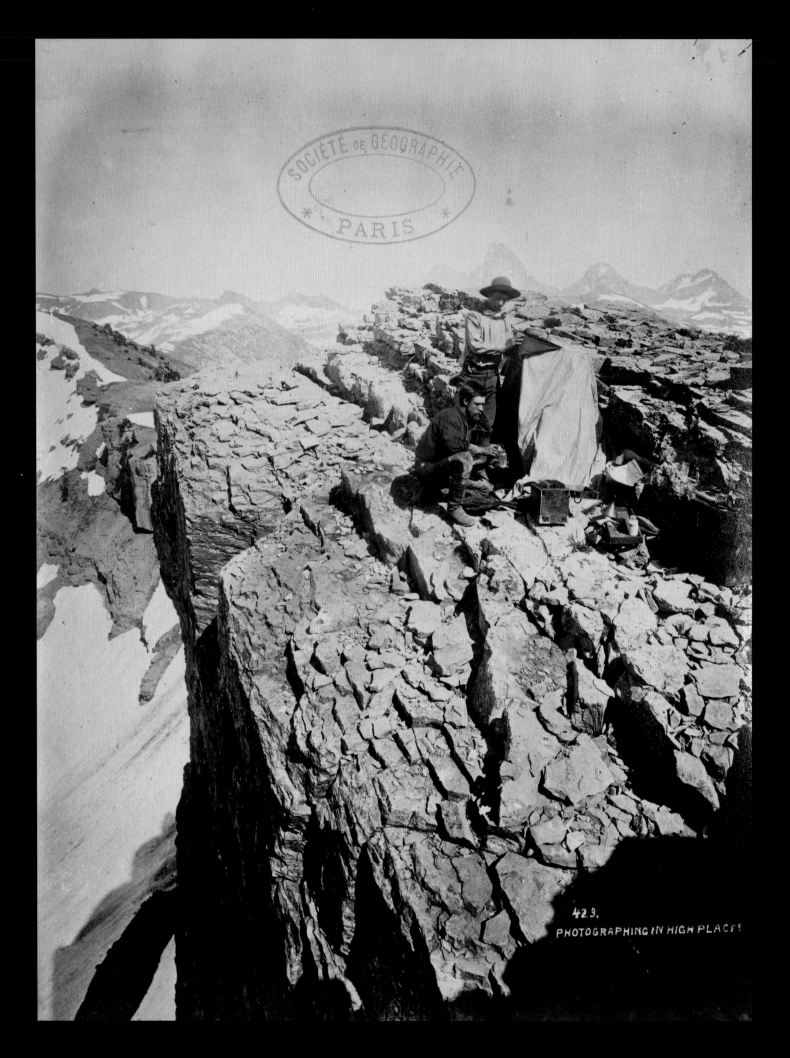

42.3.
PHOTOGRAPHING IN HIGH PLACES

APPENDIX

William H. Jackson
"Photographing in High Places" in *Photographs
of the Principal Points of Interest in Colorado, Wyoming,
Utah, Idaho, and Montana from Negatives Taken in 1869,
'70, '71, '72, '73, '74 and '75* (Washington, D.C.:
Department of the Interior, United States Geological
Survey of the Territories, 1876), cat. 423, [169]
Société de Géographie, Paris

BIOGRAPHIES

William Bell
(1830–1910)

Often confused with his contemporary William A. Bell, a doctor and photographer who also took part in an expedition to the West, William Bell is the great unknown among the exploration photographers. Born in Liverpool, England in 1830, he began his career as a photographer in Philadelphia around 1850. He participated in the Civil War as a member of a cavalry regiment. Beginning in 1863 he took photographs of wounds and mutilations that formed the core of the collection of the Army Medical Museum, becoming the museum's chief photographer after the war. In 1867, while his namesake was taking part in a reconnaissance in the West on behalf of the Union Pacific Railroad, Bell purchased the studio of James E. McClees in Philadelphia. He may have been in the West as early as 1868. In 1872 he was hired as a photographer by George M. Wheeler to replace Timothy H. O'Sullivan, who had joined the King expedition. It is in the course of this survey, which focused primarily on Arizona, that he took numerous images of the Grand Canyon of the Colorado River—often breathtaking vertical views—and a few portraits of Paiute Indians. In 1882 he joined an expedition to Patagonia to photograph the transit of the planet Venus. Although his photographic career was fairly modest, Bell left behind an important account of exploration photography, published in the *Philadelphia Photographer* in 1873. Since the 1970s, his work, which was long overshadowed by that of O'Sullivan, has been included in a growing number of exhibitions.

Alexander Gardner
(1821–1882)

Born in Glasgow, Scotland, Gardner emigrated to the United States in 1856—having already trained as a journalist and photographer—and joined Mathew B. Brady's studio in New York, for which he took celebrated portraits of Abraham Lincoln. Together with Brady he covered the Civil War but soon refused to allow his work to be published under Brady's name and left him to create a competing firm with Timothy H. O'Sullivan. This dispute, which was one of the first concrete manifestations of the emergence of a copyright for photographs in the United States, led him to adopt a more direct reporting style, reflected in his famous *Gardner's Photographic Sketchbook of the Civil War* (1866). After the war he left for the West and in 1867 became the official photographer and propagandist for one of the branches of the Union Pacific Railway, which published several illustrated albums of his images. In 1868 he served as the official witness to the negotiations between the Plains Indians and the American government in Fort Laramie. Since the late 1850s he had also begun to photograph the Indian delegations on their visits to Washington, and in 1867 he resumed this practice at the instigation of the patron William H. Blackmore. His extremely numerous Indian portraits, which often display a high degree of formal elegance, are largely unknown today, while his views of the building of the railroad, less successful than those of his colleagues, are rarely exhibited.

John Karl ("Jack") Hillers
(1843–1925)

A native of Hanover, Germany and a typical example of the self-taught photographer, John K. Hillers is still underappreciated today by the museography of exploration, despite the fact that his photographic work is enormous. After serving in the army, in 1871 he joined the Powell expedition as an oarsman during the descent of the Colorado. There he learned photography from Elias O. Beaman and James Fennemore, who were briefly employed by Powell, and went on to become the expedition's photographer in 1872. From 1872 to 1879 he shot several thousand photographs for the Powell survey, images of the canyons and plateaus of the Colorado and the native populations of the Southwest (Ute, Navajo, and Hopi). Like his colleagues on the Powell survey, he kept extremely detailed journals that provide extensive information on the conditions of exploration photography and his friendly ties with several groups of Ute and Hopi Indians, who gave him the name "Myself in the Water," a reference to photography as a mirror. Like Timothy H. O'Sullivan and William H. Jackson, Hillers spent a lot of time producing and distributing prints, especially stereographic ones, as well as preparing the Philadelphia Centennial Exhibition in 1876. Thanks to Powell, in 1879–80 he became the chief photographer of the Bureau of Ethnology and the United States Geological Survey, a dual

post that he continued to occupy until his death. Virtually a state employee in the field of geographic and anthropological photography, Hillers is the author of a large number of very high-quality images, which have yet to receive the attention they deserve.

William Henry Jackson
(1843–1942)

The best-known of the exploration photographers and one of the very few to have been born in the United States (in Keeseville, New York), William H. Jackson claimed to be a descendant of "Uncle Sam" in his autobiography, which, in its most complete version (*Time Exposure*, 1940), retraces a career that lasted nearly a century. Trained as an artist (a watercolorist), he learned photography before 1860 but served in the Union Army as a painter. After the war he left to seek his fortune in the West and opened a studio in Omaha, Nebraska with his brother, going on to take several thousand photographs for the Union Pacific Railroad in 1868–69. In 1870 he became the photographer for the Hayden survey, for which he produced several thousand negatives and tens of thousands of prints until 1878. His public renown began with the creation of Yellowstone National Park, which was associated with the dissemination of his images. Between 1873 and 1878 Jackson was the linchpin of the remarkable system of distributing images identified with the Hayden survey, which involved the creation of two detailed catalogues of photographs, one of landscapes, the other of Indian portraits. Well aware of the "show" character of his work as a photo-explorer (even as he carried documentary rigor to considerable lengths), Jackson was not unhappy to leave the survey and resume—together with his negatives, to which he had retained the rights—a business career that was fueled by his fame. Settling in Denver, he worked for several western and southwestern railroad companies. Along with his collection of images, he then joined the Detroit Publishing Company, the first big American company for the distribution of views (especially photochromes) and postcards. After a stint as the official photographer of the Columbian Exposition of 1893 in Chicago, Jackson traveled the world and finally became a tremendously prolific writer of memoirs of the West and early photography. In the 1920s and 1930s, having become a legend and the darling of Washington dinner parties, Jackson had the privilege of seeing his photographic work exhibited at the Museum of Modern Art in New York, which makes him a unique link between photography's first and second centuries. His exceptional productiveness as a photographer and author, coupled with the often spectacular style of his images, explains the profusion of exhibitions and publications devoted to his work.

Andrew Joseph Russell
(1829-1902)

A native of Walpole, New Hampshire who trained as a painter and served as an infantry captain in the Civil War, Andrew J. Russell was the first officer photographer and the official photographer of the army's railroads and structures. In 1868 he became an employee of the Union Pacific Railroad, for which he took several hundred views of the building of the transcontinental line up to and including the ceremony of the "Wedding of the Rails" in May 1869. Beginning in 1868 he published these images commercially as well as in a deluxe album that appeared under the aegis of the railroad (*The Great West Illustrated*, 1869). A portion of his negatives was then purchased by Ferdinand V. Hayden, who republished them in *Sun Pictures of Rocky Mountain Scenery* (1870), a lesser-quality book that was widely distributed. It appears that he may also have briefly collaborated with the King survey in Utah. Back in New York after 1870, Russell became the staff photographer for the magazine *Frank Leslie's Illustrated Newspaper*, for which reason he is generally regarded as the first American photoreporter. While continuing to sell his earlier images, he remained in this post until after 1890. Of special interest by virtue of his illustration of the building of the West and the "technological sublime" and highly prized by collectors, his work remains underappreciated in the museum world.

Antonio Zeno Shindler
(1823–1899)

Still little-known despite the in-depth research of Paula Fleming, Shindler was of Bulgarian or Romanian extraction and was born Antonio Zeno—he fled a threat of clan vengeance and took the patronymic of a French benefactor who was also a lover of art. Beginning in 1852 he is attested as a painter and draftsman in Philadelphia, where he exhibited regularly until 1863. Around 1867 he settled in Washington as a photographer—he opened a gallery there, in which he photographed the Indian delegations, and became a partner of William H. Blackmore and the Smithsonian Institution's planned Indian exhibition. Blackmore entrusted him with several hundred portraits from his collection for purposes of reproduction and frequently complained about the slow pace of his work. But Shindler was busy with several projects at once—preparing the catalogue of the Smithsonian's Indian photographs and the exhibition of 1869 (reconstructed by Paula Fleming in 2003) and perhaps also a planned exhibition of George Catlin's Indian paintings. After 1870—a period in which, according to some sources, he accompanied one of Hayden's expeditions—he began to produce oil paintings of some photographic portraits. He went on to hold various jobs before returning to work at the Smithsonian in 1876 as a copyist and colorer of plaster

casts of various species of fish, snakes, etc., an exercise in which he enjoyed a certain degree of success, which enabled him to remain an employee of the Smithsonian "Castle" until his accidental death in 1899.

Timothy H. O'Sullivan
(1840–1882)

The biography of the most important of the exploration photographers is incomplete, since Timothy H. O'Sullivan left almost no writings or verifiable images of himself. Born in Ireland (or according to some sources in New York), he learned photography from Mathew B. Brady and was employed by him during the Civil War, before leaving him in 1863 to work with Alexander Gardner. During the war he took several hundred photographs of camp scenes, equipment, fortifications, and battlefields (including the famous images of corpses at Gettysburg in 1863), while also reproducing documents and maps for the Army of the Potomac. Beginning in 1867 he was almost continuously employed by the federal government—especially the War Department—as a photographer for the King (1867–69, 1872) and Wheeler (1871, 1873–74) surveys as well as the Selfridge survey in Central America (1870). As a member of these various surveys, and often under extremely harsh conditions, he practiced wet-collodion photography on very large glass plates as well as in the stereo format, producing several hundred views of the mountainous West and the Southwest. After 1874 he continued to work for the surveys, realizing thousands of prints for distribution together with his brother-in-law, William R. Pywell. Thanks to his reputation, he was appointed a photographer for the Treasury Department in 1880, thus making him a quasi-federal government employee throughout his entire career. He died prematurely at the age of forty-two, leaving behind a corpus of several thousand photographs that is regarded today as one of the three or four major works of the American nineteenth century. The only textual source that sheds a small amount of light on his point of view as an exploration photographer is an article published in *Harper's Monthly* in 1869, whose author quotes the photographer's remarks on the pleasures and perils of "viewing" without referring to him by name.

Carleton Emmons Watkins
(1829–1916)

Regarded today as the greatest landscape photographer of the century, Carleton E. Watkins was a self-taught independent entrepreneur and only rarely directly employed by the explorers. Born in Oneonta in New York State, he left for California shortly after the Gold Rush and, beginning in 1854, learned photography at the gallery of the San Francisco daguerreotypist Robert Vance. Having switched to photography on glass, in 1858 he opened his own gallery (Watkins's Yosemite Art Gallery), which reflected his already pronounced artistic ambitions, while earning his living as an expert in real-estate disputes. Beginning in 1860–61 he devoted himself to the illustration of Yosemite Valley, which he played a substantial role in making known together with a few other operators, including Charles L. Weed and later Eadweard J. Muybridge. His "mammoth"-format and stereoscopic views traveled round the world and earned him a bronze medal at the Paris Universal Exposition in 1867. Having met the members of the California Geological Survey in the circle of John C. Frémont, whose Mariposa estate he photographed, Watkins entered into partnership with them on a contract basis from 1864 to 1869, first selling images to Josiah D. Whitney for purposes of illustration and then returning to Yosemite in 1866 equipped with a camera with a Dallmeyer lens for the express purpose of taking photographs for the California Geological Survey. It is the prints of these views that were used to produce Whitney's lavish *Yosemite Book* (1868). Regarded by Clarence King as "the most skilled operator in America," Watkins was nonetheless almost uniformly unsuccessful in business—he watched as his views of Yosemite were pirated and was forced to sell his entire first collection to the photographer and dealer Isaiah W. Taber, who later published these images under his own name. The rest of his career, during which he tirelessly photographed the cities, mines, business ventures, and natural sites of California and the Pacific Coast, was hardly more lucrative. After losing his gallery in the great San Francisco fire of 1906, he ended his days impoverished and unknown, before being rediscovered in the 1960s.

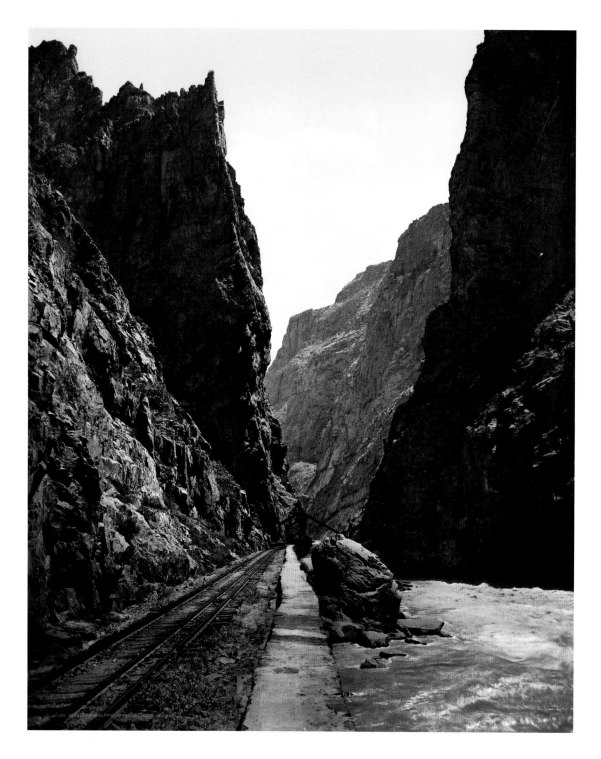

William H. Jackson
The Royal Gorge, Canyon of the
Arkansas, Colorado, copyright 1901
Photochrome, 54×43 cm
Marc Walter Collection

William H. Jackson
La Gorge royale, Grand Canyon de l'Arkansas
*(Colorado)** [The Royal Gorge, Grand Canon*
of the Arkansas, Colorado], after 1880
Albumen print, 53.5×42 cm
Musée d'Orsay, Paris.
Gift of Mr. Robert Gérard, 1987

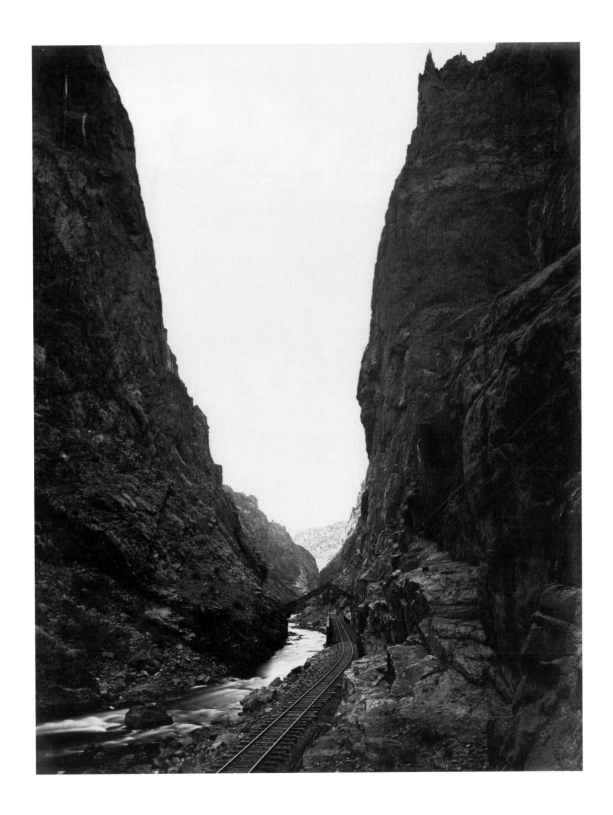

FRENCH COLLECTIONS

Presented here are only the four main collections which compose the exhibition "Images of the West: Survey Photography in French Collections, 1860–1880." The Musée Nicéphore Niépce in Chalon-sur-Saône and the Club Alpin Français in Paris, which possess only isolated objects, are not mentioned. Although we believe we have located the main collections relevant to the exploration of the West in the nineteenth century, it is quite possible that there are other, smaller collections elsewhere, especially at learned societies, museums of science, large educational institutions, and some government departments. In fact, there are other collections of nineteenth-century American photographs and illustrated publications (unrelated to our subject) in some libraries, such as the Bibliothèque Centrale of the Muséum National d'Histoire Naturelle and the Bibliothèque Administrative de la Ville de Paris (whose unique collection was assembled by Alexandre Vattemare) as well as in archives such as those of the Ministère des Affaires Étrangères. Finally, the private collections (from which most of the images preserved at the Musée d'Orsay and the Département des Estampes et de la Photographie of the Bibliothèque Nationale de France originally come) remain to be explored in greater depth.

Société de Géographie
Paris, Bibliothèque Nationale de France,
Département des Cartes et Plans

The photographic collection of the Société de Géographie, which boasts tens of thousands of images and thousands of negatives of a geographical and anthropological nature, emerged from obscurity in 2006 thanks to the book that accompanied the exhibition "Trésors Photographiques de la Société de Géographie," which was conceived by Olivier Loiseaux and held at the Bibliothèque Nationale de France (Fall 2007). While the first donation of images to the Société de Géographie dates back to 1861, the year 1875 was "a turning point in the society's acknowledgement of photography" (Loiseaux 2006, 199) thanks to the International Congress of Geographical Sciences and the photographic exhibition associated with it. The American explorers played an important role in this watershed. In 1868, the American diplomat W. Heine donated a series of views of the building of the transcontinental railroad (the series is not currently listed). Beginning in 1873–74, the Société de Géographie initiated increasingly frequent contacts with the American explorers through Alphonse Pinart and James Jackson, especially with Ferdinand V. Hayden, whose photographic activity is discussed in the *Bulletin* in 1874. In early 1875 the Société de Géographie received numerous publications from the "government of the United States" (especially the War Department). Late in the year it received a promise that it would regularly be mailed the publications of Hayden, who became a foreign correspondent of the society at the same time as his rival, Lieutenant Wheeler. It is on the occasion of the International Congress that General Andrew A. Humphreys sent the six portfolios of the King and Wheeler surveys, "magnificent volumes" according to the society's secretary, Charles Maunoir. Finally donated to the Société de Géographie in late 1876, they contain, respectively, 137 views (King) and about 100 (Wheeler). A copy of the album of fifty views published by the Wheeler survey in 1875 also reached the Société de Géographie. For his part, in 1875 Hayden sent an album of views of Yellowstone, followed by two slightly different copies of the extremely rare album of 1876 containing approximately seven hundred prints. In 1877 the Société de Géographie exhibited John K. Hillers's large-format images of Hopi villages, which were a gift of the Powell survey. This dynamic relationship between the Société de Géographie and the American explorers resumed in the 1880s, when James Jackson, who had become the society's archivist, organized and systematized its photographic collection while also soliciting donations throughout the world. The substantial donations of 1875–77, which make up the core of the collection of the Société de Géographie, were supplemented by gifts from the United States Geological Survey (with numerous series by William H. Jackson and John K. Hillers donated in 1889) and members of the Société de Géographie, including Élisée Reclus and above all James Jackson himself.

Musée du Quai Branly
Paris, formerly Musée de l'Homme

Among the museum's extremely rich holdings in anthropological photography are two North American collections of the first importance, the Pinart collection (with close to three hundred images) and the Simonin collection (with about sixty). These col-

lections primarily consist of Indian portraits from the Shindler-Jackson catalogue (the images may be viewed online at the museum's website). Alphonse Pinart and Louis Simonin were leading Americanists who traveled to the United States at the end of the Second Empire and during the 1870s (see in particular the columns of the *Bulletin de la Société de Géographie* and the Pinart archives, preserved at the museum). As early as 1868–69 Simonin collected Indian photographs in the United States. Pinart, who was in the United States in 1874–75, was in close contact with the Hayden survey. The details surrounding the acquisition of these collections, however, remain to be clarified. It is also known that in 1878 the great Americanist Édouard-Théodore Hamy deposited at the Musée d'Ethnographie du Trocadéro the objects that would appear in the museum's anthropological exhibition later that year, and that the Laboratoire d'Anthropologie of the Muséum mounted and captioned the Pinart collection after 1880 (information provided by Christine Barthe). In addition, the museum's library possesses a series of stereoscopic views from the Wheeler survey and a copy of the Wheeler survey's album of 1875 containing the bookplate of Jules Marcou, a Swiss geologist who worked in the United States, and the stamp of the Société des Américanistes de Paris. Its jewel, finally, is a two-volume copy of the extremely rare album of Indian photographs assembled by William H. Jackson in 1877 and containing 864 pasted prints, which came from the personal library of Paul Broca—it is accompanied by a copy of Jackson's catalogue of Indian photographs with a dedication by F. V. Hayden. It is worth noting that the second volume of the album contains a series of shots of the Yucatan by Désiré Charnay following the images from Jackson's catalogue, thus making this copy the only one of its kind.

Musée d'Orsay
Paris

The Musée d'Orsay, which also possesses several other large collections of American photographs, houses several series and isolated images of the exploration effort that come from private collections. The most sizeable group forms part of a 1987 donation by Robert Gérard, a descendant of the French photographer and traveler Léon Gérard, who seems to have been in the United States during the Second Empire. Especially noteworthy are several large-format prints by William H. Jackson and William Notman as well as two smaller prints (one of them by Carleton E. Watkins, p. 17) which are mounted on blue cardboard and accompanied by French captions that seem to have been added when the prints were acquired. Other images and groups of images have been acquired by the museum since its creation, including a pair of Indian portraits by Jackson and Alexander Gardner from the collections of two connoisseurs of Indian objects, Maurice Dérumeaux and Daniel Dubois.

Bibliothèque Nationale de France
Paris, Département des Estampes
et de la Photographie

Among the extremely diverse collections of American photographs in the possession of the Cabinet des Estampes are several noteworthy groups related to the exploration effort of 1860–80. Most of them were acquired very early. Thus, a series of nineteen prints of Timothy H. O'Sullivan's views for the Wheeler survey in 1873 comes from a donation by Wheeler himself (while four other views in the same collection were acquired in 1983). The largest set is drawn from the collection of Georges Sirot, which was assembled in Paris beginning in 1919 and given to the Bibliothèque Nationale de France in several stages—of special note is an anthology of views of America containing fifteen images by Carleton E. Watkins (p.35 and cat. p. 52 and 53). A number of other donations include groups of two or three images by Watkins, Isaiah W. Taber, and William H. Jackson—the latter is also the author of two large views of the railroad that were acquired in 1983.

CHECKLIST TO THE EXHIBITION

All the photographs are albumen prints from collodion-on-glass negatives.

The asterisk (*) indicates an original French caption hand written on a mount followed (in brackets) by the original English caption from the negative.

Some of the photographs belong to the same portfolios which are referenced using the following abbreviations:

Portfolio King

Clarence King, *Photographs of American Scenery Taken in Connection with the Geological Exploration of the 40th Parallel… Clarence King, Geologist in Charge*, 3 vols., n. d. Société de Géographie, Paris Sg gd in f° D7 / 421

Portfolio Wheeler 1871

George M. Wheeler, *Explorations in Nevada and Arizona, 1871, Photographs*, 2 vols., 1871 Société de Géographie, Paris Sg gd in f° D7 / 359

Portfolio Wheeler 1872

George M. Wheeler, *Explorations West of the 100th Meridian in Utah, Nevada and Arizona, 1872, Photographs*, 1872 Société de Géographie, Paris Sg gd in f° D7 / 424

Portfolio Jackson 1873

William H. Jackson, *Photographs of the Yellowstone National Park and Views in Montana and Wyoming Territories*, 1873 Musée Nicéphore Niépce, Chalon-sur-Saône Portfolio 1873

EXPLORATION AND ITS CONTEXTS

The Surveys and the Development of the American West

Camp Scenes

Timothy H. O'Sullivan
Entrance to Grand Canyon, 1872
Albumen print, 20×28 cm
Société de Géographie, Paris
Portfolio King, vol. 3, no. 122
Fig. p. 10

Timothy H. O'Sullivan
Group of Officers and Assistants at Rendezvous Camp near Belmont, Nevada, 1871
Albumen print, 20×28 cm
Société de Géographie, Paris
Portfolio Wheeler 1871, vol. 1, no. 21
Fig. p. 7

William H. Jackson
Camp on Mystic Lake, c. 1872
Albumen print, 25×32 cm
Musée Nicéphore Niépce, Chalon-sur-Saône
Portfolio Jackson 1873, no. 25

William H. Jackson
Camp at the Mouth of Teton Canyon, c. 1872
Albumen print, 25×32 cm
Musée Nicéphore Niépce, Chalon-sur-Saône
Portfolio Jackson 1873, no. 8

Timothy H. O'Sullivan
Wahsatch Mountains, Lone Peak Summit, Utah, 1869
Albumen print, 20×28 cm
Société de Géographie, Paris
Portfolio King, vol. 2, no. 59
Fig. p. 22

Timothy H. O'Sullivan
Summit of Wahsatch Mountains, Sliding Down, Utah, c. 1869
Stereograph, 11.5×18 cm
Société de Géographie, Paris
Sg Wf 139, no. 100
Fig. p. 23

Uses of the Land

Timothy H. O'Sullivan
Water Rhyolites near Logan Springs, Nevada, 1871
Albumen print, 20×28 cm
Bibliothèque Nationale de France, Paris. Département des Estampes et de la Photographie
Eo 241 fol.

Timothy H. O'Sullivan
Opening of Brooklyn Mine, Pahranagat Lake District, Nevada, 1871
Albumen print, 20×28 cm
Société de Géographie, Paris
Portfolio Wheeler 1871, vol. 1, no. 30
Cat. p. 81

Timothy H. O'Sullivan
Wahsatch Mountains, American Fork Canyon, 1869
Albumen print, 20×28 cm
Société de Géographie, Paris
Portfolio King, vol. 2, no. 61
Cat. p. 84

Timothy H. O'Sullivan
Gould & Curry Reduction Works, 1867–68
Albumen print, 20×28 cm
Société de Géographie, Paris
Portfolio King, vol. 1, no. 8
Cat. p. 85

William H. Jackson
Toltec Tunnel, after 1880
Albumen print, 41×53,5 cm
Bibliothèque Nationale de France, Paris.
Département des Estampes et de la Photographie
Eo 176a gd fol.

The Circulation of the Photographs

An Example of the Official Presentation

Timothy H. O'Sullivan
Tertiary Bluffs, Echo Canyon, 1869
Albumen print, 20×28 cm
Société de Géographie, Paris
Portfolio King, vol. 2, no. 87
Fig. p. 31

Reports, Albums, Illustrated Publications

Andrew J. Russell
"Hanging Rock, Echo City, Utah" in Ferdinand V. Hayden, *Sun Pictures of Rocky Mountain Scenery, with a Description of the Geographical and Geological Features, and some Account of the Resources of the Great West; Containing Thirty Photographic Views Along the Line of the Pacific Rail Road, from Omaha to Sacramento* (New York: Julius Bien, 1870), pl. XVII
Club Alpin Français, Paris
CAF AR 1506
Fig. p. 30

"Eminent American Explorers and Artists" in Henry T. Williams, *Williams' Pacific Tourist Guidebook* (New York: 1876), 30 Xylograph
Club Alpin Français, Paris
CAF AR 322
Fig. p. 18

Le Tour du Monde, nouveau journal des voyages 28 (1874), opened on pages 292–93
École Normale Supérieure, Paris. Bibliothèque des Lettres
H V g 49 4° vol. 28 (1874/2nd sem.)
Fig. p. 26

R. A. Muller
"Running a Rapid" in John W. Powell, *Exploration of the Colorado River and its Tributaries; Explored in 1869, 1870, 1871 and 1872* (Washington, D.C.: 1875), fig. 28
Xylograph, 13.5×9.5 cm
Bibliothèque Administrative de la Ville de Paris
BAVP EU 1612
Fig. p. 12

John W. Powell
Canyons of the Colorado, 1895
Muséum National d'Histoire Naturelle, Paris. Bibliothèque Centrale
109160

Timothy H. O'Sullivan
"Canyon de Chelly. Walls of the Grand Canyon about 1200 Feet in Height" in George M. Wheeler *Photographs Showing Landscapes, Geological and Other Features*, 1874
Médiathèque du Quai Branly, Paris
Plano 4 pl. 1873 no. 15

George M. Wheeler
Report upon United States Geographical Surveys West of the 100th Meridian, vol. 3, *Geology*, 1875
Société de Géographie, Paris
Sg D7 / 324, 4°, vol. 3

Clarence King
Report of the Geological Exploration of the 40th Parallel, vol. 2, *Descriptive Geology* (Washington, D.C.: Government Printing Office, 1877)
Société de Géographie, Paris
Sg 4°, D7 / 421, vol. 2
Fig. p. 31

Stereoscopic Views

Timothy H. O'Sullivan
The Start from Camp Mojave, Arizona, 1871
Stereograph, 10×18 cm
Musée du Quai Branly, Paris
PP0026660
Fig. p. 25

Timothy H. O'Sullivan
Coyotero Apache Scouts, at Apache Lake, Sierra Blanca Range, Arizona, 1873
Stereograph, 10×18 cm
Musée du Quai Branly, Paris
PP0026697

Timothy H. O'Sullivan
*Apache Braves Ready
for the Trail, Arizona*, 1873
Stereograph, 10×18 cm
Musée du Quai Branly, Paris
PP0026700

George M. Wheeler
*Vues photographiques
de l'Amérique*, 1874
Société de Géographie, Paris
Sg Wf 135
Fig. p. 28

**A French Collector:
Léon Gérard (1817–1896)**

Carleton E. Watkins
Five Views of Yosemite
Five albumen prints
(Isaiah W. Taber, after 1876)
on mount from collodion-
on-glass negatives (attributed
to C. E. Watkins, c. 1865).
French captions added
by Léon Gérard in
the late nineteenth century.
Musée d'Orsay, Paris.
Gift of Mr. Robert Gérard, 1987
PHO 1987 33 14 1 to 5
Fig. p. 17

*Vue du Demi-Dôme
prise de la rivière Merced,
vallée de Yosemite* [*Half Dome,
from "Merced River"*]
12.5×20 cm
PHO 1987 33 14 1

Les Arches, Yosemite [*Royal Arches, Yosemite*]
20.5×55.5 cm
PHO 1987 33 14 2

*El Capitan, Yosemite**
20.2×71.5 cm
PHO 1987 33 14 3

*Vue générale de Glacier Point** [*View from Glacier Point*]
19.6×12.4 cm
PHO 1987 33 14 4
Cat. p.55

*Les Clochers de Cathédrale** [*Cathedral Spires*]
20.4×12.4 cm
PHO 1987 33 14 5

Anonymous
Garden of the Gods, c. 1870
Eight albumen prints
on mount from collodion-on-glass negatives.
French captions added
by Léon Gérard in the late
nineteenth century.
Musée d'Orsay, Paris.
Gift of Mr. Robert
Gérard, 1987
PHO 1987 33 17 1 to 8

Gateway at Siview South
8.5×8 cm
PHO 1987 33 17 1

Gate Way
9.4×7.7 cm
PHO 1987 33 17 2

*Tower of Babel,
Garden of the Gods*
9.4×7.6 cm
PHO 1987 33 17 3

*Le Rocher branlant, Jardin
des dieux (Colorado)**
9.2×8 cm
PHO 1987 33 17 4

*Mother Mushroom,
Garden of the Gods*
9.8×7.9 cm
PHO 1987 33 17 5

*Les Rochers du Jardin
des dieux (Colorado)**
8.9×7.7 cm
PHO 1987 33 17 6

Seven Falls
9.5×7.8 cm
PHO 1987 33 17 7

*Les Trois Perchés, Monument
Valley (Colorado)**
9.5×8.3 cm
PHO 1987 33 17 8

WIDE OPEN SPACES

Yosemite

Carleton E. Watkins
El Capitan, Yosemite, 1860s
Albumen print, 53×42 cm
Bibliothèque Nationale
de France, Paris.
Département des Estampes
et de la Photographie
Eo 115a
Cat. p. 53

Carleton E. Watkins
Sentinel River View, 1861
Albumen print, 10.6×7.6 cm
Musée d'Orsay, Paris.
Gift of Françoise Heilbrun
and Philippe Néagu, 1983
PHO 1983 207

Carleton E. Watkins
*Cascade, Nevada Falls,
Yosemite*, c. 1861
Albumen print, 42×53 cm
Bibliothèque Nationale
de France, Paris.
Département des Estampes
et de la Photographie
Eo 115a
Cat. p. 52

Carleton E. Watkins
*Cathedral Mountain,
Yosemite*, 1865
Albumen print, 53×42 cm
Bibliothèque Nationale
de France, Paris.
Département des Estampes
et de la Photographie
Eo 115a
Fig. p. 35

Carleton E. Watkins
*Route creusée dans le tronc
d'un séquoia gigantesque,
forêt de Mariposa (Californie)**
[*Wawona–28 Feet Diameter,
275 Feet High–Mariposa
Grove*], c. 1865–80
Albumen print, 49.2×40 cm
Musée d'Orsay, Paris.
Gift of Mr. Robert Gérard, 1987
PHO 1987 33 16
Cat. p. 54

Carleton E. Watkins
*General View of Yosemite
Valley from Artist's Point*,
before 1880
Albumen print, 40.5×48.3 cm
Musée d'Orsay, Paris.
Gift of Mr. Robert Gérard, 1987
PHO 1987 33 15

Yellowstone

William H. Jackson
*Le Vieux Fidèle, geyser**
[*Old Faithful, Geyser*], 1870
Albumen print, 51.5×41.5 cm
Musée d'Orsay, Paris.
Gift of Mr. Robert Gérard, 1987
PHO 1987 33 1
Cat. p. 56

William H. Jackson
Old Faithful in Eruption, c. 1878
Albumen print, 34×25 cm
Société de Géographie, Paris
Sg Wf 130, no. 7

William H. Jackson
*Sources chaudes "mammouth",
parc du Yellowstone**
[*Mammoth Hot Springs*], 1871
Albumen print, 43×53.5 cm
Musée d'Orsay, Paris.
Gift of Mr. Robert Gérard, 1987
PHO 1987 33 8
Cat. p. 57

William H. Jackson
*Mammoth Hot Springs,
on Gardiner's River*, c. 1872
Albumen print, 25×33 cm
Musée Nicéphore Niépce,
Chalon-sur-Saône
Portfolio Jackson 1873, no.13
Cat. p. 58

William H. Jackson
*Upper Fire-Hole Basin,
from Old Faithful*, c. 1872
Albumen print, 25×33 cm
Musée Nicéphore Niépce,
Chalon-sur-Saône
Portfolio Jackson 1873, no. 10
Cat. p. 59

William H. Jackson
Tower Falls, c. 1872
Albumen print, 25×33 cm
Musée Nicéphore Niépce,
Chalon-sur-Saône
Portfolio Jackson 1873, no. 22

William H. Jackson
"The Grand Canon
of the Yellowstone"
in Portfolio Jackson 1873, pl. 21
Musée Nicéphore Niépce,
Chalon-sur-Saône
Portfolio 1976.15.51

Grand Canyon

William Bell
*Grand Canyon of the Colorado,
Mouth of Kanab Wash,
Looking West (no. 52)*, 1872
Albumen print, 28×20 cm
Société de Géographie, Paris
Portfolio Wheeler 1872, no. 52
Cat. p. 62

William Bell
*Grand Canyon of the Colorado,
Mouth of Kanab Wash,
Looking West (no. 54)*, 1872
Albumen print, 23×18 cm
Société de Géographie, Paris
Portfolio Wheeler 1872, no. 54
Cat. p. 63

William Bell
*Looking South into the Grand
Canyon, Colorado River,
Shivwits Crossing*, 1872
Albumen print, 27.5×20.3 cm
Musée d'Orsay, Paris
PHO 1983 79
Cat. p. 61

William Bell
*The Northern Wall of the Grand
Canyon of the Colorado, near
the Foot of To-ro-weap Valley*, 1872
Stereograph, 10×18 cm
Musée du Quai Branly, Paris
PP0026683

William Bell
*Chocolate Butte near Mouth
of the Paria*, 1872
Albumen print, 23×18 cm
Société de Géographie, Paris
Portfolio Wheeler 1872, no. 58
Cat. p. 64

Timothy H. O'Sullivan
Iceberg Canyon, 1871
Albumen print, 20×28 cm
Société de Géographie, Paris
Portfolio Wheeler 1871, vol. 2,
no. 90

Timothy H. O'Sullivan
*Canyon of Colorado,
near Mouth of San Juan River,
Arizona*, 1873
Albumen print, 28×35,5 cm
Bibliothèque Nationale
de France, Paris.
Département des Estampes
et de la Photographie
Eo 241 fol.

William H. Jackson
*Grand Canyon du Colorado
(Arizona)** [*Grand Canyon
of the Colorado, Arizona*], 1883
Albumen print, 53.5×42.5 cm
Musée d'Orsay, Paris.
Gift of Mr. Robert Gérard, 1987
PHO 1987 33 4
Cat. p. 60

William H. Jackson
*La Gorge royale, Grand
Canyon de l'Arkansas (Colorado)**
[*The Royal Gorge, Grand
Canyon of the Arkansas, Colorado*],
after 1880
Albumen print, 53.5×42 cm
Musée d'Orsay, Paris.
Gift of Mr. Robert Gérard, 1987
PHO 1987 33 6
Cat. p. 123

William H. Jackson
*The Royal Gorge, Canyon
of the Arkansas, Colorado*,
copyright 1901
Photochrome, 54×43 cm
Marc Walter Collection
Cat. p.122

Canyons de Chelly
and del Muerte, Arizona

John K. Hillers
*The Canyon de Chelly from
Explorers' Monument*, 1870s
Albumen print, 25×33 cm
Société de Géographie, Paris
Sg Wf 131, no. 1
Cat. p. 65

John K. Hillers
Captains of the Canyon, Canyon de Chelly, Arizona, 1870s
Albumen print, 33×25 cm
Société de Géographie, Paris
Sg Wf 131, no. 4
Cat. p. 66

John K. Hillers
Canyon del Muerte, Arizona, 1870s
Albumen print, 33×25 cm
Société de Géographie, Paris
Sg Wf 131, no. 9
Cat. p. 67

Timothy H. O'Sullivan
"Ancient Ruins in Canyon de Chelly, New Mexico. In a Niche 50 Feet Above Present Canyon Bed," 1871, in George M. Wheeler, *Photographs Showing Landscapes, Geological and Other Features*, 1874
Albumen print, 28×20 cm
Médiathèque du Quai Branly, Paris
Plano 4 pl. 1873 no. 10
Cat. p. 69

John K. Hillers
Ruins of Cliff Dwellings, Canyon de Chelly, 1870s
Albumen print, 25×33 cm
Société de Géographie, Paris
Sg Wf 131, no. 8
Cat. p. 68

FEATURES OF THE LANDSCAPE

Water

John K. Hillers
Bullion Canyon, Utah, années 1870
Albumen print, 33×25 cm
Société de Géographie, Paris
Sg Wf 129, no. 6

John K. Hillers
Mary's Veil, Bullion Canyon, Utah, 1870s
Albumen print, 33×25 cm
Société de Géographie, Paris
Sg Wf 129, no. 9
Cat. p. 70

William H. Jackson
Little Firehole Falls, 1870s
Albumen print, 33×25 cm
Société de Géographie, Paris
Sg Wf 130, no. 16
Cat. p. 72

William H. Jackson
Mystic Lake, Montana, c. 1872
Albumen print, 25×33 cm
Musée Nicéphore Niépce, Chalon-sur-Saône
Portfolio Jackson 1873, no.27
Cat. p. 73

William H. Jackson
Mammoth Hot Springs, c. 1878
Albumen print, 25×33 cm
Société de Géographie, Paris
Sg Wf 130, no. 14
Cat. p. 74

Rocks

Timothy H. O'Sullivan
Rock Carved by Drifting Sand, 1871
Albumen print, 20×27.5 cm
Paris, Musée d'Orsay
PHO 1987 78
Cat. p. 77

William Bell
Chocolate Mesa, Rocker Creek, Arizona, 1872
Albumen print, 18×20 cm
Société de Géographie, Paris
Portfolio Wheeler 1872, no. 56
Cat. p. 75

William Bell
Hieroglyphic Pass, Opposite Parowan, Utah, 1872
Albumen print, 23×18 cm
Société de Géographie, Paris
Portfolio Wheeler 1872, no. 8
Cat. p. 76

Timothy H. O'Sullivan
Tufa Domes, Pyramid Lake, Nevada, 1867–68
Albumen print, 20×28 cm
Société de Géographie, Paris
Portfolio King, vol. 1, no. 12
Fig. p. 46

Timothy H. O'Sullivan
Tertiary Conglomerates, Weber Valley, Utah, 1869
Albumen print, 20×28 cm
Société de Géographie, Paris
Portfolio King, vol. 2, no. 82
Cat. p. 78

Timothy H. O'Sullivan
Mauvaises Terres, Washakie Basin, 1872
Albumen print, 20×28 cm
Société de Géographie, Paris
Portfolio King, vol. 3, no. 105
Cat. p. 79

Timothy H. O'Sullivan
Columnar Basalt, Mouth of Grand Wash, 1871
Albumen print, 20×28 cm
Société de Géographie, Paris
Portfolio Wheeler 1871, vol. 2, no. 89
Cat. p. 80

John K. Hillers
Reflected Tower, Rio Virgen, Utah, 1870s
Albumen print, 33×25 cm
Société de Géographie, Paris
Sg Wf 129, no. 13
Cat. p. 82

John K. Hillers
Shini-Mo Altar, from Brink of Marble Canyon, Colorado River, Arizona, 1870s
Albumen print, 33×25 cm
Société de Géographie, Paris
Sg Wf 129, no. 5
Cat. p. 83

John K. Hillers
The Last of the Collodion, c. 1872
Stereograph, 11.5×18 cm
Société de Géographie, Paris
Sg Wf 2, no.6

William H. Jackson
Sultan Mountain, Baker Park, 1888–90
Albumen print, 42×53 cm
Bibliothèque Nationale de France, Paris. Département des Estampes et de la Photographie
Eo 176a gd fol.

TIMOTHY H. O'SULLIVAN: A PHOTOGRAPHER AT WORK

The Photographer and his Equipment

Timothy H. O'Sullivan
Sand Dunes, Carson Desert, Nevada, 1868
Albumen print, 20×28 cm
Société de Géographie, Paris
Portfolio King, vol. 1, no. 23
Cat. p. 88

Timothy H. O'Sullivan
Hot Sulphur Spring, Ruby Valley, Nevada, 1868
Albumen print, 20×28 cm
Société de Géographie, Paris
Portfolio King, vol. 1, no. 37
Cat. p. 89

Timothy H. O'Sullivan
Comstock Lode, Gold Hill, 1867–68
Albumen print, 20×28 cm
Société de Géographie, Paris
Portfolio King, vol. 1, no. 6
Cat. p. 90

The Photographer and his Boat, the *Picture*

Timothy H. O'Sullivan
Black Canyon, Looking Above from Camp 7, 1871
Albumen print, 20×28 cm
Société de Géographie, Paris
Portfolio Wheeler 1871, vol. 2, no. 77
Cat. p. 91

Timothy H. O'Sullivan
Black Canyon, from Camp 8, Looking Above, 1871
Albumen print, 20×28 cm
Société de Géographie, Paris
Portfolio Wheeler 1871, vol. 2, no. 80
Cat. p. 92

Timothy H. O'Sullivan
Light and Shadow in Black Canyon from Mirror Bar, 1871
Albumen print, 20×28 cm
Société de Géographie, Paris
Portfolio Wheeler 1871, vol. 2, no. 83
Cat. p. 93

Around Shoshone Falls

Timothy H. O'Sullivan
Shoshone Falls, Snake River–210 Feet, 1868
Albumen print, 20×28 cm
Société de Géographie, Paris
Portfolio King, vol. 1, no. 42
Cat. p. 95

Timothy H. O'Sullivan
Shoshone Falls, from Below, 1868
Albumen print, 20×28 cm
Société de Géographie, Paris
Portfolio King, vol. 1, no. 44
Cat. p. 94

Timothy H. O'Sullivan
Snake River, Canyon, Looking over edge of Falls, 1868
Albumen print, 20×28 cm
Société de Géographie, Paris
Portfolio King, vol. 1, no. 45
Cat. p. 94

Light

Timothy H. O'Sullivan
Grand Canyon Bottom, Morning, 1872
Albumen print, 28×20 cm
Société de Géographie, Paris
Portfolio King, vol. 3, no. 132
Cat. p. 96

Timothy H. O'Sullivan
Grand Canyon Bottom, Afternoon, 1872
Albumen print, 20×28 cm
Société de Géographie, Paris
Portfolio King, vol. 3, no. 133
Cat. p. 97

IMAGES OF NATIVE AMERICANS

Studio Portraits

William H. Jackson
Kam-ne-but-se, "Black Foot," 1871
Albumen print, 20.7×13.8 cm
Musée d'Orsay, Paris
PHO 1996 12
Cat. p. 110

William Bell
Paiute Group, Cedar, Utah, 1872
Albumen print, 18×23 cm
Société de Géographie, Paris
Portfolio Wheeler 1872, no. 1
Fig. p. 21

Alexander Gardner
Black Crow, Arapaho, 1860–76
Albumen print, 18.5×13.5 cm
Musée du Quai Branly, Paris. Gift of Laboratoire d'Anthropologie du Muséum and Alphonse Pinart
PP0022141
Cat. p. 100

Alexander Gardner
Chef arapaho du Sud *
[*Southern Arapaho Chief*], 1869
Albumen print, 18.5×13.5 cm
Musée du Quai Branly, Paris. Gift of Laboratoire d'Anthropologie du Muséum and Alphonse Pinart
PP0022064
Cat. p. 101

Alexander Gardner
Long Foot, Yankton, Dakota, 1867
Albumen print, 18.3×13.3 cm
Musée du Quai Branly, Paris. Gift of Laboratoire d'Anthropologie du Muséum and Alphonse Pinart
PP0022080
Cat. p. 102

Alexander Gardner
Long Foot, Yankton, Dakota, 1867
Albumen print, 18.3×13.3 cm
Musée du Quai Branly, Paris.
Gift of Laboratoire
d'Anthropologie du Muséum
and Alphonse Pinart
PP0022081
Cat. p. 103

Alexander Gardner
*He-gma-wa-ku-wa, "One
Who Runs the Tiger,"
North Dakota*, 1872
Albumen print, 18.5×13.5 cm
Musée du Quai Branly, Paris.
Gift of Laboratoire
d'Anthropologie du Muséum
and Alphonse Pinart
PP0022137
Cat. p. 105

Antonio Zeno Shindler
*Hin-han-du-ta, "Red Owl,"
Arapaho*, 1860–76
Albumen print, 18.5×13.5 cm
Musée du Quai Branly, Paris.
Gift of Laboratoire
d'Anthropologie du Muséum
and Alphonse Pinart
PP0022171
Cat. p. 104

Antonio Zeno Shindler
Indian Type, 1860–69
Albumen print, 18.4×13.2 cm
Musée du Quai Branly, Paris.
Gift of Laboratoire
d'Anthropologie du Muséum
and Alphonse Pinart
PP0022191
Cat. p. 106

Antonio Zeno Shindler
*Se-tan-si-tan, "Yellow Hawk,"
Sans Arc Chief, Dakota*, 1860–69
Albumen print, 18×13 cm
Musée du Quai Branly, Paris.
Gift of Laboratoire
d'Anthropologie du Muséum
and Alphonse Pinart
PP0023907
Cat. p. 107

Antonio Zeno Shindler
*Psi-ca-na-kin-yan, "Jumping
Thunder," Yankton Sioux
Chief, Dakota*, 1868–69
Albumen print, 18×14.3 cm
Musée du Quai Branly, Paris.
Gift of Laboratoire
d'Anthropologie du Muséum
and Alphonse Pinart
PP0023924
Cat. p. 109

Antonio Zeno Shindler
*Wa-jin-ka, "Little Bird,"
Yankton Sioux Brave,
Dakota*, 1868–69
Albumen print, 18.4×13.2 cm
Musée du Quai Branly, Paris.
Gift of Laboratoire
d'Anthropologie du Muséum
and Alphonse Pinart
PP0023939
Cat. p. 108

Timothy H. O'Sullivan
Types of Mojave Indians, 1871
Stereograph, 10×18 cm
Musée du Quai Branly, Paris
PP0026677

Timothy H. O'Sullivan
*Sleeping Mojave Guides,
Arizona*, 1871
Stereograph, 10×18 cm
Musée du Quai Branly, Paris
PP0026668
Fig. p. 40

Timothy H. O'Sullivan
*Young Apache Warrior
and his Squaw, near Camp
Apache, Arizona*, 1873
Stereograph, 10×18 cm
Musée du Quai Branly, Paris
PP0026701

William H. Jackson
"Navajo Warriors" in
*Photographs of North American
Indians*, 1877, 1: n. p.
Médiathèque
du Quai Branly, Paris
A 200422 vol. 1
Fig. p. 24

William H. Jackson
*Descriptive Catalogue
of Photographs of North American
Indians*, 1877, opened
on pages 26–27, "Navajos"
Brochure, 22×27 cm (opened)
Médiathèque
du Quai Branly, Paris
A 12531
Fig. p. 24

Villages

John K. Hillers
Dancers Rock, Walpi, c. 1876
Albumen print,
42.5×53.3 cm
Société de Géographie, Paris
Sg Wf 5, no. 2
Cat. p. 111

John K. Hillers
Walpi, Moqui Town, Arizona,
1879–80
Albumen print, 25×33 cm
Société de Géographie, Paris
Sg Wf 132, no. 4
Cat. p. 113

John K. Hillers
*Pueblo de San Juan,
New Mexico*, 1879–80
Albumen print, 25×33 cm
Société de Géographie, Paris
Sg Wf 132, no. 10
Cat. p. 112

John K. Hillers
*Pueblo de Taos,
New Mexico*, 1879–80
Albumen print, 25×33 cm
Société de Géographie, Paris
Sg Wf 132, no. 13
Cat. p. 114

John K. Hillers
*Oraibi, A Moqui Town,
Arizona*, 1879–80
Albumen print, 25×33 cm
Société de Géographie, Paris
Sg Wf 131, no. 6

John K. Hillers
*Pueblo de Sandia,
New Mexico*, 1879–80
Albumen print, 25×33 cm
Société de Géographie, Paris
Sg Wf 132, no. 18

John K. Hillers
*Terraced Houses, Zuni,
New Mexico*, 1879–80
Albumen print, 25×33 cm
Société de Géographie, Paris
Sg Wf 43, no. 2
Fig. p. 37

Timothy H. O'Sullivan
*Aboriginal Life Among
the Navajo Indians, near Old
Fort Defiance, Arizona*, 1873
Albumen print, 28×20 cm
Société de Géographie, Paris
Sg Wf 6, no. 7
Cat. p. 115

Timothy H. O'Sullivan
*View on Apache Lake, Sierra
Blanca Range, Arizona. Two Apache
Scouts in the Foreground*, 1873
Albumen print, 28×20 cm
Société de Géographie, Paris
Sg Wf 6, no. 3
Cat. p. 98

Stereoscopic Views

John K. Hillers
*Ku-ra-tu, Kaibab Paiute
Woman*, c. 1872
Stereograph, 11.5×18 cm
Société de Géographie, Paris
Sg Wf 2, no. 9
Fig. p. 39

John K. Hillers
*Ku-ra-tu and Mu-pates,
Paiutes*, c. 1872
Stereograph, 11.5×18 cm
Société de Géographie, Paris,
Paris
Sg Wf 2, no. 10

John K. Hillers
Kindling Fire by Friction, c. 1872
Stereograph, 11.5×18 cm
Société de Géographie, Paris
Sg Wf 2, no. 12
Fig. p. 42

John K. Hillers
Pile of Little Indians, c. 1872
Stereograph, 11.5×18 cm
Société de Géographie, Paris
Sg Wf 2, no. 13

John K. Hillers
The Hunter, U-ai-nu-ints, c. 1872
Stereograph, 11.5×18 cm
Société de Géographie, Paris
Sg Wf 2, no. 16

John K. Hillers
Wu-nav-ai Gathering Seeds, c. 1872
Stereograph, 11.5×18 cm
Société de Géographie, Paris
Sg Wf 2, no. 20

John K. Hillers
*Nu-a-gun-tits, Ka-ni,
Sleeping*, c. 1872
Stereograph, 11.5×18 cm
Société de Géographie, Paris
Sg Wf 2, no. 27

SELECTED BIBLIOGRAPHY

This bibliography lists the relevant secondary sources as well as the primary sources that are explicitly cited by the essays contained in the catalogue. For a comprehensive survey of the major primary sources related to the subject, see Brunet 1993, vol. 2. Two French primary sources should nevertheless be mentioned, the *Bulletin de la Société de Géographie* and the *Bulletin Trimestriel du Club Alpin Français*.

Adams [1907] 1983
Adams, Henry. *The Education of Henry Adams* [1907]. New York: Library of America, 1983.

Adams 1996
Adams, Robert. *Beauty in Photography*. New York: Aperture, 1996.

Alinder 1979
Alinder, James, ed. *Photographs of the Columbia River and Oregon/Carleton Watkins*. Carmel, Calif.: Friends of Photography, Weston Gallery, 1979. Exh. cat.

Alison 1998
Alison, Jane, ed. *Native Nations: Journeys in American Photography*. London: Booth-Clibborn Editions for Barbican Art Gallery, 1998.

Aubenas 2004
Aubenas, Sylvie, ed. *Des photographes pour l'Empereur: les albums de Napoléon III*, Paris: Bibliothèque Nationale de France, 2004. Exh. cat.

Barrow 1971
Barrow, Thomas. *Figure in Landscape*. Rochester, N.Y.: George Eastman House, 1971.

Barthe 2003
Barthe, Christine. "Les éléments de l'observation. Des daguerréotypes pour l'anthropologie." In Quentin Bajac and Dominique Planchon-de Font-Réaulx, eds. *Le Daguerréotype français: Un objet photographique*. Paris: Réunion des Musées Nationaux, 2003, 73–86. Exh. cat.

Barthe 2007
Barthe, Christine, ed. *Le Yucatan est ailleurs: Expéditions photographiques de Désiré Charnay*. Arles: Actes Sud, 2007. Exh. cat.

Bartlett 1962
Bartlett, Richard A. *Great Surveys of the American West*, Norman: University of Oklahoma Press, 1962.

Birrell 1975
Birrell, Andrew. *Into the Silent Land: Survey Photography in the Canadian West, 1858–1900*. Ottawa: Public Archives of Canada, 1975. Exh. cat.

Blair 2005
Blair, Bob, ed. *William Henry Jackson's "The Pioneer Photographer."* Santa Fe: Museum of New Mexico Press, 2005.

Boorstin 1962
Boorstin, Daniel J. *The Image; or, What Happened to the American Dream*. Boston: Atheneum, 1962.

Bossen 1982
Bossen, Howard. "A Tall Tale Retold: The Influence of the Photographs of William Henry Jackson upon the Passage of the Yellowstone Park Act of 1872." *Studies in Visual Communication* 8, no. 1 (Winter 1982): 98–109.

Brechin 1999
Brechin, Gray. *Imperial San Francisco: Urban Power, Earthly Ruin*. Berkeley: University of California Press, 1999.

Brilliant 1991
Brilliant, Richard. *Portraiture*. London: Reaktion Books, 1991.

Brown 1971
Brown, Dee. *Bury My Heart at Wounded Knee: An Indian History of the American West*. London: Barrie and Jenkins, 1971.

Bruce 1990
Bruce, Chris. *Myth of the West*. New York: Rizzoli International Publications, 1990. Exh. cat.

Brunet 1993
Brunet, François. *La Collecte des vues: Explorateurs et photographes en mission dans l'Ouest américain 1839–1879*, Ph.D. diss., 2 vols. Paris: École des Hautes Études en Sciences Sociales, 1993.

Brunet 1994
Brunet, François. "'Picture Maker of the Old West': W. H. Jackson and the Birth of Photographic Archives in the United States." *Prospects: An Annual of American Cultural Studies* 19 (1994): 161–87.

Brunet 1998
Brunet, François. "Frémont et le daguerréotype: la photographie au service du mythe." *Revue française d'études américaines* 76 (March 1998): 28–43.

Brunet 1999
Brunet, François. "Geological Views as Social Art: Explorers and Photographers in the American West, 1859–79." In Clair 1999, 86–92.

Brunet 2000
Brunet, François. "Anonymat, réflexivité et signature chez les photographes de l'Ouest américain au XIXᵉ siècle." *Interfaces, Image Texte Langage* 17. Dijon: Université de Bourgogne, 2000, 99–117.

Brunet 2001
Brunet, François. "Explorer's Images of the West, 1820–50." In *Milbert, Lesueur, Tocqueville. Le voyage en Amérique, 1815–1845*. Giverny: Musée d'Art Américain Giverny, 2001, 66–70. Exh. cat.

Brunet 2007a
Brunet, François. "L'entreprise américaine de Désiré Charnay." In Barthe 2007, 10–23.

Brunet 2007b
Brunet, François. "Revisiting the Enigmas of Timothy H. O'Sullivan: Notes on the William Ashburner Collection of King Survey Photographs at the Bancroft Library." *History of Photography* (Summer 2007).

Bush and Mitchell 1994
Bush, Alfred L. and Lee Clark Mitchell. *The Photograph and the American Indian*. Princeton, N.J.: Princeton University Press, 1994.

Cahn 1981
Cahn, Robert. *American Photographers and the National Parks*. New York, Washington, D.C.: Viking Press, National Park Foundation, 1981. Exh. cat.

Carter 1999
Carter, Edward C., II, ed. *Surveying the Record: North American Scientific Exploration to 1930*. Philadelphia: American Philosophical Society, 1999.

Cassidy 2000
Cassidy, James G. *Ferdinand V. Hayden: Entrepreneur of Science*. Lincoln: University of Nebraska Press, 2000.

Castleberry 1996
Castleberry, May et al. *Perpetual Mirage: Photographic Narratives of the Desert West*. New York: Whitney Museum of Art, 1996. Exh. cat.

Christadler, Naef and Stuffmann 1993
Christadler, Martin, Weston Naef and Margaret Stuffmann. *Gustave Le Gray, Carleton Watkins: Pioneers of Landscape Photographs; Photographs from the Collection of the J. Paul Getty Museum*. Mainz: H. Schmidt, 1993. Exh. cat.

Clair 1999
Clair, Jean, ed. *Cosmos: From Romanticism to the Avant-Garde*, Montreal: The Montreal Museum of Fine Arts, Munich: Prestel, 1999. Exh. cat.

Clisby and Himelfarb 1980
Clisby, Roger D. and Harvey Himelfarb. *Large Spaces in Small Places: A Survey of Western Landscape Photography, 1850–1980*. Sacramento: Crocker Art Museum, 1980. Exh. cat.

Conn 2004
Conn, Steven. *History's Shadow: Native Americans and Historical Consciousness in the Nineteenth Century*. Chicago and London: University of Chicago Press, 2004.

Cronon, Miles and Gitlin 1992
Cronon, William, George Miles and Jay Gitlin, eds. *Under an Open Sky: Rethinking America's Western Past*. New York and London: W. W. Norton, 1992.

Current and Current 1978
Current, Karen and William R. Current. *Photography and the Old West*. New York: Harry N. Abrams in association with the Amon Carter Museum, 1978. Exh. cat.

Danly 1996
Danly, Susan. "Photography, Railroads, and Natural Resources in the Arid West: Photographs by Alexander Gardner and Andrew J. Russell." In Castleberry 1996, 49–56.

Darrah 1977
Darrah, William C. *The World of Stereographs*. Gettysburg, Pa.: Darrah, 1977.

Davidson 2006
Davidson Gail S. et al. *Frederic Church, Winslow Homer, and Thomas Moran: Tourism and the American Landscape*, New York: Cooper-Hewitt, National Design Museum, Bulfinch Press, 2006. Exh. cat.

Dawdy 1993
Dawdy, Doris Ostrander. *George Montague Wheeler: The Man and the Myth*. Athens, Ohio: Swallow Press, Ohio University Press, 1993.

Dingus 1982
Dingus, Rick. *The Photographic Artifacts of Timothy O'Sullivan*. Albuquerque: University of New Mexico Press, 1982.

Dippie 1991
Dippie, Brian. *The Vanishing American: White Attitudes and U.S. Indian Policy*. Lawrence: University Press of Kansas, 1991.

Edkins and Newhall 1975
Edkins, Diana and Beaumont Newhall. *William H. Jackson*. New York: Morgan & Morgan, 1975.

Enyeart 1998
Enyeart, James L. *Land, Sky, and All That Is Within: Visionary Photographers in the Southwest*. Santa Fe: Museum of New Mexico Press, 1998. Exh. cat.

Fels 1987
Fels, Thomas Weston. *Destruction and Destiny: The Photographs of A. J. Russell; Directing American Energy in War and Peace, 1862–1869*. Pittsfield, Mass.: Berkshire Museum, 1987. Exh. cat.

Fierro 1986
Fierro, Alfred. *Inventaire des photographies sur papier de la Société de géographie*. Paris: Bibliothèque Nationale de France, Département des Cartes et Plans, 1986.

Flattau, Gibson and Lewis 1980
Flattau, John, Ralph Gibson and Arne Lewis. *Landscape: Theory*. New York: Lustrum Press, 1980.

Fleming and Luskey 1986
Fleming, Paula Richardson and Judith Luskey, *The North American Indians in Early Photographs*, New York: HarperCollins, 1986.

Fleming 2003
Fleming, Paula Richardson. *Native American Photography at the Smithsonian: The Shindler Catalogue*. Washington, D.C. and London: Smithsonian Books, 2003. Exh. cat.

Fowler 1972
Fowler, Don D., ed. *"Photographed All the Best Scenery": Jack Hillers's Diary of the Powell Expeditions, 1871–1875*. Salt Lake City: University of Utah Press, 1972.

Fowler 1989
Fowler, Don D. *The Western Photographs of John K. Hillers: Myself in the Water*. Washington, D.C. and London: Smithsonian Institution Press, 1989.

Fox 2001
Fox, William L. *View Finder: Mark Klett, Photography, and the Reinvention of Landscape*. Albuquerque: University of New Mexico Press, 2001.

Frassanito [1975] 1996
Frassanito, William T. *Gettysburg: A Journey in Time* [1975]. Gettysburg, Pa.: Thomas Publications, 1996.

Gervais 2000
Gervais, Thierry. "D'après photographie. Premiers usages de la photographie dans le journal *L'Illustration* (1843–1859)." *Études photographiques* 13 (July 2003): 56–85.

Gidley 1992
Gidley, Mick, ed. *Representing Others: White Views of Indigenous Peoples*. Exeter: University of Exeter Press, 1992.

Gidley 1998
Gidley, Mick. *Edward S. Curtis and the North American Indian, Incorporated*. New York and Cambridge: Cambridge University Press, 1998.

Gidley 2005
Gidley, Mick. "Topographical Portraits: Seven Views of Richard Avedon's *In the American West*." *Prospects: An Annual of American Cultural Studies* 30 (2005): 685–713.

Gidley and Lawson-Peebles [1989] 2007a
Gidley, Mick and Robert Lawson-Peebles, eds. *Views of American Landscapes* [1989]. Cambridge: Cambridge University Press, 2007.

Gidley [1989] 2007b
Gidley, Mick. "The Figure of the Indian in Photographic Landscapes." In Gidley and Lawson-Peebles [1989] 2007a, 199–220.

Goetzmann 1959
Goetzmann, William H. *Army Exploration in the American West, 1803–1863*. New Haven: Yale University Press, 1959.

Goetzmann [1966] 1972
Goetzmann, William H. *Exploration and Empire: The Explorer and the Scientist in the Winning of the American West* [1966]. New York, Random House, 1972.

Goetzmann and Goetzmann 1986
Goetzmann, William H. and William N. Goetzmann, *The West of the Imagination*. New York: W. W. Norton & Company, 1986.

Goetzmann 1996
Goetzmann, William H. "Desolation, Thy Name is the Great Basin: Clarence King's Fortieth Parallel Geological Explorations." In Castleberry 1996, 57–61.

Goodyear 2003
Goodyear, Frank H., III. *Red Cloud: Photographs of a Lakota Chief*. Lincoln: University of Nebraska Press, 2003.

Hague 1904
Hague, James D., et al. *Clarence King Memoirs: The Helmet of Mambrino*. New York: G. P. Putnam's Sons, 1904.

Hales 1988
Hales, Peter B. *William Henry Jackson and the Transformation of the American Landscape*. Philadelphia: Temple University Press, 1988.

Hansen [1989] 2007
Hansen, Olaf. "The Impermanent Sublime: Nature, Photography and the Petrarchan Tradition." In Gidley and Lawson-Peebles [1989] 2007a, 31–50.

Hayden 1871
Hayden, Ferdinand V. *Preliminary Report of the United States Geological Survey of Wyoming, and Portions of Contiguous Territories*. Washington, D.C.: Government Printing Office, 1871.

Hollein and Kort 2006
Hollein, Max and Pamela Kort. *I Like America: Fiktionen des Wilden Westens*. Frankfurt: Schirn Kunsthalle, 2006.

Horan 1966
Horan, James David. *Timothy O'Sullivan, America's Forgotten Photographer: the life and work of the brilliant photographer whose camera recorded the American scene from the battlefields of the Civil War to the frontiers of the West*. Garden City, N.Y.: Doubleday, 1966.

Huth 1948
Huth, Hans. "Yosemite: The Story of an Idea." *Sierra Club Bulletin* 33, no. 3 (1948): 47–78.

Jackson [1940] 1986
Jackson, William H. *Time Exposure: The Autobiography of William Henry Jackson* [1940]. Albuquerque: University of New Mexico Press, 1986.

Jackson 1947
Jackson, Clarence S. *Picture Maker of the Old West: William H. Jackson*. New York: Charles Scribner's Sons, 1947.

Jones 1991
Jones, Peter C. *The Changing Face of America*. New York: Prentice Hall Press, 1991.

Jussim 1974
Jussim, Estelle. *Visual Communication and the Graphic Arts*. New York and London: R. R. Bowker, 1974.

Jussim and Lindquist-Cock 1985
Jussim, Estelle and Elizabeth Lindquist-Cock. *Landscape as Photograph*. New Haven: Yale University Press, 1985.

Kailbourn and Palmquist 2001
Kailbourn, Thomas R. and Peter Palmquist. *Pioneer Photographers of the Far West: A Biographical Dictionary 1840–1865*. Stanford, Calif.: Stanford University Press, 2001.

Kailbourn and Palmquist 2005
Kailbourn, Thomas R. and Peter Palmquist. *Pioneer Photographers From The Mississippi To The Continental Divide: A Biographical Dictionary, 1839–1865*. Stanford, Calif.: Stanford University Press, 2005.

Kelsey 2003
Kelsey, Robin E. "Viewing the Archive: Timothy O'Sullivan's Photographs for the Wheeler Survey, 1871–74." *Art Bulletin* 85, no. 4 (December 2003): 702–23.

Kelsey 2004
Kelsey, Robin. "Les espaces historiographiques de Timothy O'Sullivan." *Études photographiques*, no. 14 (January 2004): 4–33.

Kelsey 2007
Kelsey, Robin. *Archive Style.*
Berkeley: University
of California Press, 2007.

King [1872] 1970
King, Clarence. *Mountaineering
in the Sierra Nevada* [1872].
Lincoln: The University
of Nebraska Press, 1970.

King 1878
King, Clarence. *Systematic
Geology (Final Report of
the United States Geological
Exploration of the Fortieth
Parallel),* vol. 1. Washington,
D.C.: Government Printing
Office, 1878.

Kinsey 1992
Kinsey, Joni Louise.
*Thomas Moran and
the Surveying of the American
West.* Washington, D.C.:
Smithsonian Institution, 1992.

Kittredge 1996
Kittredge, William.
Who Owns the West.
San Francisco:
Mercury House, 1996.

Klett and Manchester 1984
Klett, Mark, and Ellen
Manchester. *Second View:
The Rephotographic Survey
Project.* Albuquerque:
University of New Mexico
Press, 1984.

Klett 2004
Klett, Mark et al.
*Third Views, Second Sights:
A Rephotographic Survey
of the American West.*
Santa Fe: Museum of
New Mexico Press, 2004.

Krauss 1982
Krauss, Rosalind.
"Photography's Discursive
Spaces: Landscape/View."
Art Journal 42, no. 4
(Winter 1982): 311–19.

Limerick 1987
Limerick, Patricia Nelson.
*The Legacy of Conquest:
The Unbroken Past of the
American West.* New York:
W. W. Norton, 1987.

Lindquist-Cock 1977
Lindquist-Cock, Elizabeth.
*The Influence of Photography
on American Landscape Painting,
1839–1880.* New York and
London, Garland Reprints,
1977.

Lippard 1992
Lippard, Lucy R., ed. *Partial
Recall.* New York: New Press,
1992.

Loiseaux 2006
Loiseaux Olivier, ed.
*Trésors photographiques
de la Société de géographie.*
Paris: Bibliothèque Nationale
de France, Éditions Glénat,
2006. Exh. cat.

McCarron-Cates 2006
McCarron-Cates, Floramae.
"The Best Possible View:
Pictorial Representation
in the American West."
In Davidson 2006, 74–117.

Mondenard 2002
Mondenard, Anne de.
*La Mission héliographique:
Cinq photographes parcourent
la France en 1851.* Paris:
Éditions du patrimoine,
2002. Exh. cat.

Naef and Wood 1975
Naef, Weston and James N.
Wood. *Era of Exploration:
The Rise of Landscape
Photography in the American
West, 1860–1885.* Boston:
New York Graphic Society
for the Albright-Knox Gallery
and the Metropolitan
Museum of Art, 1975. Exh. cat.

Newhall 1966
Newhall, Beaumont. *Timothy H.
O'Sullivan.* Rochester, N.Y.:
George Eastman House, 1966.

Newhall 1982
Newhall, Beaumont.
The History of Photography,
5th ed. New York: Museum
of Modern Art, 1982.

Nickel 1999
Nickel, Douglas R. *Carleton
Watkins: The Art of Perception.*
San Francisco: San Francisco
Museum of Modern Art, 1999.
Exh. cat.

Novak 1980
Novak, Barbara. *Nature
and Culture: American Landscape
Painting 1825–1875.* London:
Thames & Hudson, 1980.

Ostroff 1981
Ostroff, Eugene. *Western Views
and Eastern Visions,* Washington
D.C., Smithsonian Institution,
1981. Exh. cat.

Palmquist 1983
Palmquist, Peter E.
*Carleton E. Watkins: Photographer
of the American West.*
Albuquerque: University
of New Mexico Press
for the Amon Carter Museum,
1983. Exh. cat.

Palmquist 2002
Palmquist, Peter, et al.
*Points of Interest: California
Views 1860–1870: The Lawrence
and Houseworth Albums.*
Berkeley: Berkeley Hills Books,
San Francisco: The Society
of California Pioneers, 2002.

Panzer 1997
Panzer, Mary. *Mathew Brady
and the Image of History.*
Washington, D.C.:
Smithsonian Books, 1997.

Phillips 1996
Phillips, Sandra S., et al.
*Crossing the Frontier: Photographs
of the Developing West, 1849
to the Present.* San Francisco:
Chronicle Books, 1996.

Pratt 1964
Pratt, Richard H. *Battlefield
and Classroom: Four Decades
with the American Indian
1867–1904.* New Haven:
Yale University Press, 1964.

Rudisill 1971
Rudisill, Richard. *Mirror Image:
The Influence of the Daguerreotype
on American Society.*
Albuquerque, University
of New Mexico Press, 1971.

Rule 1993
Rule, Amy. *Carleton Watkins:
Selected Texts and Bibliography.*
Boston: G. K. Hall, 1993.

Russell 1882
Russell, Andrew J.
"Photographic Reminiscences
of the Late War." *Anthony's
Photographic Bulletin* 13
(July 1882): 212–213.

Sampson 1869
Sampson, John. "Photographs
from the High Rockies."
Harper's Magazine 39, no. 232
(September 1869): 465–75.

Sandweiss 1991
Sandweiss, Martha A.
*Photography in the Nineteenth-
Century America.* New York:
Harry N. Abrams, Fortworth:
Amon Carter Museum, 1991.

Sandweiss 2002
Sandweiss, Martha A.
*Print the Legend: Photography
and the American West.*
New Haven and London:
Yale University Press, 2002.

Sandweiss 2006
Sandweiss, Martha.
"A Stereoscopic View of
the American West." *Princeton
University Library Chronicle* 67,
no. 2 (Winter 2006): 271–89.

Schama 1995
Schama, Simon. *Landscape
and Memory.* London:
HarperCollins, 1995.

Sekula 1983
Sekula, Alan. "Photography
Between Labour and Capital."
In Benjamin H. D. Buchloh
and Robert Wilkie, ed.
*Mining Photographs and Other
Pictures, 1948–1968: A Selection
from the Negative Archives
of Shedden Studio, Glace Bay, Cape
Breton.* Halifax: Press of the
Nova Scotia College of Art
and Design and the University
College of Cape Breton Press,
1983, 193–268.

Snyder 1981
Snyder, Joel. *American Frontiers:
The Photographs of Timothy H.
O'Sullivan, 1867–74.* Millerton,
N.Y.: Aperture, 1981. Exh. cat.

Snyder 1986
Snyder, Joel. "Aesthetics
and Documentation:
Remarks Concerning
Critical Approaches
to the Photographs
of Timothy O'Sullivan."
In Peter Walch and Thomas
Barrow, eds., *Perspectives
in Photography.*
Albuquerque: University
of New Mexico Press, 1986.

Snyder 2002
Snyder, Joel. "Territorial
Photography." In W. J. T.
Mitchell, ed., *Landscape and
Power.* Chicago and London:
University of Chicago Press,
2002, 175–201.

Snyder 2006
Snyder, Joel. *One/Many: Western
American Survey Photographs
by Bell and O'Sullivan.* Chicago:
The David and Alfred Smart
Museum of Art, The University
of Chicago, 2006. Exh. cat.

Stegner 1954
Stegner, Wallace. *Beyond
the Hundredth Meridian:
John Wesley Powell and the Second
Opening of the West.* Boston:
Houghton Mifflin, 1954.

Sweet 1990
Sweet, Timothy. *Traces of War:
Poetry, Photography and the
Crisis of the Union.* Baltimore:
The Johns Hopkins University
Press, 1990.

Szarkowski 1963
Szarkowski, John.
*The Photographer and the
American Landscape.* New York:
The Museum of Modern Art,
1963. Exh. cat.

Taft 1953
Taft, Robert. *Artists
and Illustrators of the Old West
1850–1900.* Princeton: Princeton
University Press, 1953.

Taft [1938] 1964
Taft, Robert. *Photography and
the American Scene: A Social History
1839–1889* [1938]. New York:
Dover Publications, 1964.

Taylor 1980
Taylor, Colin. "'Ho, for the Great
West!': Indians and Buffalo,
Exploration and George
Catlin; The West of William
Blackmore." In Barry C.
Johnson, ed. *"Ho, for the Great
West!" and other Original Papers
to Mark the 25th Anniversary
of the English Westerners' Society.*
London: English Westerners'
Society, 1980, 8–49.

Trachtenberg 1982
Trachtenberg, Alan.
*The Incorporation of America:
Culture and Society in the Gilded
Age.* New York: Hill and
Wang, 1982.

Trachtenberg 1989
Trachtenberg, Alan. *Reading American Photographs: Images as History, Mathew Brady to Walker Evans*. New York: Hill and Wang, 1989.

Trachtenberg 2004
Trachtenberg, Alan. *Shades of Hiawatha: Staging Indians, Making Americans, 1880–1930*. New York: Hill and Wang, 2004.

Truettner 1991
Truettner, William H., ed. *The West as America: Reinterpreting Images of the Frontier, 1820–1920*. Washington: Smithsonian Institution Press, 1991. Exh. cat.

Tyler 1996
Tyler, Ron. "Prints vs. Photographs, 1840–60." In Castleberry 1996, 41–47.

Viola 1981
Viola, Herman J. *Diplomats in Buckskins: A History of Indian Delegations in Washington City*. Washington, D.C.: Smithsonian Institution Press, 1981.

Viola 1987
Viola, Herman J. *Exploring the West*, Washington, D.C.: Smithsonian Institution Press, 1987.

Watkins 1997
Carleton Watkins: Photographs from the J. Paul Getty Museum. Los Angeles: The J. P. Getty Museum, 1997. Exh. cat.

Welling [1978] 1987
Welling, William. *Photography in America: The Formative Years 1839–1900* [1978]. Albuquerque: University of New Mexico Press, 1987.

Wheeler 1874
Wheeler, George M., *Progress Report upon Geographical and Geological Explorations and Surveys West of the Hundredth Meridian in 1872*, Washington: Government Printing Office, 1874.

Wheeler 1983
Wheeler, George M. *Wheeler's Photographic Survey of the American West, 1871–1873: With Fifty Landscape Photographs by Timothy O'Sullivan and William Bell*. New York: Dover Publications, 1983.

White 1991
White, Richard. *"It's Your Misfortune and None of My Own": A History of the American West*. Norman: University of Oklahoma Press, 1991.

Wilkins [1958] 1988
Wilkins, Thurman. *Clarence King: A Biography: Revised and Enlarged Edition* [1958]. Albuquerque: University of New Mexico Press, 1988.

Williams 2003
Williams, Carol J. *Framing the West: Race, Gender, and the Photographic Frontier in the Pacific Northwest*. Oxford and New York: Oxford University Press, 2003.

Wolf 1983
Wolf, Daniel. *The American Space: Meaning in Nineteenth-Century Landscape Photography*. Middleton, Conn.: Wesleyan University Press, 1983. Exh. cat.

Wrobel 2002
Wrobel, David M. *Promised Lands: Promotion, Memory, and the Creation of the American West*. Lawrence: University Press of Kansas, 2002.

INDEX

Photograph Credits